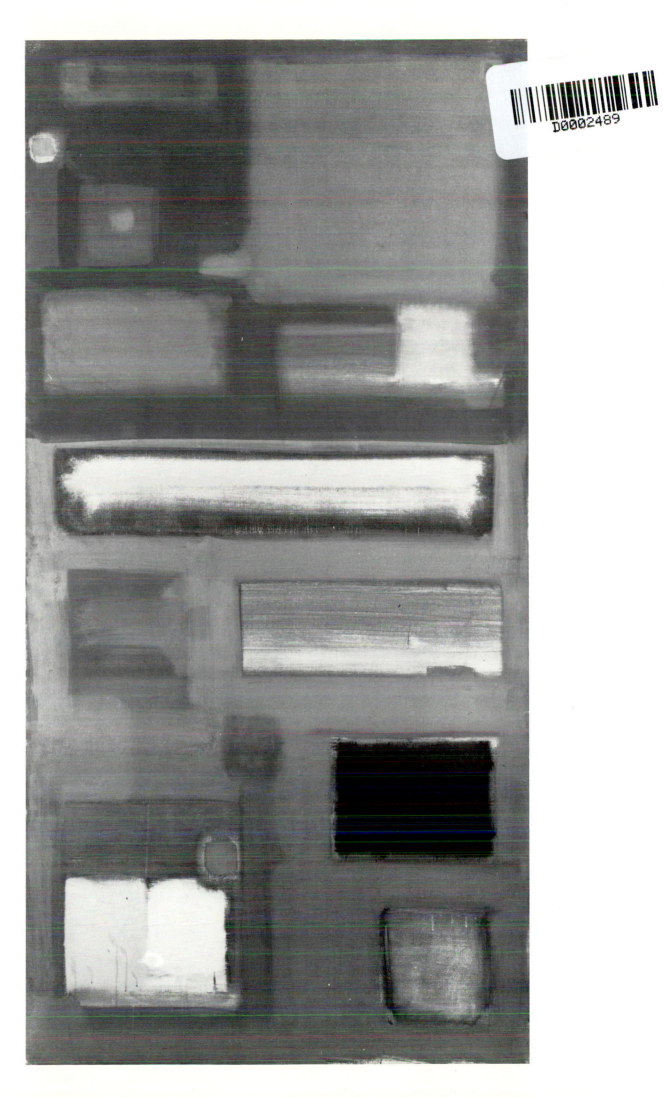

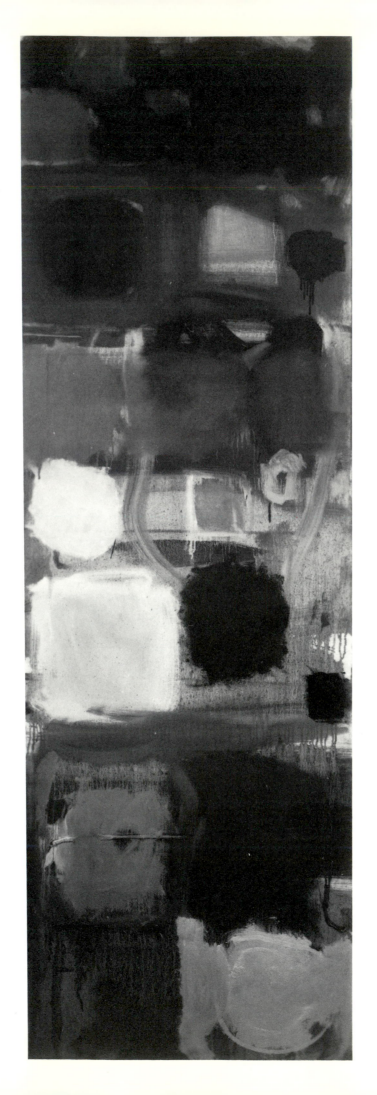

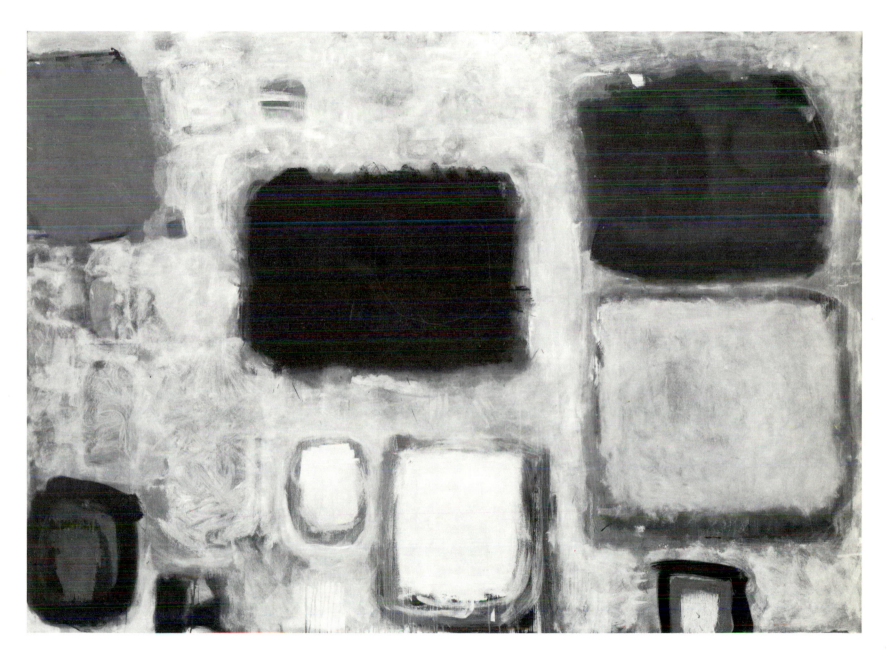

opposite : 35 Ragged Squares – Tall Painting : December 1958 oil on canvas 72 × 24in/182·9 × 61cm
above : 36 Yellow Painting : October 1958–June 1959 oil on canvas 60 × 84in/152·4 × 213·4cm

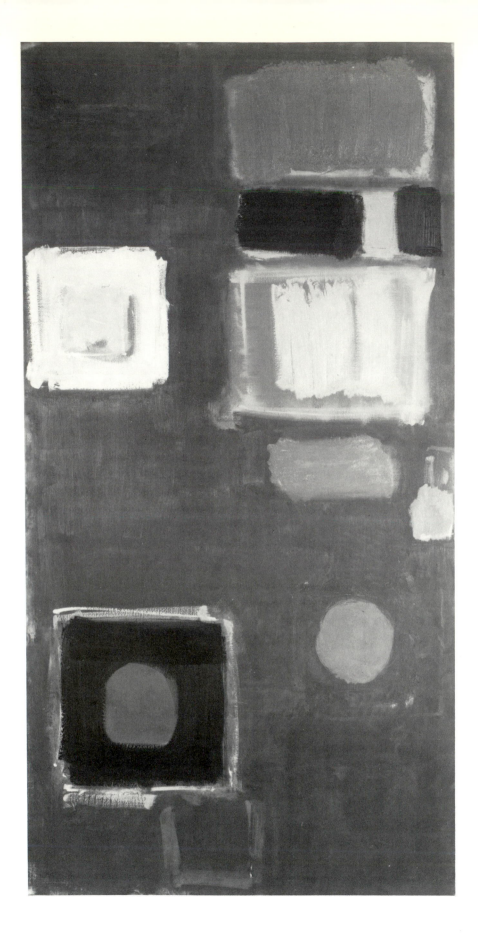

37 Tall Brown : June 1959 oil on canvas 72 × 36in/182·9 × 91·5cm

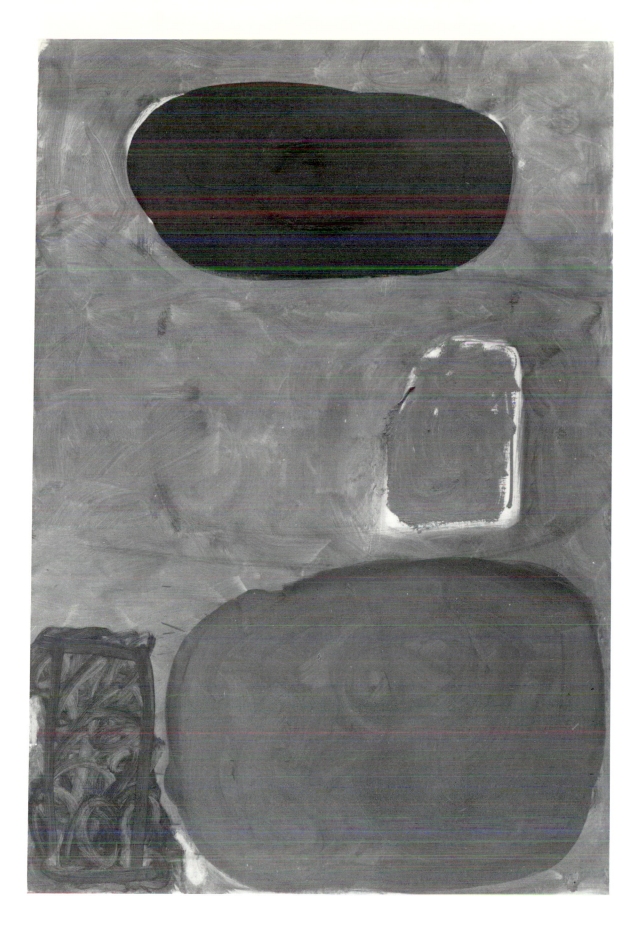

38 Black Shape: March 1960 oil on canvas 72 × 48in/182·9 × 121·9cm

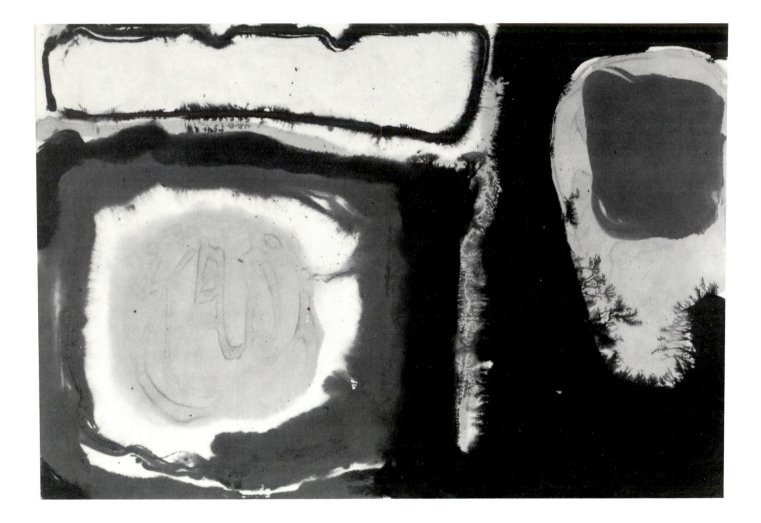

above: 39 Gouache No 2: March 1961 gouache on paper 15 × 22in/38 × 55·9cm
opposite: 40 Incandescent Skies, Yellow and Rose: December 1957 oil on canvas 72 × 36in/182·9 × 91·5cm

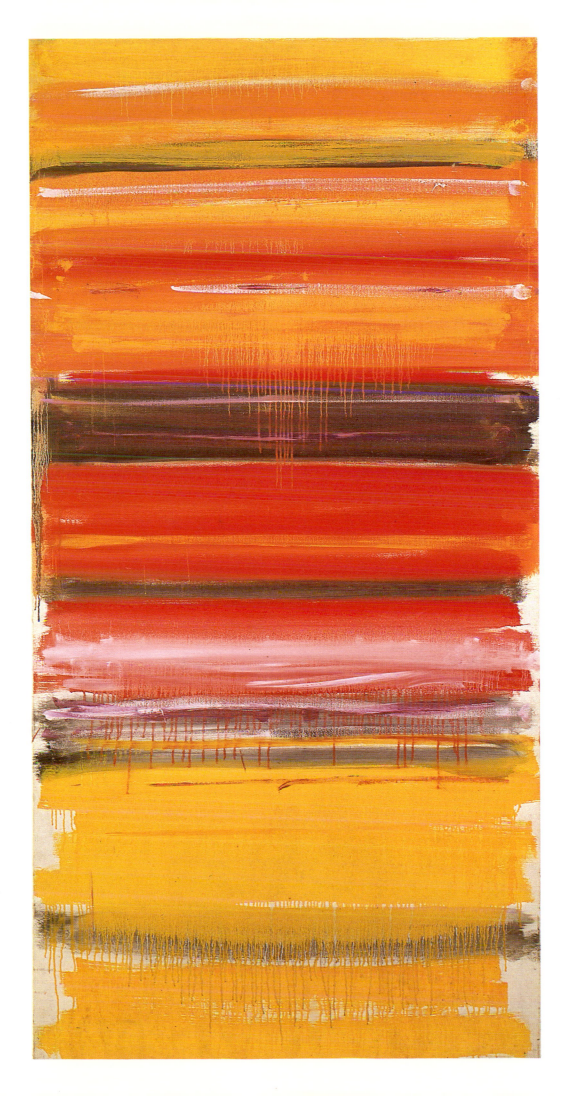

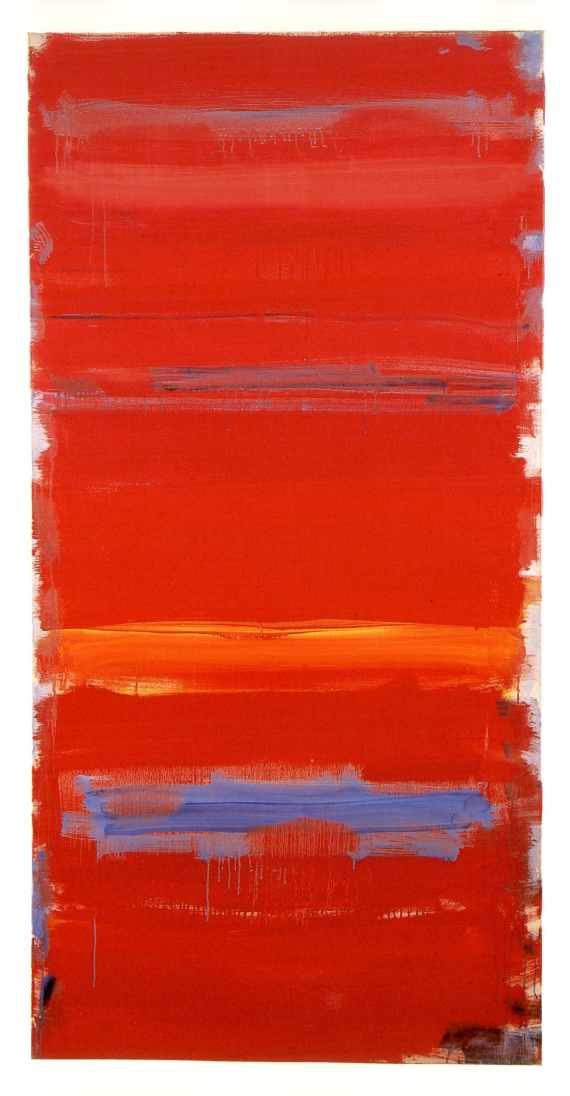

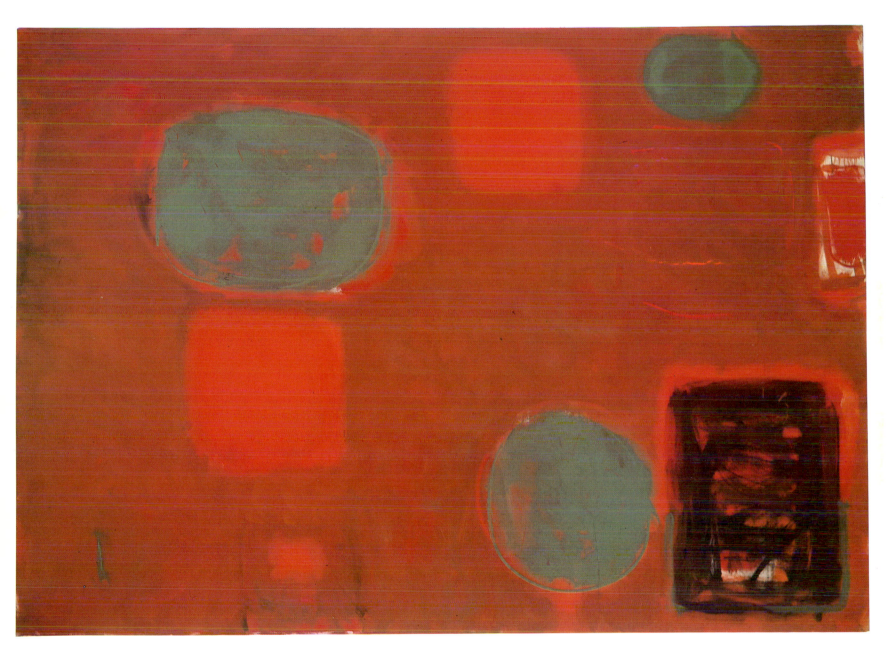

opposite: 41 Red Layers with Blue and Yellow: December 1957 oil on canvas 72 × 36in/182·9 × 91·5cm
above: 42 Brown Ground (with soft red and green): August 1958–July 1959 oil on canvas 60 × 84in/152·4 × 213·4cm

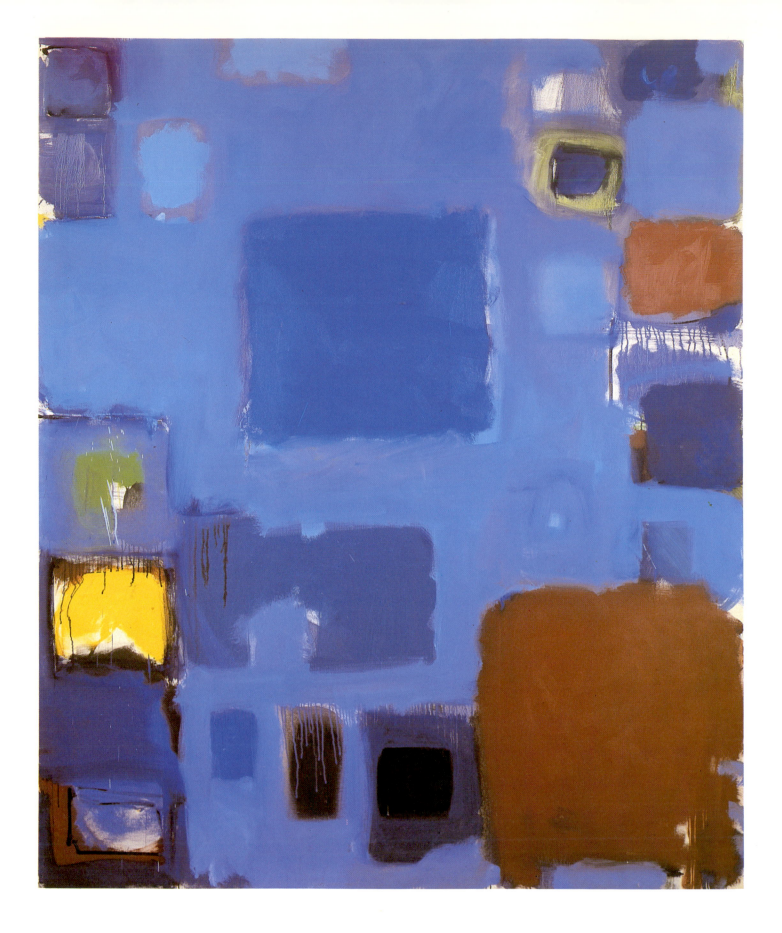

43 Blue Painting: November–December 1958 oil on canvas 72 × 60in/182·9 × 152·4cm

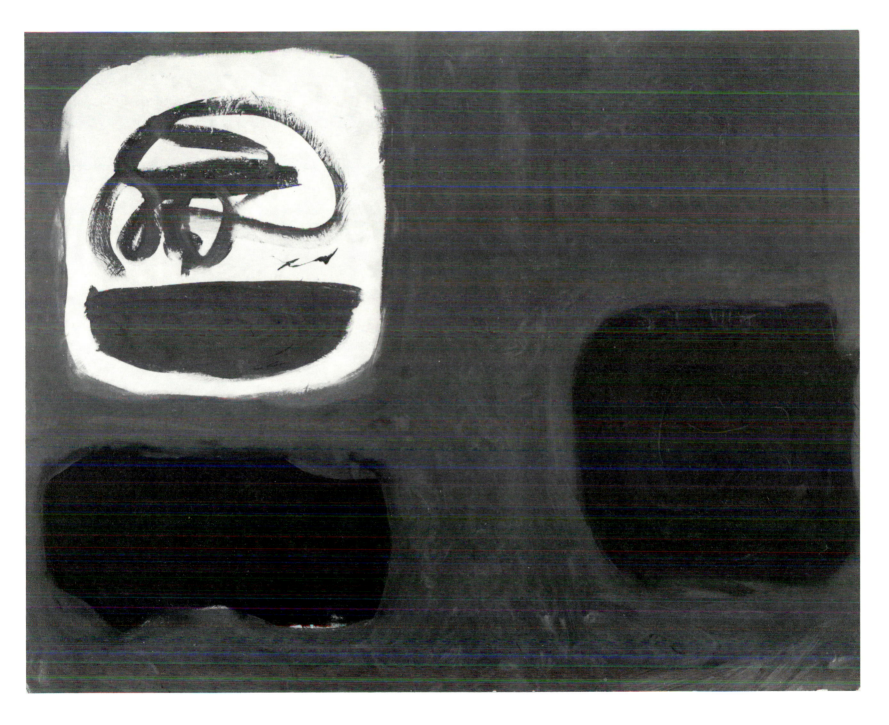

44 Ceruleum Sea : June 1961 oil on canvas 48 × 60in/121·9 × 152·4cm

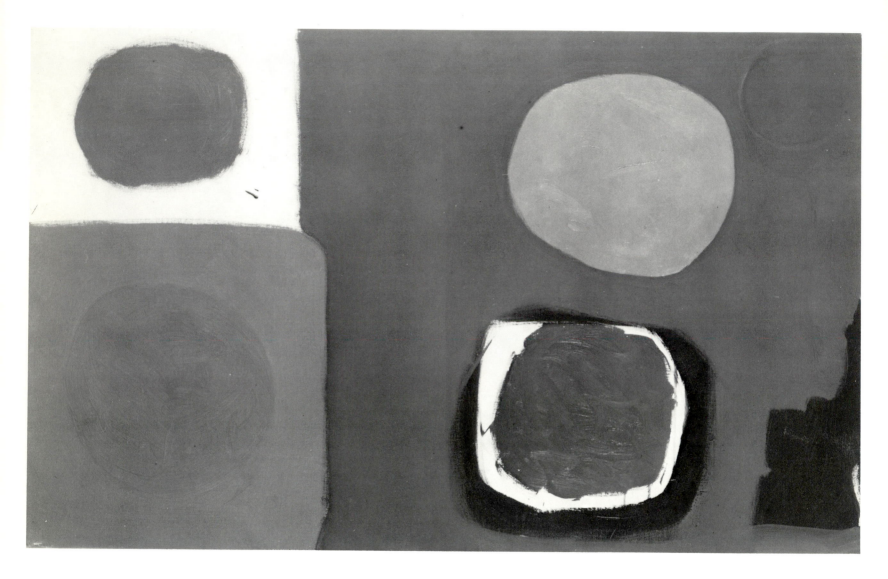

45 Red Disc in Dusky Blue : September 1962 oil on canvas 30 × 48in/76·2 × 121·9cm

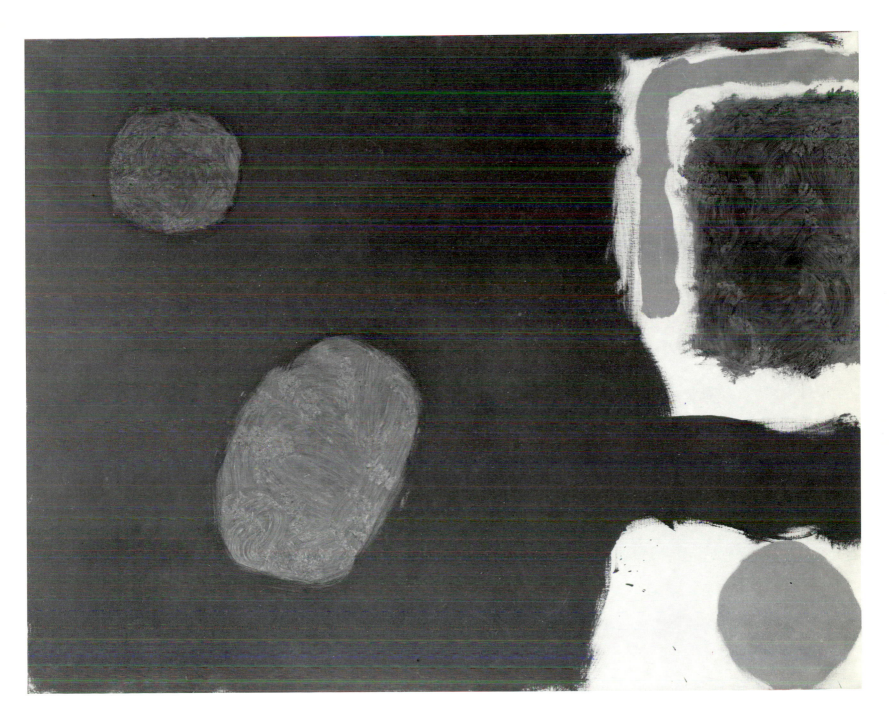

46 Clèar Blues in Green and White 1962 oil on canvas 38 × 48in/96·5 × 121·9cm

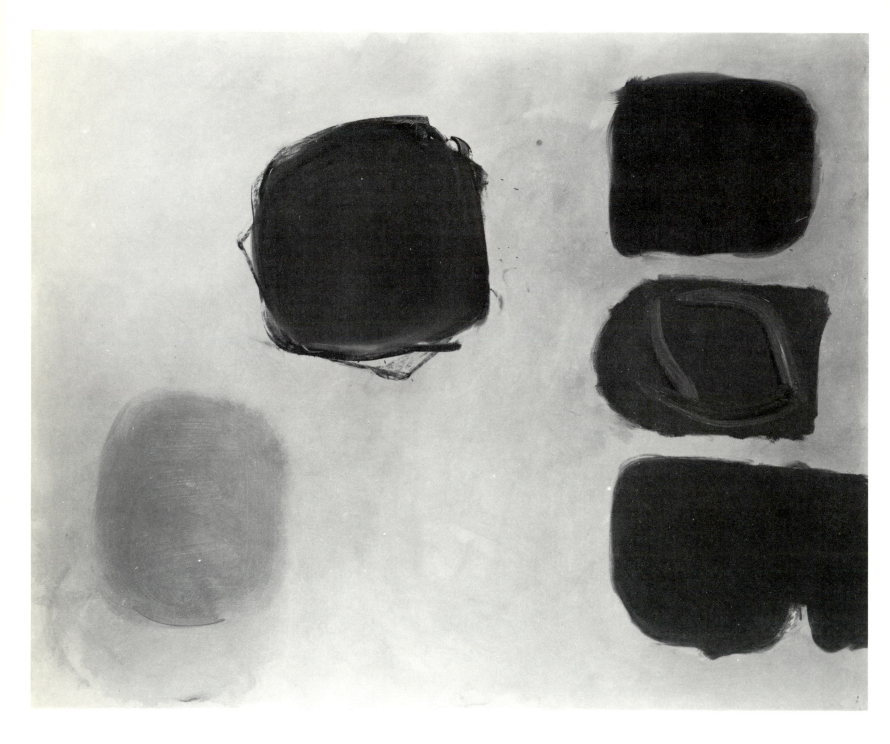

47 Orange (with Five): September 18 1962 oil on canvas 48 × 60in/121·9 × 152·4cm

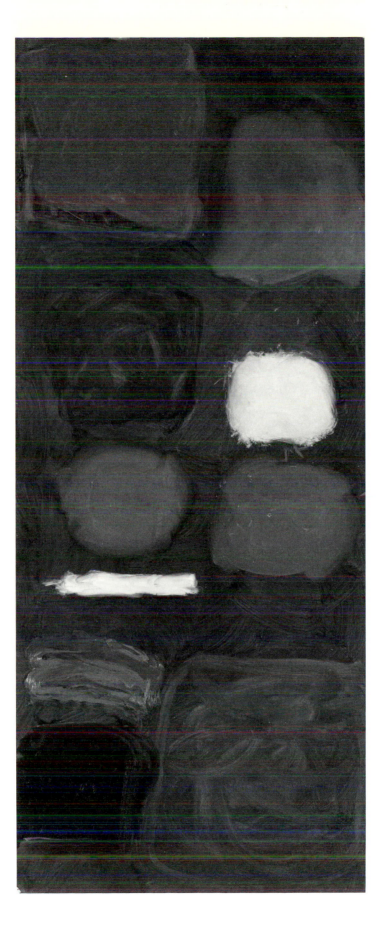

48 Tall Purple: September 1962 oil on canvas 72 × 30in/182·9 × 76·2cm

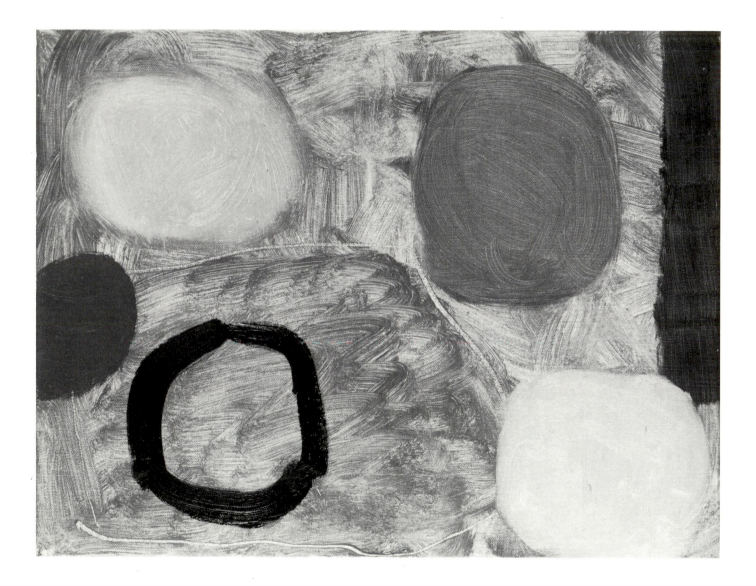

49 Small Areas (Lime and Blue in Pale Violet) : 10 September 1962 oil on canvas 10 × 13in/25·4 × 33cm

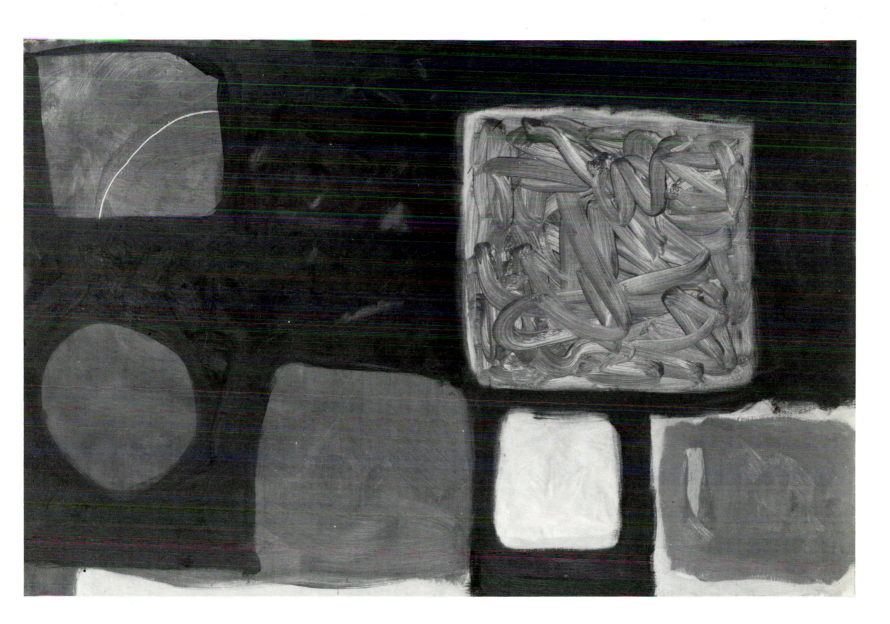

50 Various Blues in Indigo : December 1962 oil on canvas 40 × 60in/101·6 × 152·4cm

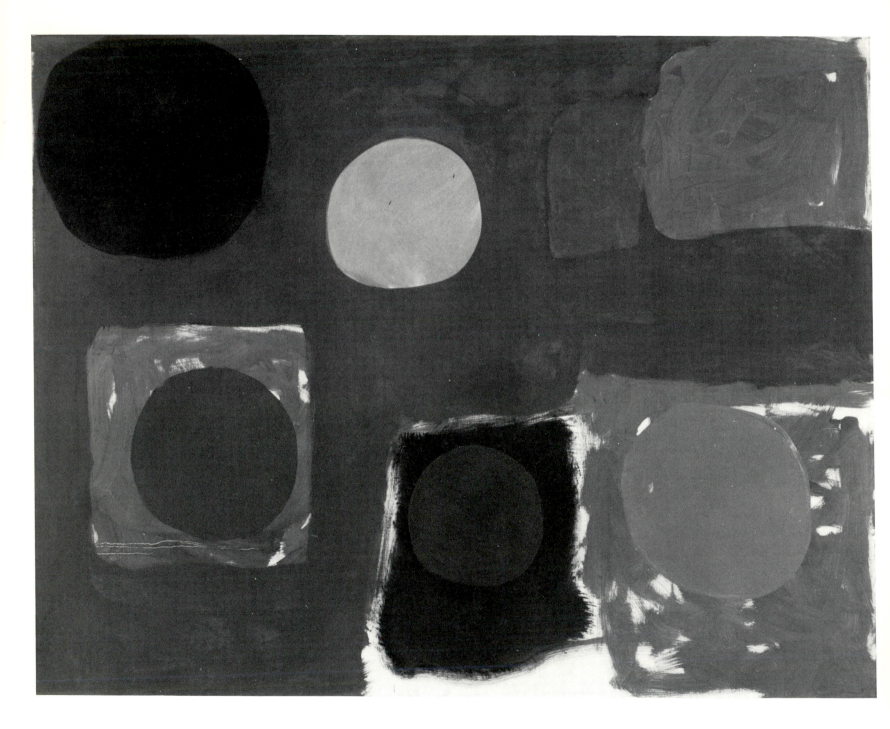

51 Five Discs in Red 1964 oil on canvas 38 × 48in/96·5 × 121·9cm

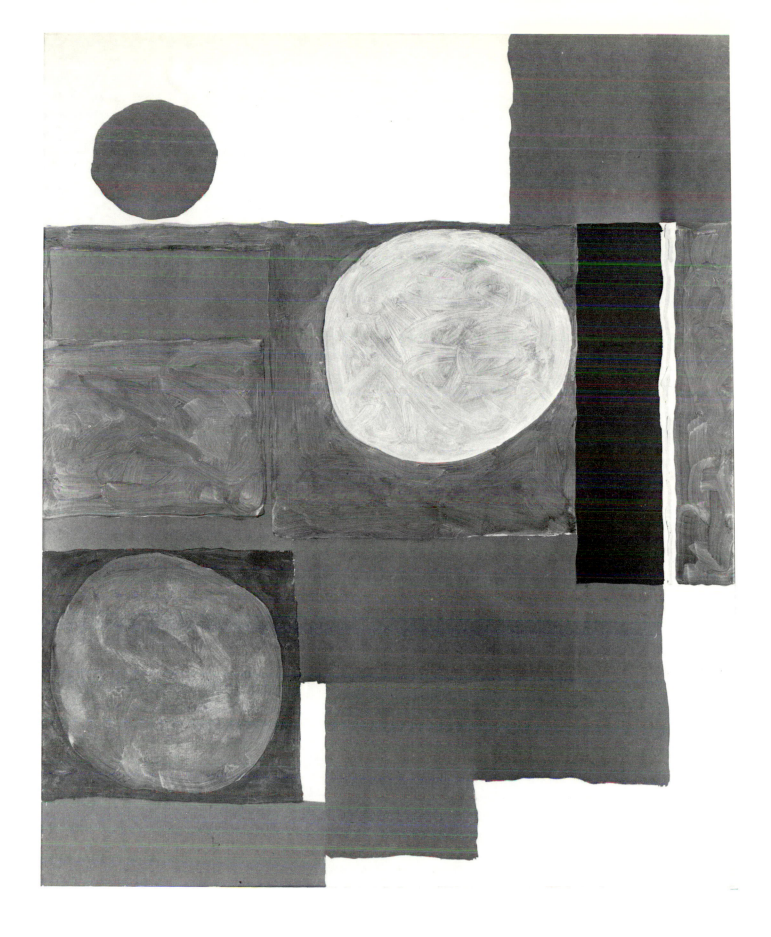

52 Blue in Blue with Red and White 1964 oil on canvas 60 × 48in/152·4 × 121·9cm

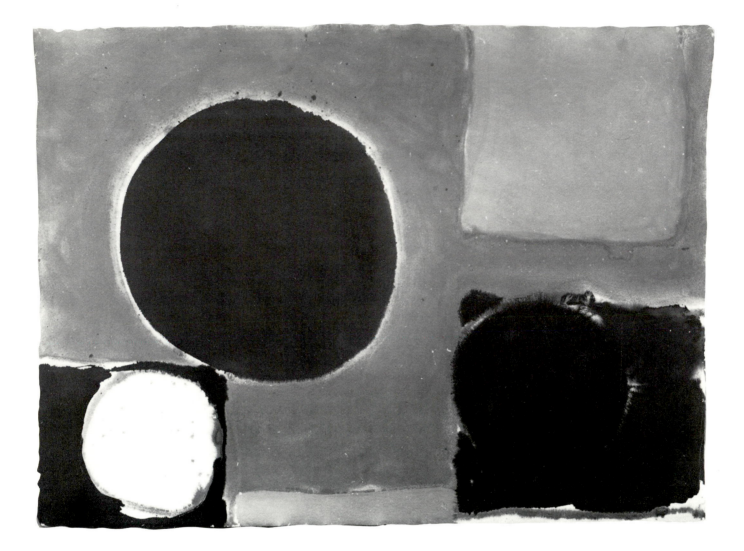

53 Various Blues: June 1964 gouache on paper 23 × 31in/58·4 × 78·7cm

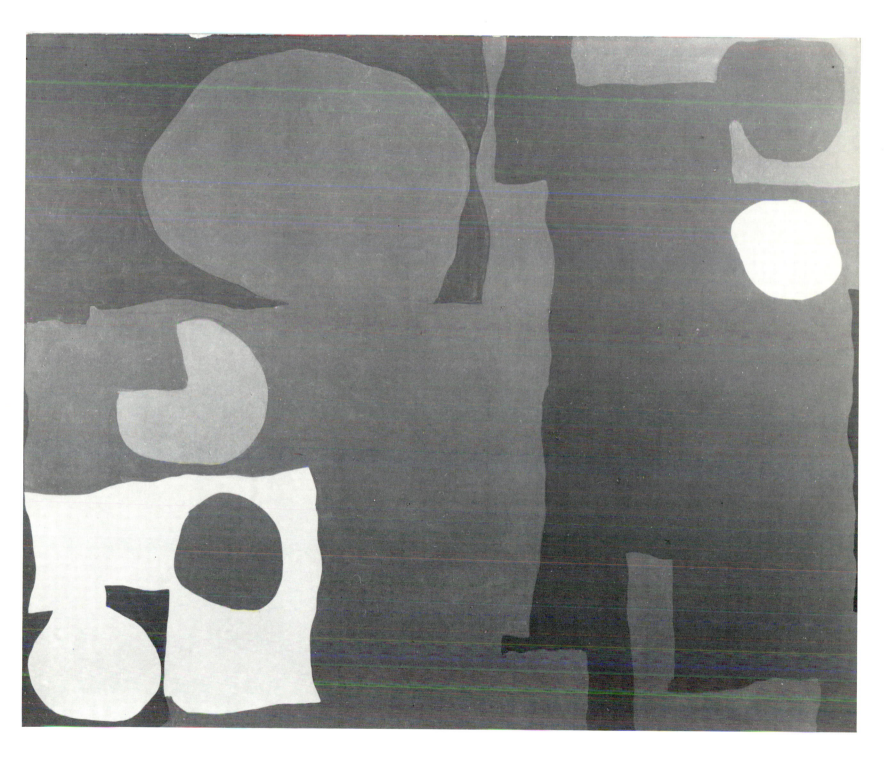

54 Emerald and Scarlet with Yellows: June 1966 oil on canvas 60 × 72in/152·4 × 182·9cm

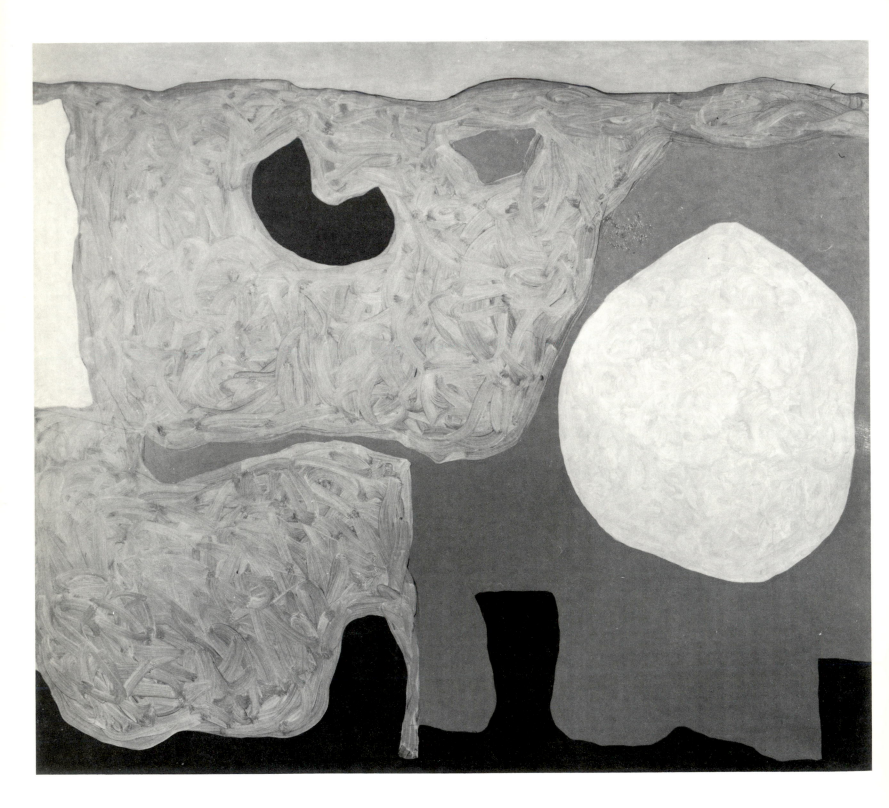

55 Mainly Ultramarine and Venetian: November 1966 oil on canvas 72 × 84in/182·9 × 213·4cm

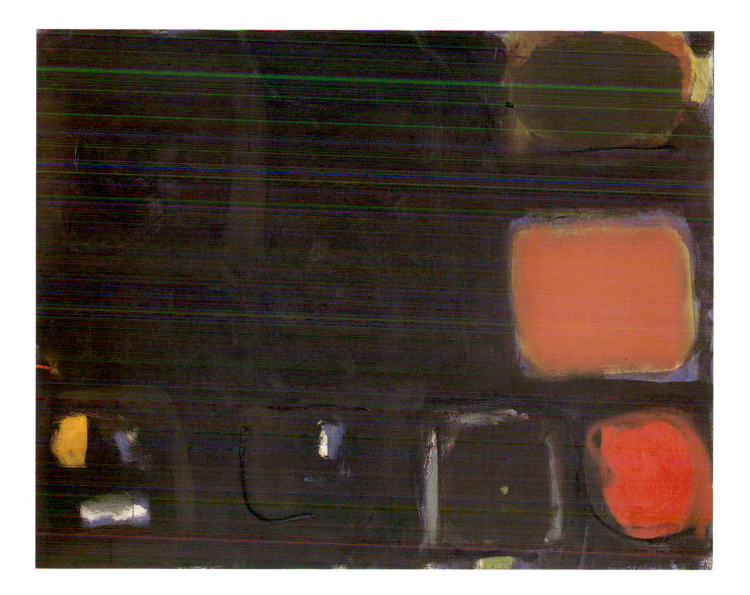

56 Black Painting, Red, Brown and Olive : July 1959 oil on canvas 38 × 48in/96·5 × 121·9cm

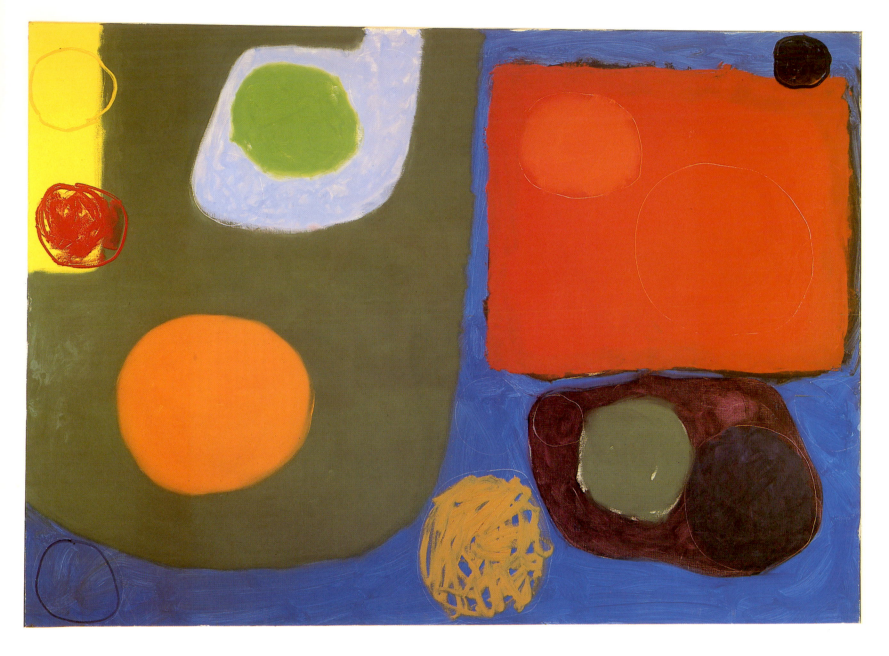

57 Fourteen Discs 1963 oil on canvas 60 × 84in/152·4 × 213·4cm

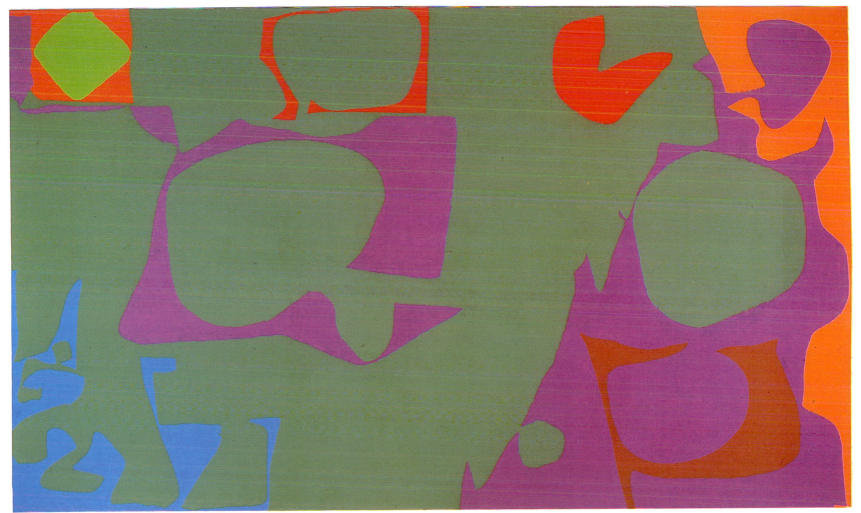

58 Complicated Green and Violet: March 1972 oil on canvas 72 × 120in/182·9 × 305cm

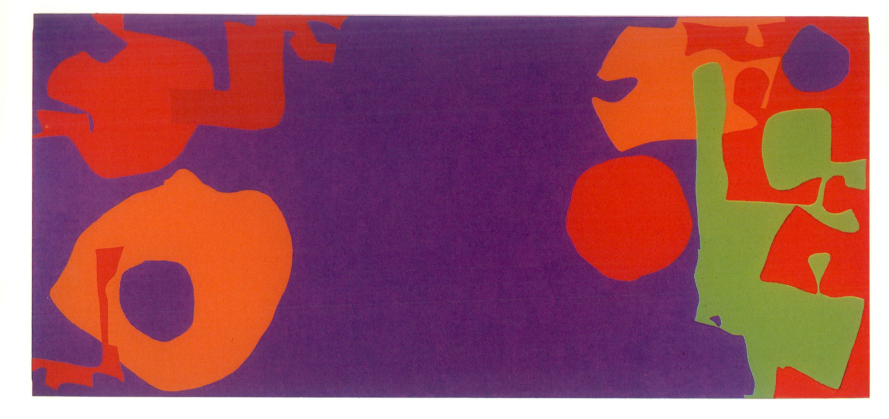

59 Big Cobalt Violet: May 1972 oil on canvas 82 × 180in/208 × 457cm

60 Cadmium with Violet, Scarlet, Emerald, Lemon and Venetian 1969 oil on canvas 78 × 156in/198 × 396cm

61 March–April 1975 oil on canvas 82 × 180in/208·3 × 457·2cm

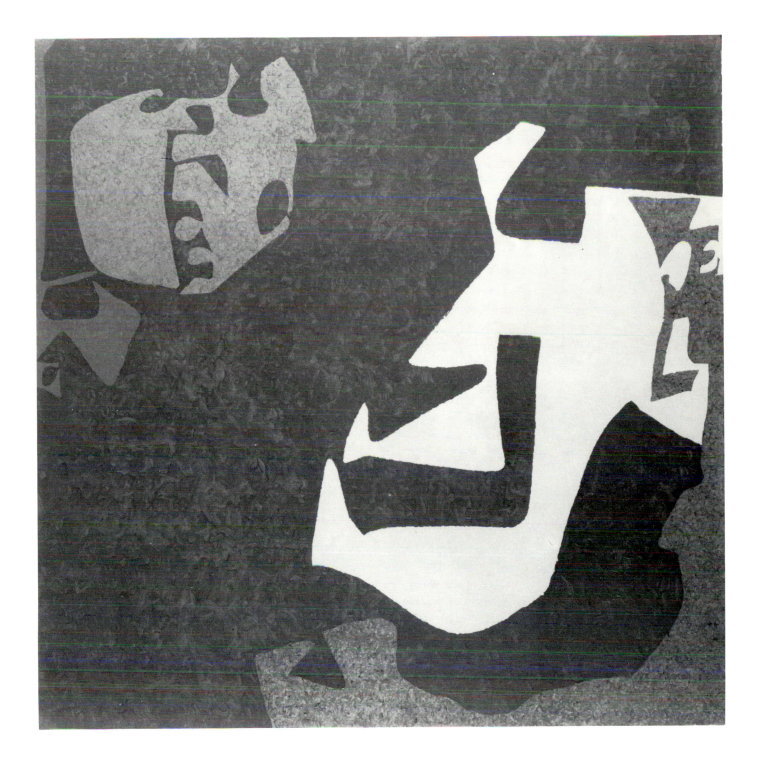

62 Complex Ceruleum in Dark Green Square: March–August 1977 oil on canvas 60 × 60in/152·4 × 152·4cm

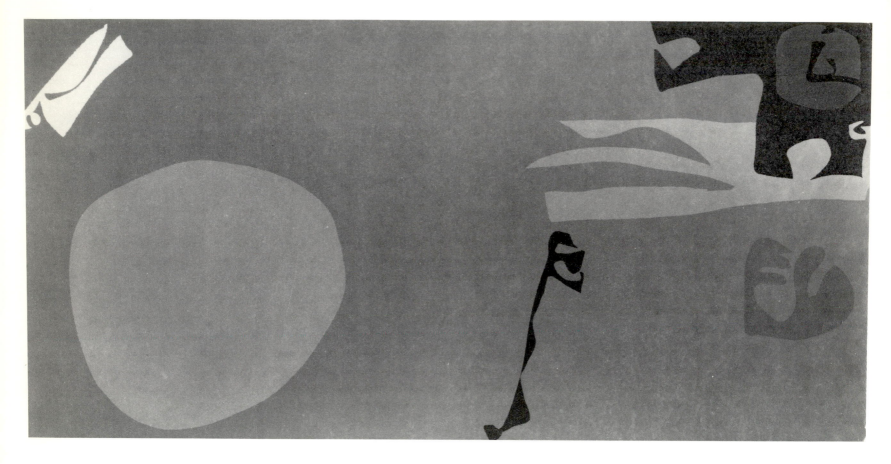

63 Long Cadmium with Ceruleum in Violet (Boycott) : July–November 1977 oil on canvas 78 × 156in/198 × 396·2cm

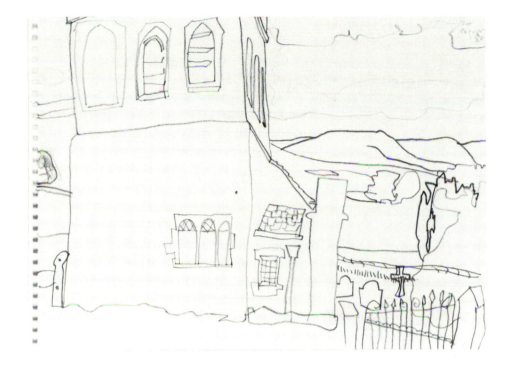

64 Selside Church Tower and Gate 1980 pencil on paper 10 × 14in/25·4 × 35·6cm

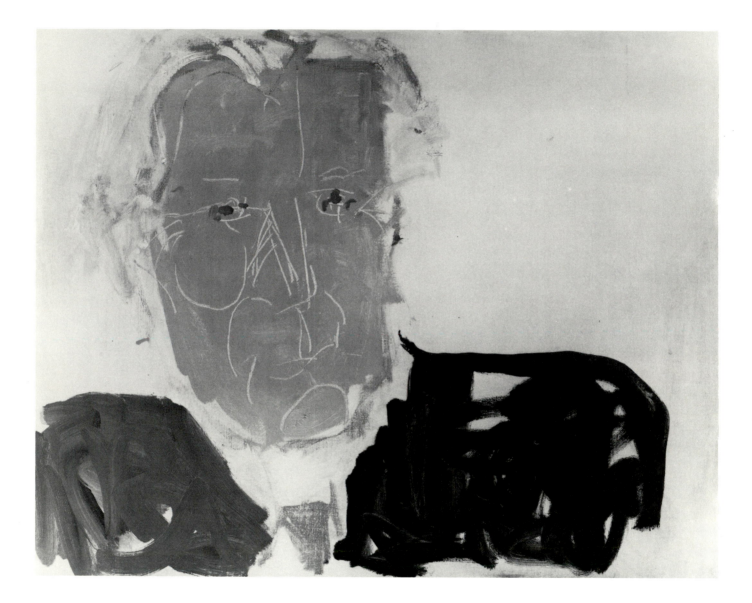

65 Portrait of Jo Grimond III : September 4 1986 oil on canvas 16 × 20in/40·6 × 50·8cm

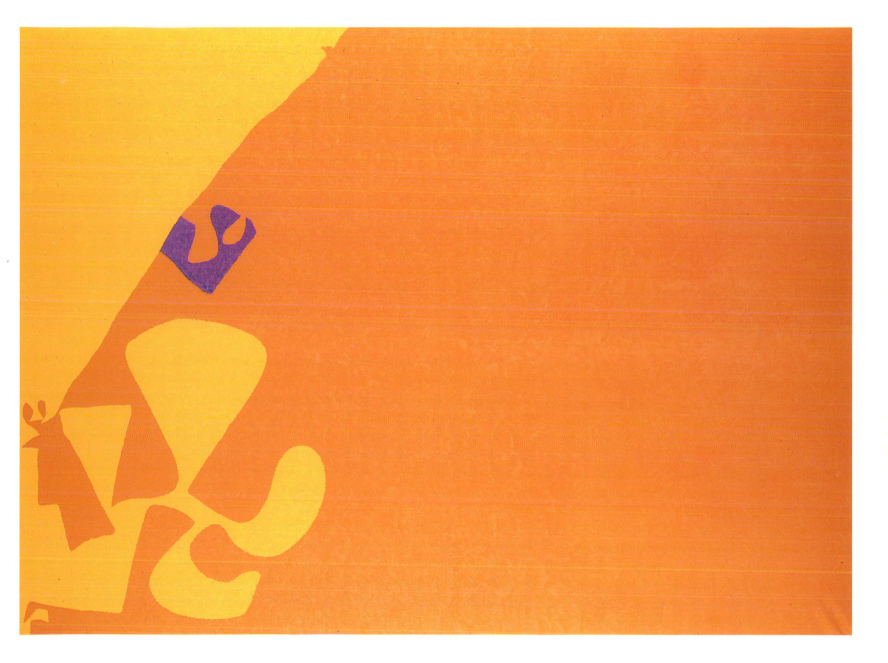

66 Orange and Lemon with Small Violet: April–July 1977 oil on canvas 78 × 108in/198 × 274·3cm

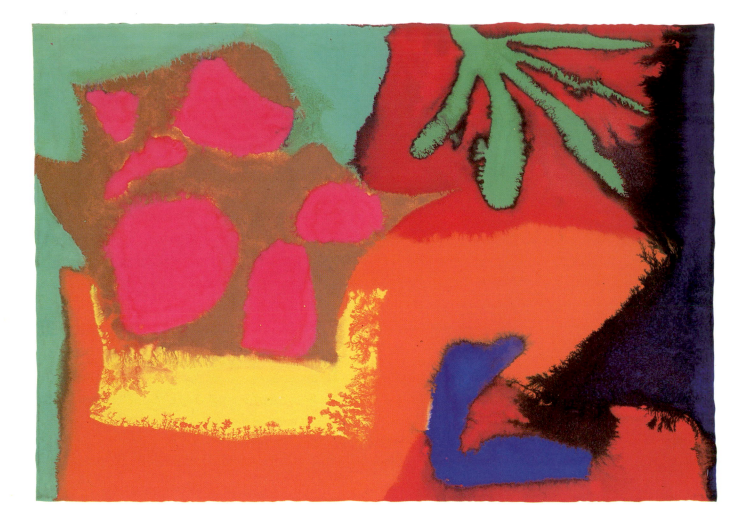

67 January 3 1984 gouache on paper $13\frac{7}{8} \times 19\frac{7}{8}$ in/35 \times 50·3cm

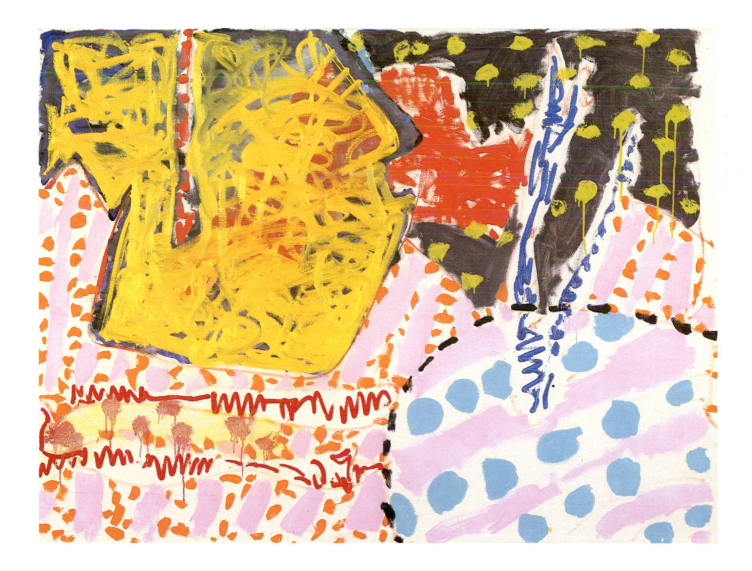

68 Garden Painting with Lemon : May 1985 oil on canvas 38 × 48in/96·5 × 121·9cm

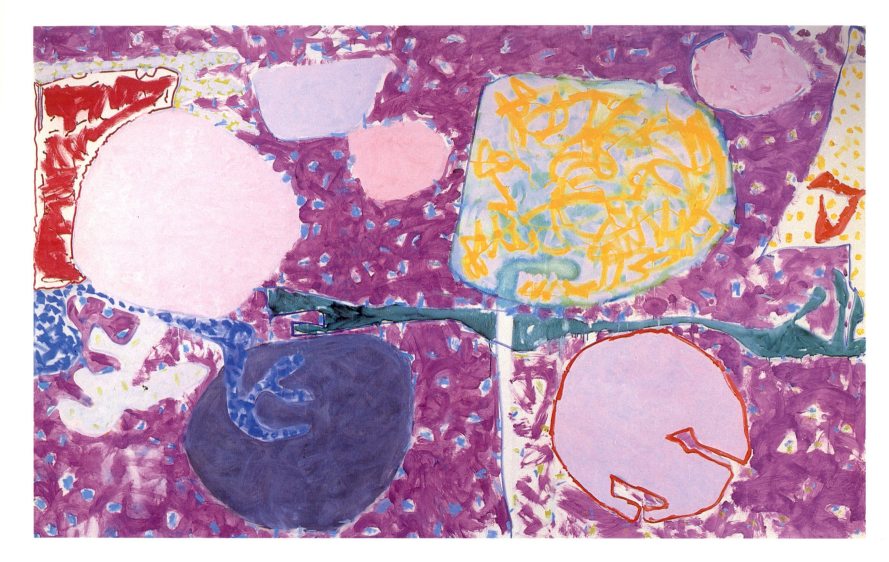

69 Big Purple Garden Painting : July 1983–June 1984 oil on canvas 82 × 132in/208·3 × 335·3cm

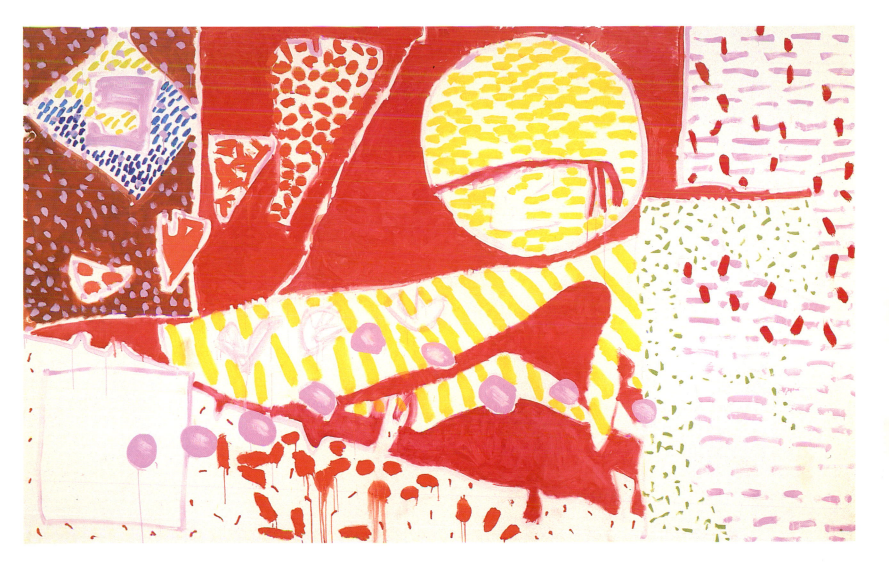

above: 70 Red Garden Painting: June 3–5 1985 oil on canvas 82 × 132in/208·3 × 335·3cm

on following pages:
above: 71 November 5 1985 gouache on paper 12⅞ × 18¾in/32·7 × 47·6cm
below: 72 November 7 1985 gouache on paper 12¾ × 18¾in/32·4 × 47·6cm
above: 73: October 2 1985 gouache on paper 15⅛ × 23⅝in/38·4 × 60cm
below: 74 October 22 1986 gouache on paper 15¼ × 23¼in/38·7 × 69cm

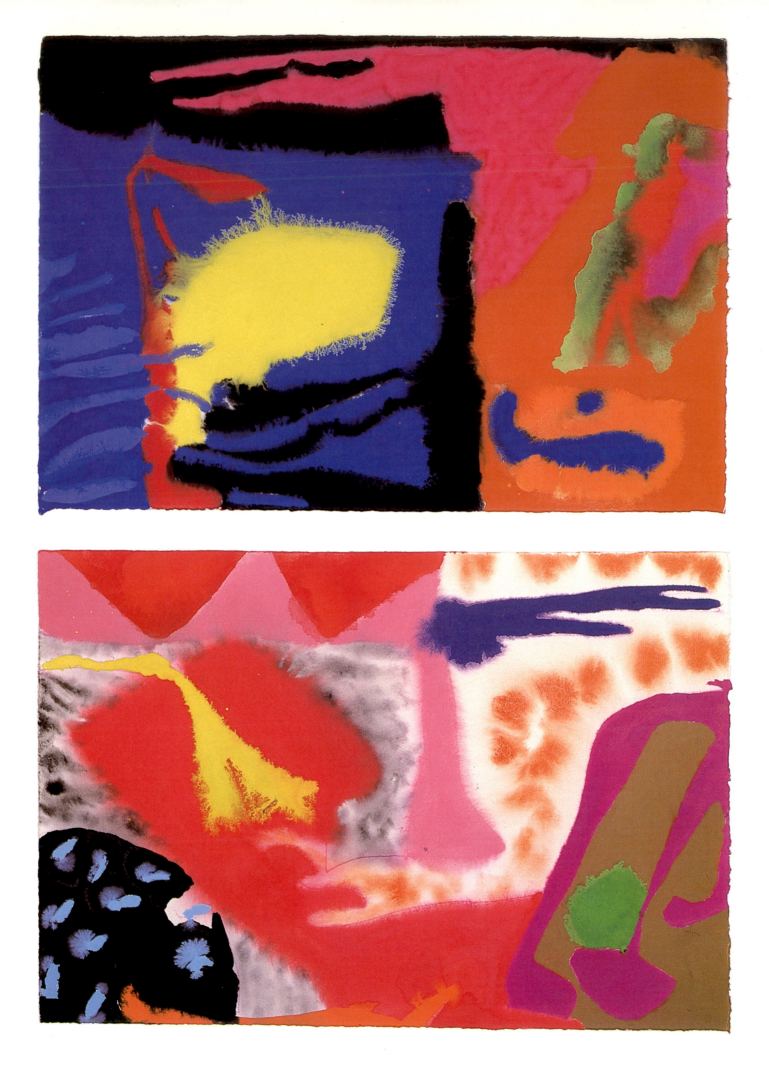

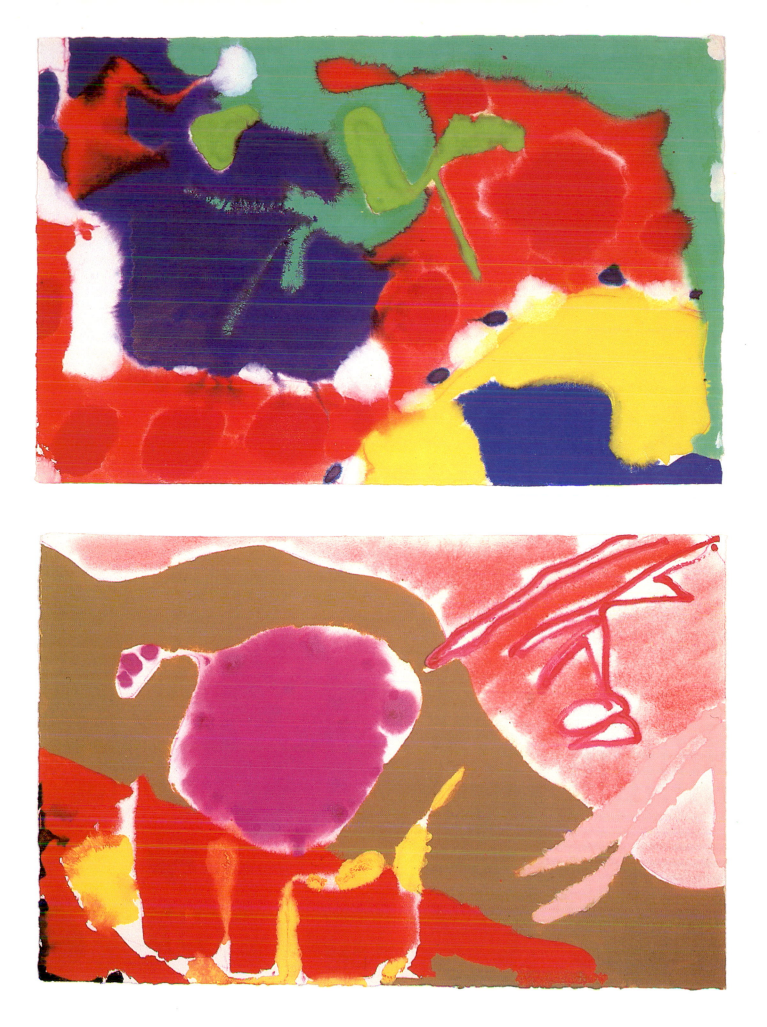

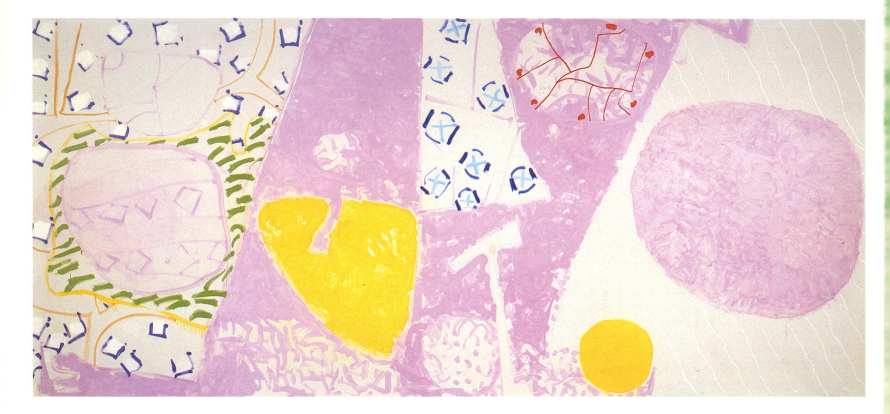

75 White Garden Painting : May 25–June 12 1985 oil on canvas 82 × 180in/208·3 × 457·2cm

CONTENTS

LIST OF PLATES

INTRODUCTION

Patrick Heron was described by Sir Herbert Read as 'something very rare in the history of criticism – an artist of distinction who can at the same time express himself clearly in conceptual terms [. . .] we have to go a long way back – indeed, to the eighteenth century and Sir Joshua Reynolds – for the particular combination of gifts represented by Mr Heron'. Others have considered Heron's writing the equal of Roger Fry's, and this is most appropriate since Fry, whose essays on Cézanne and Matisse he read in his early teens, was a major influence on Heron's criticism, devoted as it is to formal description and analysis. It was at the same period that Heron first encountered, and was impressed by, the writings of Read, Lawrence and Eliot; he has said 'I don't think it would have ever occurred to me to write if it hadn't been for Eliot. I was enormously impressed by his critical writing – hypnotised of course by his poetry. I also thought that if a major poet could write major criticism too, then why [. . .] couldn't a painter also write major criticism?' Heron's own criticism was influential both in England and America; nevertheless, it occupied only a subordinate role to his primary activity and clearly reflected his own preoccupations as a painter.

Underlying the development of Heron's painting is a continuity of personal experience that links his earliest childhood drawings with the paintings he makes today. His father, Tom Heron, a Leeds blouse manufacturer and a Socialist, was friendly with many artists and writers and encouraged his son's drawing. When he became managing director of the Newlyn textile firm Crysede in 1925 the family moved to Cornwall, living at Newlyn, Lelant, and St Ives. Heron was immediately affected by the landscape and some of his earliest surviving drawings were made at the age of seven at Eagles Nest, the house which his parents borrowed from Will Arnold-Forster (creator of its famous garden) for the winter of 1927; Heron was to return permanently to Eagles Nest with his own young family in 1956.

In 1929 Heron's parents moved to Welwyn Garden City where his father founded the avant-garde textile firm Cresta Silks. Cresta's shops were designed by Wells Coates, and Cedric Morris, Paul Nash and E. McKnight Kauffer were among those who supplied designs; Nash was an early though brief influence on the young Heron. His early awareness of contemporary French painting is reflected in the first scarf design he made for Cresta in 1934, *Melon*, which is strongly influenced by Matisse. When Heron became the firm's chief designer after the war, the painting of Matisse and Braque continued to provide him with a model which satisfied the inherently flat and decorative requirements of textile design; an intense love of decoration has motivated him ever since.

Heron was unsympathetic to the doctrine of the Slade School of Fine Art, where he began – but did not complete – part-time studies in 1937. As a conscientious objector he spent the war as an agricultural labourer in Cambridgeshire, moving, after his health deteriorated, to the Bernard Leach Pottery in St Ives; Heron was later to speculate on the subliminal influence on him of the shapes of Leach's pots. After his marriage in 1945 to Delia Reiss he moved to London and began to paint full-time. Part of each summer was spent painting in Cornwall – at Carbis Bay in 1945, Mousehole in 1946 and St Ives from 1947 to 1954. He bought Eagles Nest in 1955 but did not move in until the following April. In 1958 Ben Nicholson invited him to take over his St Ives studio, which Heron occupies to this day.

The main influences on Heron's pre-war painting were Sickert and Cézanne, but he has described himself as 'electrified' by the paintings of Braque and Picasso exhibited at Rosenberg & Helft in 1939. During the war he was able to see little French painting, even in reproduction, but made repeated visits to see Matisse's *Red Studio*, hanging at the Redfern Gallery during 1943–44; later he described this picture as the most important single influence of his entire career. After the war Heron was among those who avidly awaited the first exhibitions of contemporary French painting, but in this he was in a minority: the forms of art he admired were the antithesis of those most typical of contemporary British painting. Lacking the structure, space, rhythm, plastic form and colour and overall optimism of French art, British realism and Neo-Romanticism were essentially linear, narrative, claustrophobic and melancholy. When the exhibitions of Picasso and Matisse at the Victoria & Albert Museum in 1945 and Braque and Rouault at the Tate Gallery in 1946 were greeted with hostile incomprehension, Heron decided to begin writing himself 'out of a complete sense of fury at the really benighted reaction of the whole of the British press'.

Most of Heron's writing dates from between 1945 and 1958, and since then he has written only infrequently. Interested only in the physical facts of painting and sculpture, Heron shunned 'interpretation': the value of his contribution to critical literature lies in the immediacy and precision of his descriptive analyses. Apart from his reviews in the *New English Weekly* (1945–47), *New Statesman and Nation* (1947–50 with further contributions until 1955) and *Arts* (New York, 1955–58), Heron published four books: *Vlaminck Paintings* (1947), *Ivon Hitchens* (Penguin Modern Painters series, 1955), *The Changing Forms of Art* (an anthology of approximately half his published criticism, supplemented with extracts from lectures and radio broadcasts, 1955) and *Braque* (in the Faber Gallery series, 1958). Invited

to be London correspondent to *Arts Digest* (later *Arts*, New York) in 1955, he there introduced the work of artists like Peter Lanyon, Roger Hilton, Alan Davie and William Scott to an American audience, and was the first British critic seriously to examine the work of the American Abstract Expressionists. After his resignation in 1958 Heron wrote virtually nothing until 'The Ascendancy of London in the Sixties' (*Studio International*, December 1966). In this and four subsequent articles Heron sought to redress a balance unfairly weighted in favour of American painting, arguing against an uncritical acceptance of its supposed originality and superiority and opposing its weaknesses to the strengths of contemporary British art. Since then he has written on Bonnard and other artists, on the Cornish landscape and the destruction of the British art school system (on both of which topics he is an active campaigner) and on the new Lloyds building. Since 1962 he has also written explicitly on his own painting.

Later to claim: 'for me no painter in the whole history of British painting has meant half as much as [. . .] Picasso, Braque, Matisse or Bonnard', Heron's analyses of their work revealed the elements which were his own point of departure. Bonnard's influence was to be in many ways the most enduring, but the major influences on him between 1947 and 1955 were the structure and imagery of Braque and Matisse. From these he created a personal abstract-figurative idiom in which an intricate, angular line described transparent, overlapping forms, filled in with increasingly independent patches of flat, bright, non-representational colour. His imagery had a personal significance: figures were usually those of his family, the Leach-like jugs those in daily use in his household and the window often seen behind them that of the St Ives seafront cottage where he painted every year. These elements were arranged into compositions of an inherently spatial content, and indeed the primary function of this imagery was as a vehicle for Heron's exploration of pictorial space; but Heron believed a representational element to be essential and indivisible from painting's necessarily abstract formal structure. He experimented briefly with non-figuration in summer 1952, having been impressed by the Matthiesen Gallery's exhibition in March of paintings by Nicolas de Staël, in which landscape or still-life forms were reduced to flat, thickly knifed colour planes. Although Heron soon returned to figuration, in succeeding paintings his formerly extravagant line was subdued while colour planes became larger and flatter – more like Matisse's and perhaps in memory of de Staël's 'squarish flat slabs' of paint.

Heron defined the relationship between colour, formal organisation and spatial illusion in the catalogue introduction to *Space in Colour*, an exhibition he arranged at the Hanover Gallery in 1953. Apart from Heron

himself, it included Alan Davie, Terry Frost, Roger Hilton, Ivon Hitchens, William Johnstone, Peter Lanyon, Victor Pasmore, William Scott and Keith Vaughan – artists who, despite their different aims and the varying degree of representation in their work, shared an interest in colour and the articulation of space. While Heron remained unsympathetic to Constructivism, which makes no reference to the external world, his interest in the expression of pictorial space through formal means underlay a growing uncertainty about the degree to which painting need be overtly representational. He confessed this ambivalence – which he shared with others of his generation – in his introduction to *The Changing Forms of Art*, written in October 1954. He was increasingly impressed by the work of French non-figurative painters, the Tachists, and especially by the painting of Sam Francis, an American artist then living in Paris. In 1953 Heron had criticised their 'lack of spatial structure or architectonic qualities', but their example now suggested that he might explore space and colour more directly through a spontaneous approach and beyond the confines of figurative imagery. In non-figurative canvases like *Winter Harbour*, painted at the end of 1955, any vestigial underlying framework was obliterated by dabs, strokes and trickles of paint. At the time the change from figuration to non-figuration appeared to him to represent a crisis of orientation which in retrospect seems less extreme and a logical development in terms of his consistently expressed interest in space and colour. Heron was encouraged in this direction by the first group of Abstract Expressionist paintings to be seen in London early in 1956.

Few examples of contemporary American painting had been shown in London up to this point. Heron had seen the one large and two small works by Jackson Pollock in the Institute of Contemporary Art's 'Opposing Forces' exhibition in 1953 and in 1955 works by Mark Tobey which, he wrote, 'whets our painters' growing appetite for more contemporary American painting'. When 'Modern Art in the United States' arrived at the Tate Gallery in January 1956, one room (out of six) was devoted to the New York school. Alone among British critics to focus on their painting, in his long review in *Arts* (New York), Heron registered his elation at many aspects of their work. He has recently explained that their spatial shallowness and formal simplicity excited him because they represented 'a release from the complexity of the great French'; he was, however, from the first, critical of the Abstract Expressionists' understanding and use of colour, a complaint he amplified two years later in 'Five Americans at the ICA' where he also criticised for the first time their reliance on symmetry of image and format.

The impact of the new American painting was fused with that of moving from London to Eagles Nest, with its profuse and exotic garden, in April

1956. In the series of canvases painted in a room overlooking the garden, Heron replaced the often sombre and opaque colour of the London non-figurative paintings with softer, lighter and more translucent colour patches which appeared to hang at different depths in front of the picture surface. At the time Heron claimed solely to explore the 'purely pictorial' aspects of each painting without having to depend on 'a subject'; more recently he has admitted that these pictures 'tied in very obviously with this absolute bombardment of spotted colour which was happening outside'. The relationship between the actual garden and the 'garden paintings' (as they came to be known) was one not of direct representation but of visual and spatial analogy: the sensation of space and light generated by the blurry dabs of colour was similar to that experienced within the close-packed camellia walks at Eagles Nest.

The natural source of Heron's pictorial space, light and colour was equally evident in some of the 'stripe' paintings which developed in 1957 from the lengthening of vertical paint marks towards the canvas's edges. *Scarlet, Lemon and Ultramarine: March 1957* was one of the first of this type, in which fluently brushed bands of colour, varying in width and density, hung vertically across horizontal canvases. In April he began also to make upright horizontally striped paintings, and these often suggested the sort of aerial phenomena over the sea visible from Eagles Nest. Such analogies implicit in the paintings themselves were sometimes made explicit by their titles. In 1958 Heron stated: 'my main interest, in my painting, has always been in colour, space and light [. . .] and space in colour is *the subject* of my painting today to the exclusion of everything else'. So that they should not be interpreted as a species of suppressed representation, Heron abandoned any reference in his titles to external phenomena, and gave succeeding paintings titles descriptive only of internal forms and colours and date of execution; only with his most recent paintings has this formula been relaxed.

Though relatively few in number, the stripe-paintings were to become a notorious issue and a factor in his argument about the relative positions of British and American painting of the period. The formal development of his work, however, owed more to paintings made concurrently with the stripes, in which both horizontal and vertical elements were combined with squatter planes in what Heron has described as 'a sort of fractured tartan'. During 1958 these shapes gradually resolved into the soft round-cornered squares and oblongs that were his compositional units for the next five years.

In his introduction to the Faber Gallery *Braque* (1958), Heron wrote: 'In an age inundated by every variety of spontaneous expression, Braque

reminds us that permanence, grandeur, deliberation, lucidity and calm are also essential elements of great painting. [. . .] Braque celebrates equilibrium – the balance, in tension, of opposites'. Heron sought to reintroduce these elements into his own painting, and clearly registered his increasing dissatisfaction with a limited formal structure and unvarying spontaneity of paint handling in his criticism during 1957 and 1958. By the end of that year Heron had replaced the rapid application of the 'garden' and stripe-paintings – some of which were painted in a few minutes only – with a slower and varied manipulation of colour, in which originally numerous shapes were progressively painted out. The few remaining solid forms were usually sucked towards the canvas's right edge, but were balanced by traces of earlier forms emerging from the largest area of gesturally handled colour, or by other shapes scribbled in thick impasto over squarish areas of white priming left bare, or incised into the wet paint with a brush handle. The varied handling and the tension between overt and suppressed forms created a complex and sensuous spatial sensation and this empirical method of formal organisation conformed to Heron's belief that 'painting should *resolve* asymmetric, unequal, disparate formal ingredients into a state of architectonic harmony which, while remaining asymmetrical, nevertheless constitutes a state of perfect balance, or equilibirum. [. . .] The whole process of pictorial statement [. . .] should involve an elaborate, intuitive adjustment and readjustment of initially warring and disparate elements until they finally click into the condition of *balance*'.

In 1962 Heron stated: 'For a very long time now I have realised that my overriding interest is *colour*. Colour is both the subject and the means; the form and the content; the image and the meaning, in my painting today'. In pursuit of 'an ever intensifying colour-experience or sensation', in 1963 Heron began to map out his composition in charcoal before applying paint; partitioning the canvas into a loosely rectilinear, geometric format (like a hand-drawn Nicholson relief), line defined not shapes on a ground but the shape of the colour areas to each side of it – an aspect of the drawing of Braque and Michelangelo on which Heron had written many years earlier. By eliminating the distinction between image and ground, Heron sought to make all the painting's formal elements equally active, and to allow each shape to retain its own identity while existing as an inextricable component within the whole. From 1965 the rectilinear format resolved into an increasingly asymmetric jigsaw-like configuration; 'line' existed only as the meeting edge between colour areas and defined their shapes solely in terms of those of the adjoining areas. Heron recognised that the character of their mutual boundary conditioned the perception both of their relative spatial positions and of their colours: the sharper and more

irregular their complex, fretted, interlocking edge, the more intensely adjacent colours would interact. Only a single skin of pure colour was applied, gaining brilliancy from the white priming beneath; the ground was prevented from appearing at the surface (and dulling the interaction of the colours) by Heron's method of painting exactly up to each colour boundary with a small Japanese watercolour brush. His cursive, all-over manipulation laid the pigment in small curls and peaks that articulated even the largest areas of colour and exploited the inherent qualities of different pigments (oily, lean, translucent, opaque); Heron described how brushwork could be the agent of pictorial space in 'Two Cultures' (1970) and 'Brushwork is Spatial' (1978). He employed the same laborious technique of filling out the shapes of his rapid fibre-tip underdrawing even in the very large canvases he painted from 1969 onwards.

The paintings made for his exhibition at the University of Texas at Austin Art Museum in 1978 were almost the last in Heron's 'wobbly hard-edge' manner. In their brilliant chromatic effects, taut configurations and intensive, almost obsessive handling, they seemed to have reached a point from which it seemed difficult to progress. During this period Heron denied that he was consciously influenced in his shapes and colours by those of the external world. Obvious parallels nevertheless exist between his paintings' formal elements and the forms and colours of his environment; the purple of the heathery moors surrounding Eagles Nest might meet, on his canvas, the sharp green of a rock pool in sunlight via inlets, promontories or hollows – formal devices irresistibly suggestive of the eroded rocks, harbours and coves along the Cornish coast. In fact, once familiar with Heron's abstract painting in any of its phases it is difficult to avoid seeing its colours and shapes in almost every aspect, natural or man-made, of his local landscape, from the sun's enormous red disc setting into the sea to the bronze-age walls shaping the ancient fields below Eagles Nest or the round-cornered stones in cottage walls in St Ives.

The paintings made during the longest formally consistent period of Heron's career can no longer be considered 'typical' of his means of expression. Following the sudden death of his wife, in 1979, Heron was unable to work for a time, but in 1980 he began for the first time in many years to draw directly from the landscape. The stimulus of seeking a pictorial equivalent for the forms of the external world has reintroduced into his most recent work the rhythms of the landscape and the profusion of its colours and textures. In 1949 Heron wrote of 'the immense importance of physical environment, of place'. The garden at Eagles Nest and the surrounding landscape are the welcomed source of his gaily spotted colours and organically allusive shapes; Heron's recent paintings are

imbued with the sensations of this environment. Their freedom and fluidity also derive in part from his delight in the medium of gouache, in which he has worked since 1960 and which is a major aspect of his activity. Heron now again makes use of overpainting and the white-primed ground as part of a varied manipulation of a wide range of colours, including pale ones – all elements proscribed in his work a decade ago. Excluded by definition from his post-1955 non-figurative work were portraits, and until recently Heron had painted none since those of T. S. Eliot (1949) and Herbert Read (1950). But in a sense Heron's painting has come full circle; the artist of, for example, the Eliot portrait is clearly that of *White Garden Painting: May–June 1985*. Following a commission from the Scottish National Portrait Gallery in 1986 Heron has recently painted a series of portraits of Jo Grimond which, like the earlier examples, are conceived solely in terms of his current idiom.

Despite the apparent variations in manner throughout his career, the evolution of Heron's painting has been logical and consistent. Of the many remarks one could choose to illustrate this, one perhaps may serve to define his new work in the context of all his painting. In 1955 he wrote: 'I believe that the kind of abstract configurations one creates is influenced primarily by the subject one is led, by one's whole nature, to enjoy and endlessly to contemplate [. . .] I believe in abstract figuration'.

MY PAINTING NOW: 30 AUGUST 1987

I'm sitting, trying to write this note, without a shirt, in the brilliant sun at the hot slate table which we made in the garden over twenty-five years ago. It stands, at an angle of about 40° to, and three yards out from, a sharp granite corner of the house; and it is backed up against an escallonia windbreak which I originally cut into a sort of opened-out L-shape – in plan, that is. I'm looking into the sun. The whole strangely Cubist complexities of the house are at my back; its whitish, cement-washed, blue-grey scantle-slate roofs seem dominated by triangularities – a great sharp central gable setting the essentially geometrical theme: there is even a purely pyramidal 'hat' sitting over one section of the house. But, at this moment, my eye follows up the lurching, yet taut line of an irregular path the 'drawing' of which, as it floats 'upwards' between the azaleas and senecios, makes totally available to one's visual awareness the miraculously sculptural three-dimensionality of the *contours* of the great, sloping, semi-submerged shelves of the heaving granite which once thrust this entire site right up into the sky, 623 feet above the ocean. And, as a matter of fact, we did 'draw' the path (all the paths), using twenty tons of tiny sea-shore pebbles from Mount's Bay: they seem Naples yellow-to-yellow ochre mixed with white at times – and they make yet more visible the curving levels of the natural architecture of the place – we are, in fact, a rock-and-boulder littered spur of the Zennor moors.

Since 1920 there has been a garden here, astonishingly conceived and established among the rocks by the late Will Arnold-Forster, who lent the house to my parents for five winter months when I was seven. (I remember it vividly: today's 30-foot-high eucryphias were then just two-foot, rounded clumps. I drew it all at the time.) Delia was the expert who nursed and doctored and understood the hundreds of flowering shrubs and trees when, nearly thirty years after my first introduction to it, we came to live at Eagles Nest in 1955–56. But it fell to me to cut the windbreaking hedges, as well as the lawns and paths. In clipping the escallonia into forms which meant it could best resist the gales I found, in retrospect, that I had compressed each bush or hedge into unending variations of a *square-round* theme (only in the drive in front of the house did I eventually want much *squarer*, sharper-cornered 'walls' of escallonia). But, again only with hindsight, it next became obvious that these 'square-round' hedge-shapes I was in the habit of making were surprisingly equivalent – *as* shapes – to the equally 'square-round' forms of all the granite rocks themselves. The wobbly square-round lines of an escallonia thus merged, with an almost total rhythmic unity or accord, into the equally wobbly and equally square-round profiles or silhouettes of the infinitely complex-yet-simple masses of the natural granite everywhere – and these identical blunt-ragged-square-round rhythms extended out into the surrounding landscape, it seems to me. Of course, if one pauses to consider it, it is not surprising that 400 million years (or

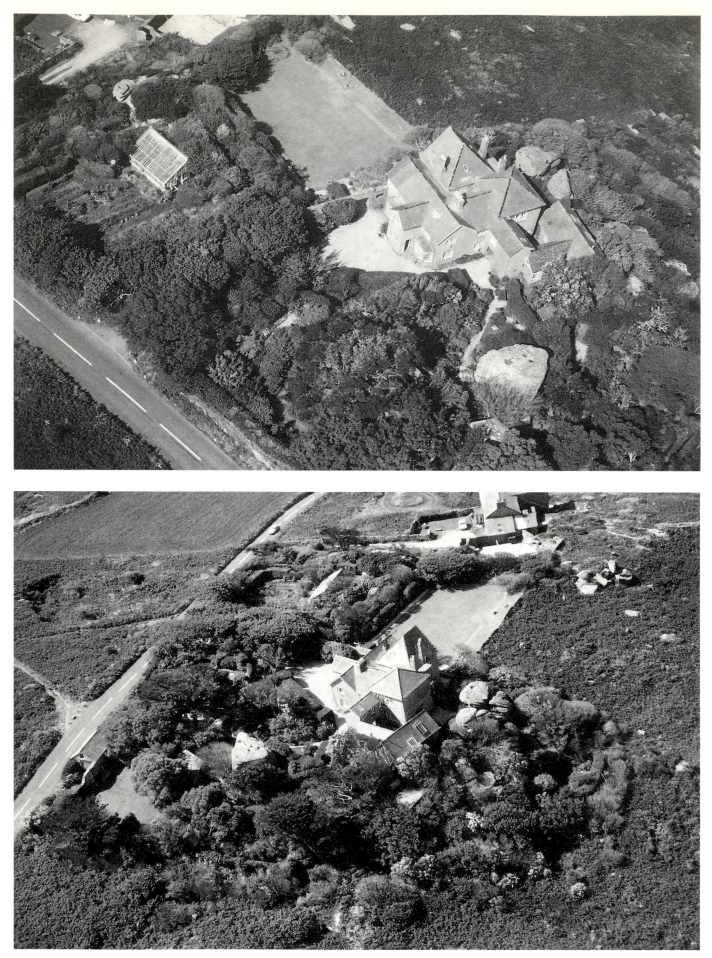

Aerial photographs of Eagles Nest, Zennor, Summer 1947

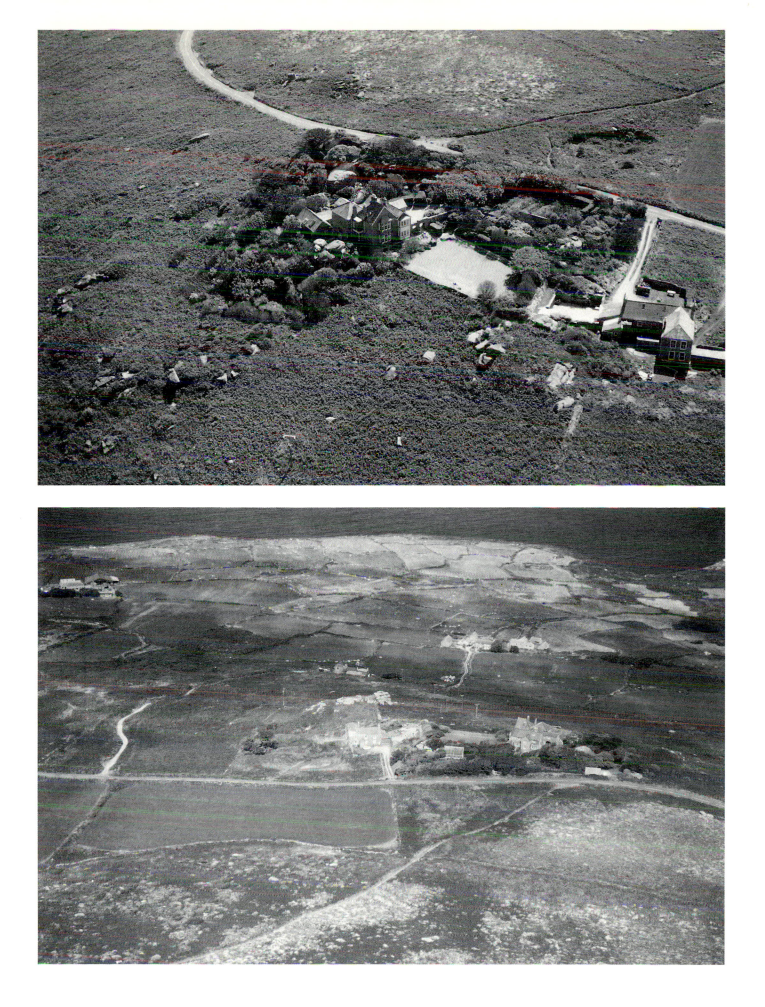

whatever it is) of erosion from the horizontal rains of Atlantic gales should have cut the rocks into shapes (weaker strata eaten away; vertical fissures widening out into total gaps) which would have this very close overlap with the forms which windbreaking bushes have also assumed. Any tiny hawthorn, which may occasionally stick its head up on these moors, looks, in profile, just like one of the rocks.

Yesterday, the hot sea-fog suddenly rose up from the ocean and scrubbed out the wobbly hard-edge line of the cliff-tops, 300 feet below us, and began to dissolve away, and eat into, the abstract calligraphic skein of Bronze Age field-walls, with, as it were, a big brush laden with a mixture of off-off-white oil paint, stained with both cadmium yellow *and* cobalt violet – impossible as that may sound. Japanese silhouettes, flattened into paper-thin planes, of the flying shapes of the balancing rocks, or of the bushes which have been brushed sideways, away from the prevailing gales, into lurching, lop-sided, cantilevered boomerang outlines – these were all one was left with . . . until the fog lifted, as suddenly and unpredictably as it had arrived. From Eagles Nest you become a connoisseur of horizons: they change every minute of every day in the year . . . Right now the upper edge of the ocean is cutting, like a cobalt knife-edge, right into the senecio leaves up here.

Two years ago, when a film was being made of the garden, I went up in a helicopter – and we floated round and round Eagles Nest, higher and lower and higher again, like a butterfly. And I was utterly astonished. There below me, in plan, were all my recent gouaches, which had been wholly non-figurative in intention, in spite of finally being called 'garden gouaches'. Let me at this point explain that although many of the latest (and largest) of the new paintings, dating from about 1983 onwards, which filled the largest and the final room in my partial retrospective at the Barbican Art Gallery in July 1985, were indeed labelled 'garden paintings', it was not, in fact, until most of them had been painted that I hit on the word *garden*, as a convenient title by which to distinguish them from the intensely hot, tightly executed paintings of the 1970s (wobbly hard-edge) which preceded them. The 'garden' *idea* therefore came *after* the new, looser, lighter, brush-scribbled series had all been slowly, painfully born – shocking me, and shocking some of my closest friends, too, I may say, by their apparently total break with the previous long and consistent development (of which *Boycott* was the final major effort, I suppose). But this very difficult break was dictated solely by totally abstract promptings – as well as a sudden longing to throw away the little Japanese watercolour brushes: to pick up my old, long-handled hog-hair brushes again (after ten years disuse) and to let my hand (and arm) once again allow a big brush to twitch and lurch, to blob and dash and scrawl and staccato-stab-and-dot its way around a *white* canvas . . .

For years I was always asked (especially during the 1950s and 1960s) what connection there was between this unique landscape and gardenscape, which is clearly very nearly the greatest passion of my life (I've spent literally years, incidentally, organising campaigns to protect it from destruction – mostly successful, so far . . .) – what connection was there, I was asked, between all this and my painting? I never could answer: the question baffled me, although I could see the logic of posing it; of suggesting that the two passions (for painting and for this landscape) had to be related. But I was in fact always irritated; and felt it revealed certain simplistic attitudes towards the realities of painting itself. I also knew that there had never been a single overt, direct connection or relationship or conscious derivation of any sort between the two. I *knew* that my colour-areas changed character steadily and (to me) unpredictably *all the time*; and that this perpetual mutation, although sometimes proceeding at a snail's pace, at other times with terrifying abruptness, was always, nevertheless, at the dictate of impulses which had absolutely nothing to do with any deliberate, sudden preoccupation with *the appearance* of any external factor whatever – whether rock, bush, flower-cluster or distant rock crest. These basic innovations, there on the canvas, had all suggested themselves, to my hand and eye, in the guise of purely formal, abstract, pictorial modifications of whatever it was that I had already been in the habit of creating *on* the canvas. (Each painting spawns its successor.) They were, on the contrary, solely impulses to meet suddenly felt new needs that were purely pictorial: to make the total image, which a painting *is* – more rectilinear; less rectilinear; softer in brush-scribble; sharper; more complex; *less* complex; emptier; fuller; grouped towards the top right-hand corner; draped across the top quarter of the total format; more all-over . . . and so on and so on and so on. Such, for years, were my sole *conscious* preoccupations.

So what did I see from the helicopter? In the dispositions of lop-sided soft discs (trees and bushes looked *down* into); and of irregular square-round rock silhouettes strung along invisible lines of drawing; and of mildly rigid, geometric fragments of rectilinear hedge-corners; and of a hundred separately delineated area-textures – I found myself gazing into a dense tapestry of area-shape images all dovetailed, all mutually defining each other as colour-shapes, exactly as identical shapes behave in my paintings.

There is a paradox. Painting as such is abstract. Yet the power of that abstraction is its capacity to render the outside world visible – by our involuntarily superimposing the very textures and configurations of the painting *upon* outside reality. Painting dictates our actual visual perception of *anything*. Coming back in the train towards the coast of the English Channel after I'd visited the Marmottan Museum in Paris, I quite involuntarily

saw *everywhere*, out of the window, deep cadmium yellow smudges and streaks, which I had not noticed *going* to Paris, on the same train, three days before . . . Monet's yellow irises had hypnotised me at the Marmottan. Coming round that bend of the road above Aix, for the first time in my life, I'd nearly crashed the Cooper S . . . there, hanging in the air, were Cézanne's very brush-strokes, far more evident to my senses than the 'real' branch of the pine tree or the slopes of the Mountain itself.

In trying to evoke, in this note, the physical realities of this setting in which I live I found myself using, almost throughout, the very same words and phrases with which I have attempted to describe purely non-figurative formal realities in my painting, in the past. It certainly strikes me as significant that I should now write 'square-round' so often when trying to evoke the peculiar character, and power, of these rock-forms, when I used precisely the same two hyphenated words twenty-eight years ago in attempting to isolate a dominant formal characteristic in my painting . . . *but without making the connection!*

One has the sensation of purely visual qualities, always comprising colour, texture, drawn scribble, ways of putting paint on, ways of reorganising every single component in a pictorial statement – one has the *feeling* of all these disembodied pictorial entities slowly floating towards one, out of nowhere. I can feel my next paintings long before I can see them. In fact, I can't see them – even when I'm doing them. I never *see* where or what or when I'm about to paint-in a passage, a structure, a scratched vacancy or a madly potent single-stroke, a *presence*. I can't even see them till long after they're dry – usually. All the best, most telling strokes are placed by the hand (*and* arm), not the eye. Nevertheless . . . because my paintings since 1983 are what they are, because their textures and dispositions are what they are . . . *therefore* I 'see' as I sit at the table in the sun, and as my painterly consciousness starts to stir, and starts to begin to sort out the infinitely amorphous mass of colour-light, which fills my eye 'from eyelid to eyelid', certain clues in the garden's baffling textures. The afternoon sun has moved round now; it's out over the ocean, with the result that the sea's surface has become a single flat blaze of white light, too white to look at. It is a distant mirror which is lighting up the russet undersides of all the senecio leaves; it is even lighting up the ceilings of the rooms in the house. The myrtle's ochre trunks are almost iridescent. And every creek and inlet of the microcosmic 'coastline' along which the emerald leaf-clusters of an olearia invade the deep violet cobalt of a hidden granite surface is punctuated by dotted shadows from the drawn-out needle-bunches which are spaced out along the horizontally wandering branch of the Monterey pine . . .

From 'Ben Nicholson'
New English Weekly
18 October 1945

In art, forms crystallise in the consciousness only after a prolonged agitation at what we might call the level of life itself. And if one seeks these forms, the forms which life alone conceals, one will not be content to manipulate an existing currency of crystals, so to speak. Rather one sets one's face towards the incoherent, vast and vastly intricate anonymities of Nature; towards the faceless and baffling but rich-to-infinity fields of Nature herself – which exists, for the painter's purpose, in whatever surrounds his physical frame by day, by night, in the moors of Celtic Cornwall and by the sea-sucked rocks, or in the lemon lamplight upon a stained and flaking city wall; in the lichen-covered stones of Zennor, or across the glittering surfaces of a Euston ABC's glass tables. New crystallisations are latent everywhere.

From 'Braque'
New English Weekly
4 July 1946

One feels that [Braque] works very slowly, with his cement-on-canvas surfaces which suck the paint from the brush, inhibiting such rapid scribbling as we find in Picasso, and forcing him, when he would record a violent gesture, to take up the tube itself and squirt the blob, or trailing line, direct! If there is no cement, there is certainly sand, the quantity and coarseness of which is varied according to pictorial need: sand is mounded half an inch high along the underside of the fryingpan in *Kitchen Table*, a superbly sooty concentration!

But sand was brought to the slow processes of these canvases as an assistant at the realisation of a vision which is essentially involved with *flat* areas of *even* tone-colour. The thin washes settle into the gritty surface as a matt stain; and a stony opacity becomes the vision. Dividing and bounding these carefully plotted areas run channels and low walls of paint, dragged on by a hand miraculously sensitive and expressive in its touch: the lightest flicks reflect the rhythms inherent in the whole conception, as small strands of rock on the Kerry coast are microcosmic illustrations of that coast's general geology. A particular function of these lines of 'drawing' which mark contours, separate overlapping forms, or, most Braque-like of all, sub-divide single masses and forms (since 1918 Braque has reduced the modulated cylinder that is a jug to two flat patches divided by a zig-zagging line, and we never tire of it for it has profundity) is in connection with colour.

By heightening these streaky boundaries to intensities of whitish-blue, blue-black, dark crimson or brown Braque makes adjacent flatnesses spring to life and three-dimensional meaning. Observe, for instance, the back of the half-nude in the big picture with the prussian blue ewer and basin before the dazzling window with four panes (and how very daringly this window fits the top right-hand corner of the canvas, the lines of window frame and canvas lying exactly parallel – a device one would have expected to be fatal to a composition of this kind!). The even pinky-beige of her back, of which the first impression must be that it is too even, too empty (until we sense that this is an emptiness strangely potent and integrated, one of Braque's latest secrets, in fact), is acted upon by a flashing white-on-blue line drawn round the profile of the shoulders, arm and face.

Here we find that the description of cold, gleaming morning flesh has been condensed into this single brilliant rim-line. All the reflections and the modelling of the back are swept aside by the flat pinky-beige piece, only to be evoked, with a vividness unequalled in their natural dispositions, by the single line at the profile.

This concentration of the evidence of the eye is characteristic of much that is best in modern painting, and is particularly characteristic of Picasso and Braque. The 'emptiness' to which I referred, which is due to a new and unfamiliar arrangement of the material of appearances, and is therefore only empty of familiar formulae, is particularly exciting in these latest paintings. The complexities of appearance have been wonderfully resolved in these great matt surfaces which are dovetailed in so simple and grand a manner. Nothing but a continual contemplation of the visible world can have inspired such original arrangements of form and colour. We are very wide of the mark if we attribute them primarily to a supreme faculty of *decoration*. One of the things that misleads us about this is the fact that everything seems to be *there*, *at the surface*. We never have that experience, so common with the painting of other times, of looking *through* brushwork, subtle as a cloud, that invisibly blends colour with the form which our eyes seek. The 'surface consciousness' which so largely began with Cézanne (in modern times) is complete in Braque, for whom subtlety of definition of three-dimensional form is possible in terms that are palpably at and of the surface – a surface perpetually reinforced in our consciousness by its load of

grit, opaque and final. Each of the modern masters in his way can evoke and define the subtlest complex of natural forms by surface shapes, gestures and textures that are *new*, and which, being new, appear to many to be crude, simple, a short cut through subtleties with which they are familiar. In this context Picasso's line drawing might be recalled, in which a single line can define a human figure with a factual efficiency and precision that many photographs would leave unequalled.

And so, although you may feel that there is the minimum of expression, either of fact or feeling, *within* the even, gritty expanses of some of these paintings (in the great brown oblong of wall behind the billiard table, perhaps, in the picture of that name), what you *will* find is an extraordinary interaction perpetually in process *between* these big bare units in the pictures. Each section of the design – so simple and quiet when you are looking straight at it – begins to nudge and jostle its neighbours the moment your eye is in motion again. Great force is locked up inside every calmly plotted shape; often the simplest shapes, so *chic* and debonair in their clean, cool, fresh paint (their obvious aspect, at the surface), often these are the most explosive; are, in fact, powerful symbols of Life itself. Inspiration comes at once from within and without; and while the force that inhabits a Braque wineglass or guitar is certainly nameless, such transformation of what is literally the furniture of our lives could only be conceived in a mind which knows its way about in the world of natural appearances.

But in considering this clandestine activity in Braque's pictures, these jostlings, the restlessness of these calm shapes, there is another factor; something that is inherent in the nature of design and pictorial organisation. Every articulate segment in the whole, every fragment or unit of form, each piece in the jig-saw puzzle of the total composition has many aspects although appearing to have a certain single identity when we are focusing directly upon it; this, however, is immediately modified when our glance moves elsewhere. Each unit, in other words, is both itself and an infinite number of variations on itself which are in accordance with our momentary 'reading' of the picture. [. . .] Furthermore, the function of *lines* – especially Braque's lines – is more complex than is usually recognised. Every line operating within the strict economy of these designs defines in at least two directions simultaneously, describing and terminating whatever lies to the right and left of it. The 'reading' which is momentarily the strongest will be the one relevant to the side from which our eye approaches. But the other meanings are latent, and the eye has only to swoop back from another direction for that first meaning to be submerged in a second, or a third meaning. Hence the elusiveness and richness of what seems so static examined in its particulars.

[. . .] I think it is the originality of his formal organisation and the compressed power of his design that make Georges Braque the great painter we know him to be.

From 'Pierre Bonnard and Abstraction' written in February 1947; submitted to *Horizon* but rejected and unpublished until included in
The Changing Forms of Art
1955

We may best conceive the underlying abstract rhythm in Bonnard if we think of a piece of large-scale fish-net drawn over the surface of the canvas; it is through an imaginary structure of loose connected squares – sometimes pulled into oblongs and sometimes into diamond shapes – that Bonnard seems to look at his subject. I'm not suggesting that he makes a conscious mental manœuvre of this kind – my image of the netting is simply a device for interpreting Bonnard's mode of vision, which is unique. His paintings have a visual all-overness, an evenness of emphasis and handling [. . .] The form of the objects in a picture by Bonnard hardly exists in isolation from the total configuration. In feeling the force of the form of a head we find we are reading a passage which includes the adjacent planes of floor and wall, as well as some formal accent of particular strength in the shoulder of the figure, and perhaps another in the chair-back. Form in Bonnard is more essentially pictorial than it is even in Renoir, for whom a picture was an arrangement of solid, rotund, sculptural, separate forms. Indeed, Bonnard's forms have an apparent flatness: the masses of his forms seem flattened so as to display the largest area or plane to the spectator. But this flattening is somehow itself the very agent of spatial realisation: in fact, we come to recognise that the flatter the masses of face or hair, or of the bush outside the window, may seem in themselves, the more profound is the spatial scheme to which, in total concourse, they contribute. In spite of the clearest *rapport* with the picture surface at every stage, every element makes its contribution to a configuration in space: the imaginary fish-net at the surface, at one extreme, and perspectival depth at the other, between them provide the poles of definition. Thus we find a sort of up-ending of all receding planes: there is a tendency for them to expand and rear up just where perspective tells them to lie down, diminish and contract. If we think of this invisible skeleton of rectilinear surface design (the fish-net) as being the real formal theme of a picture whose subject is the receding planes of the walls and floor of a room – planes broken up by numerous things, objects of furniture and persons – it can be seen that the far end of a table which tries to bend up into a position more nearly parallel to the picture-surface, or the walls which tend to bend round into a similar position, are so to speak only trying to fit themselves into one of the squarish holes of the fish-net. Bonnard's forms tend to assume the shape of a cube with rounded corners: a squarish lozenge is the prototype of form with which many of his objects seek identity.

The other thing that this fish-net may emphasise is the apparently unending all-over nature of Bonnard's design. There is an extraordinarily wide distribution of accent and pictorial stress. Right into the corners of the canvas we follow a display, a layout, in which interest is as intense half an inch from the picture's edge as it is at the centre. [. . .

. . .] Again and again [. . .] Bonnard ventured out into the fiercely horizontal meadows and orchards of Normandy; out among the vineyards or the pines of the Côte d'Azur; or to the rocky rim (rocks red or blue) of the empty, glittering, eternally changing meadow of the sea. The sea was a twitching Persian carpet, scattered with dark blue jujubes; embroidered with countless fat little yellow zeds; heavy with little purple plums. The wide-open, blank, boatless horizontality of this vibrating sea-meadow suggested to Bonnard a system of abstract forms. He equated all the vast, receding, open-air planes of seascape or landscape with just those abstract bars and lozenge forms I have described him using in another context.

From 'Van Gogh at the Tate'
New Statesman and Nation
27 December 1947

Picasso paints, as it were, at a remove in consciousness: the 'subject' of his painting is frequently the *process* of painting. As soon as Picasso sees and decides to paint a coffee-pot he is aware of his reaction to it even more forcibly than he is of the pot itself. The reaction to the coffee-pot is thus the real subject of a Picasso painting of a coffee-pot; and hence the sufficiency, not to say potency, of this article!

[. . .] Inevitably we see Van Gogh at the other side of Matisse and Picasso, with the result that much of the daring has evaporated for us. After Matisse his colour is less extraordinary, either for the intensity of the mixtures he slapped on or for the perception and originality of what may be called his colour invention. This is the ability to invest objects with certain colours – even to identify each thing with a given colour – that observation alone would never attribute, and to do this so that the general concourse of bright forms creates the conviction of an authentic sensation. Van Gogh, making a tree-trunk blue, a whitewashed wall lime green, a field orange, the sky a 'night blue' and the tree's leaves black-purple, gets over to us a total sensation of normality, a July afternoon in essence undistorted. Also, specific colours are found to have a specific poetic, even symbolic, evocativeness – though just *what* may well remain unspecifiable. But who, for twenty years now, can see ochres mix with lemon and chrome yellow without a rush-bottomed chair or a sunflower head flickering in the mind? These are images of a definite spiritual vitality; and they have a universal validity. Perhaps their author may be regarded more as a genius who painted than as a painter of genius: few great painters have had as little technical preoccupation as Van Gogh (not in the sense of struggle with the means of their art but in that of conscious power to manipulate them); few have said so much with so little. Of course Van Gogh *was* a supreme painter, but his paint followed his vision and desire at considerably more than a trot. Indeed, the headlong pursuit of his eye by his hand is the factor mainly responsible for his 'style': the dots and dashes and broken twirls were strictly a by-product: hence their inimitable nature. Hence, too, Van Gogh's remoteness from the processes of the painterly French: a Bonnard or

Braque actually arrives at his vision, one feels, by way of the pictorial means he commands, means cultivated with great patience and intelligence.

From 'Paul Nash – Memorial Exhibition at the Tate'
New Statesman and Nation
27 March 1948

Cézanne's dictum to the effect that colour and form are, in the final analysis, identical was not a piece of abstract theory but an assertion of fact. If one takes a Cubist still life by Gris, for instance, there is not one form which would not assume a different shape if rendered in a different colour: colour, by its hue and intensity, establishes a position for itself in space; adjacent colours operate upon it, and upon one another, to assist this creation of illusory space 'behind' the surface of the canvas. The colour of a form thus plays as decisive a part in the evocation of its mass, density and even its outline as does drawing. A painter who thinks in terms of black, grey and white, whose thought that is to say is fully expressed without resort to vibrating areas of colour, is vastly handicapped in the struggle to create the volume of form and space. He is likely to overtax mere drawing as such, to overemphasise the thrust and direction of his forms, thus isolating them each from each and making individual forms too closed-in, too little able to introduce us to the other forms in the picture. Every part of a picture should point us to a number of other parts just as each form should be affected by, even 'distorted' by, its neighbours.

From 'London – Paris'
New Statesman and Nation
25 March 1950

The completely abstract is, artistically, a heresy, so to speak. The immensely important truth which it magnifies to a degree where it becomes false is simply this: in all good visual art, however representational, what primarily and most immediately affects us is an underlying harmony of form and colour, a visual music of which the component notes and phrases are indeed abstract. It is by the very different quality of their underlying abstract rhythms, rather than by differences of subject, that we distinguish the great painters, one from another. But the modern abstract heresy results from having overlooked the natural origin of this all-pervading element of abstract form and colour (and all form, all colour, regarded *as such* is abstract) in the great painting of the past. The *kind* of abstract rhythm which permeates a Cézanne still life is determined precisely by the *kind* of still-life objects it occurred to Cézanne to paint. Thus we see that true abstraction is not something imposed on the objects of external reality: it is an essence precipitated by that reality – something abstracted from it.

From *Tate Gallery Illustrated Catalogue of Acquisitions 1980–82*
1983

Up to 1950 the dominant obsession was, of course, the open window, usually with a table-top seen in front of it, or indeed half a room or even the bend of a staircase providing the space on the *inside* of the window. The feeling of a sort of marriage of indoor and outdoor space, through the aperture of the window frame, itself roughly rectilinear and parallel to the picture surface, was really the main theme of all my paintings – or nearly all – between 1945 and 1955. And the window in the vast majority of them was this harbour window, looking out across a balcony over the harbour and bay from the studio cottage, perched right on the sea-wall itself, which Delia and I rented from Mrs Pauline Hewitt (an academic St Ives painter who was at least thirty years older than ourselves) every year from 1947 (our eldest daughter, Katharine, had her first birthday party in front of that window) until 1954. We rented it for two or three months in each of those years, but hardly ever at the same time of the year. I shall never forget the immense sensation of space the first moment we entered that room, at the end of our journey from London: it was an October night and a full moon was rising over Godrevy. The very last figurative work I made, which was in 1954, was a memory of this moment [. . .] but this was the window occurring over and over again in my paintings of that period, whether we were actually in St Ives when I painted them or at home in Addison Avenue, Holland Park. I probably painted more St Ives harbour window paintings in London than in Cornwall. [. . .] My habit of drawing in charcoal on a white ground, and then slotting the planes of scribbled colour in between the grid of charcoal drawing was [. . .] the procedure. [. . .] Also established at [this] time [. . .] was my habit of only applying one coat of colour over the white ground. [. . .] The entire idiom [. . .] of all my paintings then and later, was totally unrelated to any painting ever made in Cornwall. It was largely based on the French masters I so much admired, and which I was alone (with William Scott) in England, let alone Cornwall, in being influenced by at that time – Matisse, Braque, Bonnard. From Braque came the idea of the 'transparency' of the objects. [. . .] On the other hand, the nature of my charcoal drawing is far removed from Braque; for instance, there is not a single rigidly straight line, not a pure arc or circle; in their loose and speedy linearity these charcoal grids are, therefore, if anything, nearer Matisse – although I would have thought that they are perhaps personal and rather English.

From 'Matisse'
(worked up in 1953 from Heron's talk 'The Changing Jug',
given on the BBC Third Programme in January 1951,
published in *The Listener*, 25 January 1951)
The Changing Forms of Art
1955

Matisse creates his pictures, and the objects in them, in terms of colour rather than form. His extraordinarily fluent line re-creates the subject-matter of his passionately elegant, savagely intellectual canvases in terms of a compressed naturalistic imagery. The jug, the girl, the chair or table has a more or less naturalistic profile. But where the creating force is so great is in the flat colour by which he fills these profiles. The jug may be flat ultramarine, from lip to foot, with no tonal modifications. The nude may be scarlet from hip to hip. The table-top may be burning orange, the wall behind jet-black, the window square filled out flatly in violet with a white line, superimposed, tracing some leafy outdoor foliage. From the jug a fountain of large viridian green blobs and dashes, surmounted by some larger lemon-yellow discs, will indicate flowers. In all this Matisse's principal and brilliant contribution to the modern imagery of the still life or 'interior' is obviously by way of colour. The essence of each brilliant hue becomes identified with a particular object. Thus, in the picture I've described, scarlet *creates* the figure, orange *creates* table, ultramarine *creates* jug, jet-black *creates* the wall of the room. But although these areas are all flat in themselves, the sense that these objects repose in space, bathed in sunlit air, is always uppermost. Although the brilliant mixtures with which Matisse fills out all the forms in his composition, all the sections of his design, are, in a conventional sense, toneless; and are, furthermore, actually applied to the canvas in a sort of flat scribble (vitally expressive in itself); the result is always the *creation of space* (of a particular, measurable space, the space of this room or that hillside); of depth and of exquisitely economical forms reposing in that space. This is the central mystery of Matisse's art.

From 'Bonnard and Visual Reality'
New Statesman and Nation
24 November 1951

[. . .] modern painting has accelerated its own metamorphosis – an art that should be pre-eminently visual in its sources of inspiration has become merely intellectual: the subtlety of observed shapes has given way to the repetitive rhythm of symbols. The special realm of painting, the visual realm, has been increasingly ignored. Painting [. . .] has jettisoned its birthright, which is the imaginative interpretation of the infinitely suggestive, infinitely complex texture of visual reality, the reality of the eye. Painting [. . .] is no longer a window through which we may see familiar sights, but see them afresh because they have been distorted, and given a new emphasis, twist or accent by a process that is one of translation, not reproduction. Instead, the function of painting is now more comparable to that of a cinema screen upon which images are projected . . . out of man's dark mind. [. . .

. . .] If we succumb to the logic that insists that because we are aware of tragic events the only valid art for us is one that is pessimistic in content and harsh in form, we shall lose more than our capacity to create painting and sculpture. The plastic colour of Bonnard proclaims the anciently valid response of the painter to the world about him: that response is one of delight and amazement and we must

recapture it. 'The abstract glory of colour and form' (a phrase I once read in Ruskin but cannot re-discover) cannot be conveyed except in a pictorial language based on plastic values, for space also derives from the plastic. Plastic values, so strong in Bonnard, are optimistic: they must never be denied (as in the Pre-Raphaelites, Blake or Sutherland), but they may appear in disguise, as in Picasso and Klee. Plastic and spatial values are the chief values held in common by the most disparate masters: Bonnard, Constable or Leonardo. They alone confer upon this art its unique outwardness and optimism; without them painting becomes literature.

From a lecture 'Pottery and Painting' delivered at Dartington Hall, July 1952
included in 'Submerged Rhythm'
The Changing Forms of Art
1955

I have often wondered to what extent I have myself been influenced, as a painter, by the fourteen months I spent at the Leach Pottery at St Ives in 1944 and 1945. Until fairly recently the idiom which I made my own was the idiom of still life: that is to say, the sort of spatial organisation which I most habitually constructed in my canvases was an organisation involving the limited spatial sequences typical of still-life painting. It is possible to argue that all painters are *primarily* concerned with the definition of space: it is possible to believe that all painters – whether they are representational or abstract ('non-figurative', as I prefer to say) – are all more vitally concerned with giving concrete, tangible reality to certain abstract rhythms, certain patterns or formal configurations, than to specific, individual forms. To continue, this would be to argue that the actual single forms which a painter uses to create that characteristic rhythm of spatial definition which is typical of his work (which, indeed, *is* his work); that the individual forms he uses are of less significance, considered separately, than the total configuration in which they are set. In the final analysis, of course, it is impossible to separate the two. [. . .] In my own early post-war pictures – if I may continue to refer to my own experience – there appeared a number of still-life objects among which were some jugs, coffee-pots and vases. These pots looked remarkably like Leach pots. They also bore some resemblance to jugs in pictures by Braque. Critics of my painting have been very conscious of this second influence – but not, I think, of the first. Nor have I ever heard anyone speak of the extraordinary similarity which exists between the actual jugs of Bernard Leach and the pictorial jug-image which Braque has slowly evolved since about 1924, and which, in a famous picture painted in 1942, *The Washstand*, was almost identical with the waisted-stoneware 'lemonade jug' which still features in the Leach Pottery's present catalogue. [. . .

. . .] Rhythm in painting is that logical force which suddenly gives the subject – whether still life, landscape or figure – its new identity as a pictorial (as distinct from a photographically 'real') image. On the one hand, the artist may be in love with his subject and want to paint it. And, on the other, he may only have at his disposal certain habitual, if not exactly mechanical, rhythms; certain reflexes of eye, arm and hand; certain rhythmic gestures of the brush. While this is his condition, the sort of marks he makes on his canvas will be one thing and the sort of picture he is trying to paint will be quite another. This state of affairs will persist unless, and until, that sudden experience arises in which he surprises himself by seeing, for the first time, a new rhythmical statement (in terms of his medium) which *embodies* his beloved subject-matter. Personally I believe that we shall not be deluding ourselves if we insist on the *physical* nature of this whole experience. As a painter, I can testify to the following sequence of sensations: the sudden apprehension of the form of a new picture is first registered, in my own case at any rate, as a distinct feeling of hollowness: and to locate this sensation somewhere in the region of the diaphragm is not to indulge in a pretentious whim: it is merely to acknowledge physical fact. I am noting possible subjects all day long, every day, quite involuntarily. Thus it is not a question of painting when I see a subject: it is a question of calling up a subject (or to be more precise of calling up an immense variety of remembered subjects simultaneously) when I am ready for action with my brush and palette. So I begin with this hollow feeling. Next, this uncomfortable sensation in one's middle grows into a sort of palpitation, which, in turn, seems rapidly to spread upwards and outwards until the muscles of one's right arm (if one is right-handed!) become agitated by a flow of electric energy. This energy in one's arm is the prelude to painting because it can only be released by grabbing a brush and starting to paint.

This means allowing one's arm and hand free rein to weave upon the canvas a complex of forms which will, as likely as not, be decidedly problematical and surprising to oneself. Conscious thought about design or form or structure simply does not enter into it at this stage. One's arm has been given its freedom and it discharges its twitching energy upon the unfortunate, passive canvas: one's conscious mind, at such a moment, is probably doing no more than observe the swiftly changing tangle on that canvas. What time it can spare from doing this is taken up in contemplating – not design – but the subject of the picture. When I work I am thinking of one thing, but *feeling* and *doing* something else. My mind, when I am painting, is completely engrossed – not by the painting itself but by something *beyond* my painting: something I will call the subject, though I do not mean that in quite the ordinary sense of the term. I might be in London, and the subject of my picture might be a room in St Ives, Cornwall. It is a room with a view: a room with a huge window overlooking the harbour; and beyond the harbour, the bay; and beyond the bay – infinity (plus an island with a lighthouse). Now while I work away, there in London, I cannot *think* – with my conscious mind – of anything but my St Ives room, with its window. While I paint I am *in* St Ives. Meanwhile, however, the picture is being constructed very rapidly by my right hand: my hand hardly pauses to consult me, because I am lost in an intense reverie of a remembered place.

From the introduction to the exhibition catalogue
Space in Colour
Hanover Gallery
July–August 1953

In painting [. . .] space and form are not actual, as they are in sculpture, but illusory. Painting, indeed, is essentially an art of illusion; and 'pictorial science' is simply that accumulated knowledge which enables the painter to control this illusion, the illusion of forms in space. But the secret of good painting – of whatever age or school, I am tempted to say – lies in its adjustment of an inescapable dualism: on the one hand there is the illusion, indeed the *sensation*, of depth; and on the other there is the physical reality of the flat picture-surface. Good painting creates an experience which *contains* both. It creates a sensation of voluminous spatial reality which is so intimately bound up with the flatness of the design at the surface that it may be said to exist only in terms of such pictorial flatness. The true and proper care of the painted surface of the canvas not only fashions that canvas well – as an object in its own right – but also destroys it. Thus, contemplation of the 'empty' grey flatnesses in a painting by William Scott or Roger Hilton [. . .] yields a twofold experience at one and the same instant: one enjoys the opaque, gritty, scratched, uneven greyness or redness or blueness of the pigment as an object, as a fashioned entity, possessing a life of its own (like the life in a granite surface; or the surface of tarred planks which is a boat's hull); but, also, one's eye passes through and beyond this painted surface, the separate shapes dovetailed together, and finds that illusion of a spatial configuration which, I maintain, is a permanently vital feature of pictorial art.

[. . .] Colour is the utterly indispensable means for realising the various species of pictorial space. Mere perspectival drawing, mere chiaroscuro of monochromatic tone – these may render illusionist verisimilitude of reality: but it is a dead version; they cannot produce that fully created thing, found nowhere else, not even in photographs, which I call pictorial space. The imaginative, intuitive re-creation of form which, for years, I have been trying to pin down in a definition is only conceivable in terms of a vibrant picture surface. And this vibration is colour. Pictorial space [. . .] is an illusion of depth *behind* the actual canvas. It may also be a projection – of plane or mass – apparently in front of the canvas. But the existence of pictorial space implies the partial obliteration of the canvas's surface from our consciousness. This is the rôle of colour: to push back or bring forward the required section of the design. The advance or recession of different colours in juxtaposition is a physical property of colour: it is a physical impossibility to paint shapes on a surface, using different colours in a variety of tones, and avoid the illusion of the recession of parts of that surface. Colour is therefore as powerful an agent of spatial expression as drawing. Indeed, one 'draws' with flat washes of colour, as often as not, and not with line at all. Tonal colour is thus the sole means of bestowing that physical vibrancy and resonance without which no picture is alive. And this vibration can be conveyed in 'hueless colours' – that is, in blacks, whites and greys – no less than by the full, chromatic range. [. . .

. . .] Since I have never admired a picture yet which did not, as it were, give off a sensation of space [. . .] I must for the present consider *space in colour* to be as useful a criterion as any other. Spatial colour is, however, a grammar: the language of space in colour can doubtless be made to express anything that stirs in the consciousness of man.

From 'Peter Lanyon'
Art News and Review
6 March 1954

The particular terrain involved is one of which I myself have intimate experience, since I spent five years of my childhood there, and have returned to it for vital refreshment on innumerable occasions. To find it, one must, from St Ives, go still further – further west. One must crawl up, down, round and along that incredible last lap of coast, where the lonely road slips, folds and slides round rocks, under crags, past lonely huddles of granite farms, past the mines of the past, along the ledge of green fields, small and emerald, which hangs, more or less horizontal, above the savage cathedral cliffs but below the horizontally streamlined, rock-strewn, mine-and-fox-infested moors. Calligraphic walls and banks (with gorse and foxglove, whitethorn and sloe jigging from their crests in the perpetual gale) draw abstract doodles across the intricate contours of the sloping land. Pale lichen-grey granite emerges everywhere through the skin of soil in horizontal layers, pontefract cakes of stone, parallel to the permanent horizon of the horizontal ocean which accompanies you always – on your right, filling your right eye – on this final push to the western limits of the land.

This then, is West Penwith; final knob of the long, westward-yearning peninsula of Cornwall. Stop anywhere on this road and climb to the rock-crowned crest of any hill – Trevalgan, Trendrine or Carn Galva – or halt in a church-crowned village – Zennor, Morvah, St Just. You are in a world of viridian greens, of a multitude of greys, soft ceruleum blue, indigo, black, khaki, and Venetian red. A worn, asymmetric rectangle, a lop-sided disc, an uneven triangle of smooth ' stone, inlaid in the field-path at your feet, are echoed precisely, it seems, in the boulders of the hedge by the stile, in the wall of the ancient church tower, in the configuration, half a mile away, of pale giant rocks balanced in an intricate chaos on the dark bracken slopes above you – among the badgers and the magpies. The same thrusting, asymmetric, blunt but streamlined forms recur again and again; throwing a net of calligraphic design over the entire scene; pulling the originally geometrically valid and upright church tower sideways, into accord with the rock-like cottages and the cottage-like rocks; proving a formal analogy between bush (wind-clipped and lurching, straining towards the crag, and *away* from the tense curve of that Atlantic horizon-line) and hill, between the pattern the walls weave on the hillside and the pattern that mica and quartz weave in the glistening, ubiquitous granite.

A charmed, pre-Christian, un-English atmosphere haunts the headlands and the flat, small, gale-levelled hills. The

stunted, stubborn, lichen-encrusted church towers stand on the skylines, signalling to each other, as outposts of Christian security in a sliding, pagan, Celtic landscape whose outlines flow, already, with the rhythm of the waves that surround it on very nearly every side.

From the introduction, written October 1954, to
The Changing Forms of Art
1955

[. . .] I am completely certain now of one thing only, in relation to non-figurative painting and sculpture: and that is that what at first appears non-figurative (i.e. devoid of reference to objects external to the work itself) does in the course of time begin to *take on* a figurative function. It is as though non-figuration were an ideal impossible of achievement: it is as though all forms become, willy-nilly, invested by the spectator with the property of symbols, or signs, or images which overlap with those of reality. We eventually insist on seeing landscape in Ben Nicholson's rectilinear arrangements; or faces and foliage in the eloquent mottled splutters of Jackson Pollock. Are these not the 'realism' of the present, then?

From 'Inspiration for the Painter'
New Statesman and Nation
1 January 1955

Michelangelo is a great painter, not because of the athletic beauty of his male figures, but because of such abstract glories as the vital energy of his bounding, endlessly supple yet steel-firm line, and the perfect balance of the areas lying to either side of that line. The enclosed form of the solid arm is no more emphatic, as a form taking its place within the total design, than is the excluded piece of background. Michelangelo's line defines both ways at once. The shape of the piece of sky seen in the gap between arm and torso is as good, as shape, as that arm itself, or that torso. And so on.

From *Ivon Hitchens*
Penguin Modern Painters 1955

We English, it seems to me, are usually more willing to talk about painting or sculpture in general terms than we are to contemplate particular works. And what we like to discuss is not the picture itself, but its subject, its 'meaning' or 'mood'. The pictorial facts themselves tend to escape us: we spring to the 'interpretation' of a painting and are only too eager to pass over its palpable reality – its colour, form, design, or its spatial organisation. For this reason we favour on the whole two kinds of painting above all others: the 'realist' (however drab, repetitive or retrogressive); and the romantic-illustrational (however expressionist, surrealist, or whimsical). We are, of course, predominantly literary in our

approach to all imaginative experience. We are addicted to *symbol*, in all its forms. We are practically unconscious of *image* – at any rate in the visual arts. Above all, we are basically puritanical, as D. H. Lawrence rightly insisted in that very interesting essay, *Introduction to these Paintings*: we fear not only the sensual but the sensuous also. Thus, sensuous excitement before Nature, or in front of a work of art, may only be expressed obliquely, by means of an inhibited and imprecise vocabulary. We are horrified lest we reveal, in an immediate and properly articulate manner, that we are deeply moved by a merely aesthetic experience of any kind; but especially when it is one of a visual nature. [. . .]

There is no strong pulse in most English painting: its illustrative intricacy and formal irrelevancies do not conceal any firm abstract rhythm, any unifying configuration *below* the surface of the picture as it were. And colour is scarcely ever understood as the vibrant generator of space; but rather as a neat decorative or poetically emotive addition to a design, or to form, that is linear (or black and white) in conception. English pictorial colour may be bright – and usually is, nowadays: but it is hardly ever luminous. It has the literal brilliance of strong 'local colour'. It is hardly ever used with any science – with that science whereby the good painter creates pictorial space, whether in terms of illusionistic recession *behind* the canvas (as is always the the case with Hitchens), or in terms of forms that appear to exist *in front of* the picture surface. Alone of his generation in England (Matthew Smith is considerably older) Hitchens has understood the full implications not only of colour, but of the medium of oil paint itself: [. . .] Ivon Hitchens's use of colour and pigment can perhaps best be illustrated if we consider the use made of it by his most eminent contemporaries. For some, despite originality and invention and vitality, colour is never more than an exquisite but unvibrant stain; a stony, granular opacity; or a brilliancy that is toneless and spaceless (see the atonal scarlets in much contemporary English painting). For others, the haunted poet-painters, colour is primarily a poetic, not a pictorial device; it is an emotive symbol, which, again, is devoid of tonal or space-creating properties. [. . .

. . .] We are not conscious, in the best of Hitchens, of a pine-branch and yet left unconscious of the paint that expresses it; nor are we made aware of the great sideways lunge, or stab, or scribble of a large brush laden with a dull olive mixture, or an acid viridian, and, at the same time, left in ignorance of the visual reality (the pond's surface or the silver-birch foliage) which inspired it. What we perceive is the pine-branch, the water, the birch leaves *existing as paint*. To be made aware of the pine-branch but not the great stab of olive paint would be to witness the illusionism of 'realism'. And to be made conscious only of design on the surface of the canvas – but not of the sandy lane through the firs – would be to experience a limited version of non-figuration. Ivon Hitchens makes us conscious of a Sussex wood in terms of abstract colour and form. The tree is paint: and the paint is tree. In such duality lies the central tradition in Western painting – and Cubism and Fauvism are, among recent movements, its chief receptacles. [. . .] This is the

fundamental duality of pictorial art. It is flat – and not flat. It is an art which can never escape the illusionistic function altogether, however hard the non-figurative painters may try to suppress it. [. . .]

The decorative is an essential characteristic of all fine painting: the English, with puritanical emphasis, decry (and misunderstand) the decorative quality. It is never sufficiently recognised that, in 'the decorative', we have that element in the pictorial economy which is responsible for an *organised surface*.

From 'The Americans at the Tate Gallery'
Arts (New York)
March 1956

My own feelings about these painters have shifted one way, then the other, since my first sight of them, as they hung in consort in the big Tate room, at the private view a month ago. I was instantly elated by the size, energy, originality, economy and inventive daring of many of the paintings. Their creative emptiness represented a radical discovery, I felt, as did their flatness, or rather, their spatial shallowness. I was fascinated by their consistent denial of illusionistic depth, which goes against all my own instincts as a painter. Also, there was an absence of relish in the *matière* as an end in itself, such as one never misses in the French (sometimes a superbly manipulated surface texture is all one can find in Paris). These American painters were so direct in the execution of the *idea* that their paint gestures, their statement on the canvas, had an almost over-dry immaculateness – and I mean this even in connection with such wet-paint canvases as Pollock's. There is always, however, a lack of resonance in their colour.

At first I liked this lightweight colour. And it was, for me, the great surprise of the show. I had always thought that these painters (Pollock and Tobey were the only members of the school I am discussing whose works I had previously seen in the flesh) must use colours of the utmost strength and brightness: I had thought De Kooning, for instance, who is so weighty, severe and dramatic a designer, seen in black-and-white reproduction, would be at least as drastic in colour as Soutine. But not a bit! His colour is all ladylike, gossamer, pastel tints! Very beautiful, very rich in a muted way. But surprisingly feminine and Impressionist, with white in all his charming pinky-green mixtures. (I'm thinking of *Woman I, 1951–52*). Similarly, Pollock's *Number I, 1948*, is as silvery-white-grey as a Monet of snow – but less substantial and, *as colour*, less plastic. I must say that it seems to me that neither Pollock nor De Kooning fully understands the pictorial science of colour as yet. De Kooning's tone is too all-over, too even: a change of colour does not for him involve (as it should) a change of tone also. Again, I am critical of the chaotic organisation of his canvases – the centrally-placed figure, presented in terms of a most original and daring scissoring of buckled planes, is nonetheless *too* central. Its lines of force radiate outwards, only to be rejected, not accommodated, by the four edges of the

canvas. Thus the areas adjacent to the picture's edges are chaotic, vacuous, unused pictorially. Lines and planes as it were ricochet pointlessly from the horizontal and vertical sides of the picture. They hit the frame without gripping it.

Pollock, of course, is the major phenomenon – and consequently is already, surely, one of the most influential painters living? Yet I am by no means wholly enthusiastic. Of pure invention, and courage, we could not ask for more. And there is infinite artistry in the drawing of his exquisitely taut (or relaxed) threads of dribbled colour, as there is in the sputtered mottling of even the minutest area. (And one notices that perfectly organic relationship of microcosm to macrocosm: almost any single square inch of *Number I, 1948* is a miniature *equivalent* of the total canvas.) But I am worried by the indefinitely extended web or transparent veil effect: one never comes up against a resistant plane; one's eye sinks ever deeper and deeper into the transparency of the mesh. Consequently there is a strange denial of spatial experience; from a distance this Pollock painting seems to be a great patch of fungus, only three inches in depth, there on the wall. This, I think, is due to the total absence of any strong planes, particularly planes parallel to the canvas itself – and I believe that such planes are always the prime agent of pictorial space. Thus Robert Motherwell's black, off-white and brown *Granada, 1949* has, for me, twenty times the spatial punch of a Pollock or a De Kooning. In fact, I rate it the finest painting in the entire exhibition. [. . .] But then Motherwell has in a sense a more civilised (forgive the expression) touch than all the others; his brush is wielded with a dry opulence which rivals the rich discipline of Soulages, for instance. And tonally he is perhaps the most subtle and experienced of this school. The spatial evocation of *Granada* is dependent upon a positively scientific awareness of the operation of tone-colour which I do not altogether find in Rothko, for all his misty beauty and subtlety. Nevertheless, I think Rothko probably is the more important *explorer*. Like others in this group, he is discovering things never before known. I would say that his apparently supreme concern for *surface* was in fact a concern for the exact opposite: his exquisitely powdery horizontal bands of colour in *Number 10, 1950*, bulge forwards from the canvas into one's eyes like coloured air in strata-form. He evokes the layers of the atmosphere itself. [. . .

. . .] To me and to those English painters with whom I associate, your new school comes as the most vigorous movement we have seen since the war. If we feel that far more is suggested than is achieved, that in itself is a remarkable achievement. We shall now watch New York as eagerly as Paris for new developments (not forgetting our own, let me add) – and may it come as a consolidation rather than a further exploration.

From *Tate Gallery Illustrated Catalogue of Acquisitions 1980–82*
1983

Although called *Tachist* by many at the time, I referred to the series as 'garden paintings', since they certainly related in my mind to the extraordinary effervescence of flowering azaleas and camellias which was erupting all over the garden, among the granite boulders, at Eagles Nest when we moved down to begin our lives here. Having bought the house the previous August we nevertheless did not occupy it until April 1956. The well-known crisis which confronted many British painters of my generation – I mean the moving over from overt figuration, however abstract, to overt non-figuration, overtook me at this time. Actually, my first non-figurative works (apart from those of 1952 which had no follow through) were arrived at in 1955, in London, and were decidedly Tachist and unrelated to any external scene (*Winter Harbour 1955/56* is the exception) – related only, I think, to scribbled passages of paint in my immediately preceding 'figurative' paintings. In retrospect I used to rather point to a certain continuity of texture and brush-stabs between these 'garden paintings' and a number of the last figurative paintings in which, as it were, Tachist blobs were used to infill between the charcoal lines of drawing. [. . .] Although one is always intrigued, after the event, to notice similar characteristics occurring in the paintings of one's different periods – as though one needed to feel that there was an underlying unity and continuing consistency, formally speaking [. . .] – the fact is that all transitions strike one at the time as being wholly chaotic and terrifying; one seems, at the time of change, to be jeopardising one's entire art, and the difference is seen as very extreme indeed. This was certainly the case when I ventured to make these 'garden paintings'. However, again with the passage of time, it is quite extraordinary how closely these apparently different 'periods' seem to draw together again. Perhaps the main stimulus which caused my Tachist paintings to be made was the fantastic nature of the white light at Zennor. [. . .] But again I would like to make the point that these 'garden paintings' had their nearest formal equivalents quite outside St Ives painting as it then existed. My interest in the visible registration of a paint-laden brush took over at this time and excluded, for over ten years, all trace, for instance, of the linear. At each period it seems that what one is doing is bringing together different ingredients, in a different selection, from the total mix of one's personal interests. There was a contrast that seemed quite violent between the broad brush-marks of the 'garden paintings' and the often invisibly amalgamated brush-weaving of the colour surfaces in both my earlier and my much more recent works. Yet my *total* interests include both these modes.

From 'John Wells and Bryan Wynter'
Arts (New York)
November 1956

In my own painting I am almost entirely concerned now with [. . .] consistent inconsistency – the massed leaves of a bush

looked down into closely is an equivalent, in one's awareness of the natural scene, for the spatial reality that fascinates me. I personally have tired of horizontal spatial recession – as registered by the recession of objects and planes between myself and the horizon. I am fascinated by the space that one senses only when looking *down into* the surfaces of objects at right angles – the lichened pattern on a wall; the spreading archipelagos of the stones and gravel at my feet; the indescribable, unfocusable recessions of a close-leaved bush, as one stares into the blobs (leaves), far and near, and the dashes (twigs), sharp or furry.

From *'Statements'* – a review of British abstract art in 1956 catalogue to
Institute of Contemporary Arts exhibition
16 January–16 February 1957

To me, something called *good painting* is all that matters: admittedly, I do not believe that there is any figurative painting being done today by painters under fifty or sixty which can compare with the non-figurative work of a similar age group. But I do not, on the other hand, necessarily believe that the future belongs to non-figuration. On the contrary: I think a brand-new figuration will emerge, but emerge *out* of our present non-figurative thought and practice. Current forms of 'realism' have not gone through this metamorphosis: they have merely revived past modes. But to come to my own position: my first non-figurative canvases were painted in July and August 1952 – but only two of these were exhibited and I returned, until January 1956, to figuration. The pictures I have painted since last January have much in common with my figurative paintings: but they lack the linear grid of figurative drawing. This has freed me to deal more directly and inventively (I hope) with every single aspect of the painting that is purely pictorial, i.e. the architecture of the canvas, the spatial interrelation of each and every touch (or stroke, or bar) of colour, the colour-character, the paint-character of a painting – all these I now explore with a sense of freedom quite denied me when I still had to keep half an eye on a 'subject'. Just what it is in such pictures that one comes to regard as their 'content' (and it is an unmistakable entity) is certainly mysterious. But its mystery does not invalidate its reality: quite the contrary, in fact. Thus, exclusive concentration upon the palpable facts of colour and form and spatial illusion does not oust, but actually introduces, the essential element of the mysterious.

From 'Braque at the Zenith'
Arts (New York)
February 1957

[. . .] While I still believe that all I have written about Braque [. . .] is true *objectively*, and while I reaffirm my faith in his supreme stature, I do so, for the first time, with a certain feeling of detachment. It is – subjectively – more difficult, now, for me to enter into the spirit of his genius than it used to be. The non-figurative art of today seeks a spatial freedom

and certainty in the interaction of colours at once harsher and brighter than Braque's – and through formal gestures and statements that are not controlled, as his are, by either rectilinearity or curvilinearity – but by a *new* feeling of formal coherence and consistency which depends on neither. The apparent accident of handling, the natural energy of a dripping pigment almost imperceptibly guided by the artist's hand – this new art is apparently very far removed from that of the Master of Cubist collage. Yet there is always continuity, at one level or another, between the best of one generation and the next. And in point of fact, we do not have to look far in the recent canvases of Georges Braque to find formal statements that are overtly contemporaneous with Tachism – especially with the thickly knifed planes and facets and ragged oblongs of Nicolas de Staël. In the small landscapes of wheat fields, and in certain of the beach scenes, which Braque painted between 1951 and 1955, what we have is a sort of figurative Tachism. The mounds of extremely gritty, inch-high paint have a double reading: at one moment you are responding to their purely abstract configuration as coloured, kneaded matter; at the next, a ridge of string-like splatters of indigo suddenly settles back into space and becomes the stormy August skyline which lowers over the wheat fields. Nor is the extreme freedom with the pigment (paint plus sand, and even small pebbles, it sometimes seems) a new departure for Braque. There have always been passages in his works (since 1930 particularly) where the instinctive writhing of the painter's wrist has been given free rein.

So I am saying: With a painter as great as Braque it is meaningless for younger painters to say either 'We accept him' or 'We reject him'. Modern art has not flowed round a figure of this size: it has flowed through him. We may have the *feeling* that we reject: but the fact is, we are only who we are and where we are because, in large measure, Braque is who he is where he is. Our present hopes and researches would not exist if his own had not preceded them.

From 'Kandinsky'
Arts (New York)
September 1957

I have never really liked Kandinsky. [. . .] In painting, intellectuality is valid only if transmuted, that is, if it issues *through* an intuitive and *physical* experience. By the time the picture is actually being painted it is too late to *think*: the hand and arm and shoulder and, above all, the eye, are in sole control when work is, literally, in progress. Thought there is all the time: but the thought that goes into the painting is already something that has been done before the act of painting began: it is the *result* of the hours of thinking (while looking, walking or talking; not painting) that flows, only semi-consciously, from the memory into the picture that is under construction. The last long phase of Kandinsky, so mathematically tight and so literally measured, shows a brain making use of a hand and brush; whereas true painting shows the animated hand, nearly autonomous, eliciting

meaning and energy from the mind *and* body of the painter.

I know, of course, about the influence of Kandinsky on present-day non-figurative painting. But possibly it is the things in the pictures of the Tachists and the action painters that are wrong that have come from Kandinsky? And from other Northern Expressionist sources: for Expressionism is at the root of the trouble with such quantities of Tachist and action painting now. And Expressionism springs from the overintellectual, as in Kandinsky, just as easily as from the overemotional, as in Beckmann. Expressionism is therefore not a style, obviously: it is a broad category of artistic failure, and its prime characteristic is *unbalance* – the lack of an equilibrium in which the most intense passion is precisely held in control by intense rationality, or thought. In the greatest painting initial emotions of the utmost depth and violence are caged and sieved by a relentless *formal* faculty or instinct; the steam from the boiler emerges only in the rhythmic and limited release of piston-strokes. In the painting of Van Gogh, for instance, each piston-stroke was a brush-stroke – each is perfect in its rhythmic order, for Van Gogh conquered the Expressionist in himself and forced his passions to translate themselves into impeccable design. [. . .

. . .] If non-figurative painting is to survive [. . .] it must look beyond the harsh and spatially limited world of Pollock and of the formally amorphous early Kandinsky. It must reintroduce the passionate quietness, the sensuous intellectuality, the sheerly *handsome* and physically delectable means of a Bonnard, a Matisse or a Braque. The salutary shock, administered by the brutal directness of statement, the slightly boring shallowness of the spatial scheme, and the absolutely obvious and overt spontaneity of American painting of the Pollock generation has now been absorbed. If American painting can still help us all in our search forward it is the quieter painters, Rothko, Motherwell and Still, for example, who are most relevant, perhaps. Painting must return to its fullest range: non-figurative painting must flower now into richness and subtlety. Out of its strident freedoms must now grow structures of classical weight and beauty: the profoundly *considered* must now be permitted to glow where only the rawness of the 'spontaneous' has been allowed. 'Spontaneity' has become a disease! If you put paint on canvas with a rapid movement of the arm, so that the marks left unmistakably express that speed of application . . . then you are being 'spontaneous'; i.e. you are a good painter. Yet the deepest spontaneity demands the widest variation in tempo, both of execution and thought, as revealed in both the texture of paint and the nature of the total design. But today the mere speed of paint-flicking has become a most powerful criterion. This will not do.

From 'The Monet Revival'
Arts (New York)
November 1957

Monet is now become a focus of interest once again. On every hand one hears of his relevance to certain non-figurative painters in the Tachist or Action-Painting camps. [. . .] But this return of our sympathies to Monet has not, of course, come about through any revival of interest in the illusionistic content of his picture – not, that is, through a return to an interest in his subject-matter – but rather through a new reaction to the abstract characteristics of his pictures: we are now in love with his granular surfaces, with the brush-marks which instantly convey the precise movement of wrist and arm through which they came about, with the 'all-over' dance of his nervously controlled brush, as it spreads its little explosive blobs and clouds of colour across the picture with so even and consistent a tempo. Also, there is the opalescent depth and the misty radiance of his colour, the fact that it does not define hard, resistant planes which are parallel to the picture surface – all this concerns us again, now, in our flight from the geometric definiteness of Cubism, and from the unmodulated flatness of large colour areas.

Or so the argument runs. Accordingly, I feel that I ought nowadays to be enjoying most of all the final phases of Monet's art – the series of Rouen Cathedral, where the surfaces are like those of ancient stone, encrusted with miniature lichens, or stained with the mineral drippings of some natural liquid through the ages; or the last great water-lily ponds, with their much looser textures of magnificent brush-scribble. Both kinds contain many masterpieces. And in both is to be found evidence of that supreme feat in figurative painting – the precise evocation, rather than mere description, of great detail in the subject by means of apparently casual, broad, loose, easily looping gestures of a large brush. And certainly the pleasures of contemplating the smoky, foamy, pumice-stone surfaces of the Rouen Cathedral pictures are very great: large areas of powdery blue-green, or iridescent grey, are moth-eaten at their edges and seem like natural stains – ragged stain-shapes jigsawed together – appearing quite flat and devoid of reference or any three-dimensional reality, as one looks close. But step back, and suddenly you are aware of an image unquestionably photographic in kind, of *a form* in space: the flatnesses dissolve into space, the moth-eaten stain vanishes before your eyes, and sinks back 150 feet – resolving itself into a section of architectural detail on the western façade of the cathedral. . . .

That was what used to be experienced before such a canvas. Today the conscious progress of the appreciative eye is almost exactly reversed. You start by recognising the object depicted but you end up by contemplating exclusively the paint itself, in all the subtlety of its configuration upon the surface of the canvas. Nevertheless, I cannot help feeling that just because Monet's final phases are so close to much of the non-figurative painting of the present time – that for this very reason they are less exciting, now, than many of his earlier works. In the context of the present moment the late Monets do not seem abstract *enough*! So, paradoxically, the very qualities by which Monet now attracts us also provide the criteria by which we criticise him. [. . .]

Monet's two greatest gifts were: first, a miraculously sensitive eye for harmony in the higher tones of atmospheric colour and, second, an exceptionally vital and original wrist. By the latter I mean the electrically nervous yet physically vital energy of all his brush-writing. In this amazingly varied surface quality lies his main abstract vitality. The individual brush-strokes in almost any Monet one can think of are infinitely varied: blunt strokes, square-ended; rigidly horizontal strokes; hooked strokes; semi-circular strokes, either taut and dry or fluffy and smudged; smeared dots; flicked comma-like strokes; long calligraphic glides; flat sideways-smearing slab-like strokes; soft, interweaving scribbles; and so on. And Monet being Monet, and concerned with the phenomenon of the optical sensation of refracted light, rather than with the perception of the continuous surfaces in his subjects which reflect that light, all these brush-stabs and brush-glides remain distinct from one another, individual units in the harmonious texture of the total surface. This is done by keeping each stroke, or set of rhythmically related strokes, distinct in colour from its neighbours. Each one of Monet's strokes thus stands in front of or behind its neighbours in space. They are all planted clearly one *upon* another; and they remain, visibly, one-on-top-of-another in the final canvas. This distinguishes them from the brush-strokes of Renoir, for instance; Renoir, being, on the contrary, more concerned with the modelling of continuous surfaces in the subject, tended to weave his separate systems of strokes one *into* another, spatially.

The spatial separateness of Monet's strokes gives him an extra element to play with when it comes to designing the picture. In a purely abstract sense, Monet's separate strokes *are* the main architecture of his pictures. It is the rhythmic intervals and the compositional distribution of the individual brush-strokes in a canvas of Monet's that chiefly determine its 'composition', its pictorial structure, or architecture. The arrangement of the masses and spaces of the chosen subject is positively of secondary importance for Monet; but of primary importance for Renoir. And this is doubtless the reason why we so often feel Monet's composition (in terms of *the solid subject*) is rather summary, obvious, not to say ordinary; or even, at times, downright picturesque and pretty. The jetty comes out from the left; a clump of bushes sticks up on the right; the opposite bank of the river, or a headland across the bay, lies neatly along the main horizontal dividing line of the picture (the *horizon*, in fact): everything very quickly and efficiently adds up to a perfectly balanced and ordered design. Then, these things being settled (and a fantastic optical accuracy enabled Monet to seize all this data from the scene with wonderful economy and purpose), the painter was able to give his hand and eye free rein in weaving the miraculously luminous tapestry of thick, free strokes which I have been trying to describe. But every time, his originality and power lie not in a powerful organisation of the forms of his subject (as in Cézanne), but in the extreme elegance and liveliness of the design his actual brush-strokes themselves made.

For this reason he was most assuredly finding the true, logical and personal fulfilment of his gifts when he arrived at his final discoveries in the water-lily pictures. Here all was in the touch; 'composition', considered as an arrangement in space, was at a minimum. The plane of the pond's surface filled out the entire canvas to its four corners; the miraculous life of paint, when applied by brushes, was made manifest in a new sense. Something was discovered which it has taken us over thirty years to catch up on. Yet, as I say, now that we have tipped that lily pond's surface even further up, until it exactly coincides with the plane of the canvas itself, Monet's last masterpieces seem compromised by the degree of recession they still contain. And so, for an abstract generation, it is possibly easier to savour the quality of this painter in his earlier works, where a *far* sharper perspective, a completely undisguised concern with the spatial realities of landscape, still prevailed. I feel myself that Monet's superb handwriting packs an altogether stronger punch when there *is* this communication of optical reality to be made. [. . .] I believe [. . .] that Monet was essentially an 'impressionist', one whose every gesture grew out of the lifelong study of light as it is absorbed, refracted and transmitted in the atmosphere. For him, one touch of Naples yellow placed between two of cobalt violet is not *only* a statement of 'violet-yellow-violet' – as would be the case in a non-figurative colourist of today. It was also the conveyor of an optical sensation concerning the light of the setting sun as it was reflected between two small waves of the evening sea. The abstract *content* is missing in the lily ponds: they really represent a distended representational idea. In them Monet pointed to the future; but he did not enact it.

From *Braque* with an Introduction and Notes
by Patrick Heron
The Faber Gallery
London 1958

In an age inundated by brilliant aesthetic innovation, by frenzied novelty and every variety of spontaneous expression, Braque reminds us that permanence, grandeur, deliberation, lucidity and calm are also essential ingredients of great painting. Among the most notable characteristics of his art are its massive harmony, its faultless pictorial architecture; its intellectual lucidity, its formal design at once complex yet tranquil, forceful yet calm, and its superlative craftsmanship: in short, its profound pictorial science. Braque celebrates *equilibrium* – the balance, in tension, of opposites. Conflicting passions are reconciled in his passionately exact and exactly balanced design. The intensity of his emotion is registered, transmitted, in the steady flatness of his immaculate surfaces. [. . .

. . .] With Braque, the design *is* the vision: the painting itself *is* the communication. For Braque, the created object (paint on canvas) exists in its own right and in its own terms, as an established counterpoint of colours and forms. And this paint-on-canvas object is indistinguishable, to Braque, from the vision of Reality which haunts him and which he therefore seeks to express.

From 'Five Americans at the Institute of Contemporary Arts'
Arts (New York)
May 1958

It is now just over two years since we first saw Pollock, De Kooning, Kline, Rothko, Still and Motherwell together in strength on the walls of a gallery here [. . .]. I was exhilarated at the time by the originality and the sheer directness of these American painters. This March the first five of the painters just mentioned above returned to London – this time on the walls of the Institute of Contemporary Arts [in 'Some Paintings from the E. J. Power Collection']; and one is glad of the occasion to reflect further on the nature of their achievement, both as individual artists and as a group. It is possibly a bad moment for this in one sense, in that their influence on world painting has been so great (especially during these past two years) that one is naturally tempted to blame them for something that is in no way their responsibility – namely, the rapid academicising of their thought and practice on a truly world-wide scale.

But first I will recapitulate a little. I was excited in 1956 by the extent of their break with French painting, both in their discovery of shallow depth, as a working possibility for communicating a new kind of pictorial space, and in their rejection of a European sensibility in questions of *matière*. Their paint had a rawness, their execution a brashness, their design a lack of contrapuntal complexity, which all indicated a new kind of energy and inventiveness. But more important still, their painting was evidence of a total freedom not only from figuration, but even from that abstraction which somehow still evoked familiar visual facts, whether of still life or landscape. They had abolished *the image* – if by *image* we still mean a unit, a single complex of forms, that exists on two levels simultaneously: i.e., as a purely formal fact, there on the surface of the canvas; and, secondly, as the visual *evocation* of a fact (or facts) that is *extrinsic* to that canvas. Even with most of the post-war non-figurative painters in Europe the sense remains – until well after 1950 – that 'images' are being suspended *inside* the picture space. Inside the pictorial architecture of a Manessier, a Soulages or even a de Staël of 1950, we feel that there are, so to speak, *nests* of more complicated form which are lodged *within* the all-over non-figurative structure of the composition. In this sense most European non-figurative painting of the period 1945–50 was still figurative. The kind of spatial illusion found in Soulages, for instance, involves a type of pictorial space which is still basically Cubist. We go *back* and *through* the black-brown bars; a solid structure is still an inescapable illusion in a Soulages of 1950–55, say. White equals space; black equals solid form.

True, Poliakoff for one had by 1950 ceased to deal with this sort of unidentifiable but nonetheless solid form which is situated in space. For him an area of colour was an area of colour – as it had long been for Nicholson, of course. And an area of colour has a spatial reality *without* evoking specific solids. Nevertheless, it seems to me that, by and large, it was the Americans named above who finally insisted, with a vehemence that has since converted almost everyone everywhere, that the total painting itself is the only

image involved in a painting. Today, a painting is not the vehicle of an image (still less, of a symbol). Today the painting itself *is* the image. [. . .] Again, a painting is not something which exists in order to convey meaning; on the contrary, 'meaning' is something which attaches itself to that independent, autonomous object which is a picture. Primarily, a picture *means* itself. Allusions, overt or not, to external facts (objects outside the picture itself) are secondary and, unless more or less oblique, are almost inevitably clichés. There simply is not available at the present moment, it seems to me, a valid figure, or mode of figuration, which is not retrogressive in some way or other. But in saying this I assume that I am speaking only for myself, of course. Nevertheless it does seem to me that those good painters who at present incorporate images (and 'images' are always figurative, as I've said – even when that which they figure is obscure to us) are to that extent relinquishing the exploratory function of painting and are, instead, elaborating upon something already understood and then embellishing their art with this elaboration of a known theme. This is possibly one reason why I do not greatly admire De Kooning.

[. . .] The collection of Mr E. J. Power [. . .] is certainly the most important collection of Tachist and action painting in this country. One's first impressions are once again of the forthright daring of the attack; of the generous scale; of the purity of intention. But this time I do not react with enthusiasm to the shallow space; nor to the overt speed of the muscular brush-work; nor to the harshly brittle paint; nor to the lack of subtle resonance in colour. In fact, I felt again and again what I can only describe as the absence of a dimension in the paintings of four out of the five Americans in this show. The exception is Mark Rothko, who now seems to me the best of living Americans, and better than Pollock. Yet even in Rothko the missing element in these American paintings is not wholly present. I mean that I miss a sensuous subtlety of tone colour, a subtle asymmetry of shape, a varied tempo of working – it is a terribly cramping thing, to be bound by a rigid concept of what *freedom* should look like in a painting. [. . .] It seems to me that mere quickness in actual execution, involving an evenly loose and a vigorously rhythmic movement of the arm, is a false criterion of excellence. True spontaneity demands an infinitely varied tempo – slow finickiness *allied* to swift and broad movements. We are barking up the wrong tree in worrying so much about spontaneity, immediateness, and so on, when we ought to be concerned with something called 'good painting' – which is not synonymous with spontaneity. The visible speed with which Pollock registered an impulse has proved a feat as infectious as anything from the hand of Picasso. And it has served to jog Western painting out of its post-Picassian coma. But now what we desperately need are examples of a new and fine *deliberateness*: a more fully conscious and considered mode of action, which will embrace the static and fundamentally architectural elements in painting at the same time that it displays the fluent and spontaneous.

From 'The Shape of Colour'
text of the 5th Power Lecture in Contemporary Art for 1973
published in *Studio International* February 1974 and in
Concerning Contemporary Art – the Power Lectures 1968–73,
ed. Bernard Smith
Clarendon Press, Oxford 1974

[The] soft-edged squares were to replace the bands and stripes entirely, as the predominant units of composition in my work; and in fact, between 1959 and 1963 I did little else but juggle with them, sometimes whittling them down to one – a single soft square floating in, rather than *on*, a huge ground: either edging up into one of the corners or moving, almost invisibly, along one of the canvas's edges as if drawn by a magnet. And it was at this time that something first happened which I see has gone on happening, at intervals, ever since: namely, the sweeping or sucking to one side of the canvas of all the individual formal units so that they end up clustered along, or piled against, the right-hand edge, leaving three-quarters of the picture area empty of incident. *Black Painting – Red, Brown, Olive: July 1959* is one of the first instances of this – that is, of the orientation of all the separately recognisable elements towards the right-hand edge of the canvas. [. . .] The pushing around, with a big brush, of a certain quantity of colour, was the means I used for arriving at the so-called shapes. One physically *moved* the rival areas of colour in relation to each other – and the big brush moved rapidly – until they met and collided: colour areas thus mutually defined one another by edging into each other physically: the expansion or contraction of adjacent areas was the mode or the means whereby one eventually arrived at the final configuration – the total image which was itself the painting. In pictures like this *Black Painting*, therefore, colour was quite literally determining the form or shape of all the shapes or areas in the picture. The shape of colour, at this moment in my painting, was something I arrived at by allowing different quantities of colour, of the liquid pigment itself, to expand and contract, to swim with or against one another, under the tutelage of a swiftly moving soft blunt brush, nudging, scribbling, sliding, pushing or pulling the paint across the surface. Originally this *Black Painting* was chock-a-block with soft round-cornered squares or lozenge shapes or irregular discs: but gradually the flattening tide of matt black rose and obliterated island after island until it had pushed its way across two-thirds of the surface. Those remaining islands sought the edge. And *always* in my painting, at all periods, the *edges* of the canvas have been all-important. [. . .] In other paintings at this time I did allow [. . .] the tidal wave of a single colour to sweep away all but one round-cornered square (or squarified disc). I remember resisting the logic of letting that last square also sink under the flood of a single colour – which would have left one with a painting consisting of a single colour-plane only. But after American painting of the early 1950s, with its emphasis on emptiness, I felt the urgent need for a move towards 'the re-complication of the picture surface'.

From 'A Note on my Painting: 1962'
catalogue of Galerie Charles Lienhard exhibition, Zurich,
January 1963
reprinted in *Art International*
25 February 1963

For a very long time now, I have realised that my overriding
interest is *colour*. Colour is both the subject and the means;
the form and the content; the image and the meaning, in my
painting today. [. . .] It is obvious that colour is now the *only*
direction in which painting can travel. Painting still has a
continent left to explore, in the direction of colour (and in no
other direction). [. . .] It seems obvious to me that we are still
only at the beginning of our discovery and enjoyment of the
superbly exciting facts of the world of colour. One reels at
the colour possibilities now; the varied and contrasting
intensities, opacities, transparencies; the seeming density
and weight, warmth, coolness, vibrancy; or the superbly
inert 'dull' colours – such as the marvellously uneventful
expanses of the surface of an old green door in the sunlight.
Or the terrific zing of a violet vibration . . . a violent violet
flower, with five petals, suspended against the receptive
furry green of leaves in a greenhouse!

From 'Colour in my Painting: 1969'
Studio International, December 1969 and in Edward Meneely
and Christopher de Marigny, *EM46 Patrick Heron
Retrospective*, ESM Documentations, New York, 1970

Space *in* colour. To me, this is still the most profound
experience which painting has to offer – this is true whatever
the period, idiom or style – and it is unique to painting.
Because painting is exclusively concerned with *the seen*, as
distinct from *the known*, pictorial space and pictorial colour
are virtually synonymous. That is to say, for the human eye,
there is no space without its colour; and no colour that does
not create its own space. [. . .

. . .] Since 1962 [. . .] the defining frontiers which divide one
area of colour from the next in my canvases have become
increasingly sharp and precise, until today they are very
tightly drawn indeed. Still, the interest which had
progressively compelled me [. . .] to sharpen these frontiers
was not, at the time, a growing – or a returning – *conscious*
interest in design or format or form or in any sense in the
shapes which my areas assumed; it was simply an
obsession with the interaction of colours, one upon another.
The contemplation of pure colour holds pleasures too
numerous to name here; in fact there is an intense elation
in allowing awareness of colour to flood the mind – and this
was clear to me years before Huxley made mescalin famous.
[. . .] The sensation of space I value is one generated by
plain opaque surfaces placed at a measurable distance
before my face: thus, the contemplation of colour I refer to
is something which heightens my accurate awareness of my
own physical position in relation to such surfaces, and to my
actual physical environment. [. . .]

Early in 1957, when painting my first horizontal and vertical

colour-stripe paintings, the reason why the stripes sufficed,
as the formal vehicle of the colour, was precisely that they
were so very uncomplicated *as shapes*. I realised that the
emptier the general format was, the more exclusive the
concentration upon the experience of colour itself. With
stripes one was free to deal *only* with the interaction
between varying *quantities* of varied colours, measured as
expanses or areas. One was unconsciously resisting,
perhaps, being side-tracked at that stage by the more
complex interactions which are set up along the frontiers of
colour-areas when those frontiers are themselves more
complex in character than the relatively straight lines which
separated the bands or stripes in my 1957 stripe
paintings. [. . .

. . .] All sensation of colour is relative. I mean by this that it
is not until there is more than one colour in the visual field
that we can be fully aware of either or any of the colours
involved. If I stand only eighteen inches away from a fifteen-
foot canvas that is uniformly covered in a single shade of
red, say, my vision being entirely monopolised by red I shall
cease within a matter of seconds to be *fully conscious* of that
red: the redness of that red will not be restored until a
fragment of *another* colour is allowed to intrude, setting up
a reaction. It is in this interaction between differing colours
that our full awareness of any of them lies. So the meeting
lines between areas of colour are utterly crucial to our
apprehension of the actual hue of those areas: the linear
character of these frontiers cannot avoid changing our
sensation of the colour of those areas. Hence a jagged line
separating two reds will make them cooler or hotter, pinker
or more orange, than a smoothly looping or rippling line. *The
line changes the colour of the colours on either side of it.*
This being so, it follows that it is the *linear* character that I
give to the frontiers between colour-areas that finally
determines the apparent colour of my colours. [. . .]

Complexity of the spatial illusion generated along the
frontier where two colours meet is also enormously
increased if the linear character of these frontiers *is*
irregular, freely drawn, intuitively arrived at. I have always
been intrigued by observing the way in which first the colour
on one side and then the colour on the other side of a
common, but irregularly drawn frontier dividing them, seems
to come in front. As your eye moves along such a frontier
the spatial positions of the colour-areas alternate –
according, however, to the nature of the loops in that
frontier, rather than to any change in the colours – since
these do not change. [. . .

. . .] The only rule I follow while painting is this: I always
allow my hand to surprise me (the lines of all the frontiers
in my recent paintings are drawn-in in a matter of a few
seconds): also, I always follow impulse – for instance in the
choice of colours; deliberation is fruitless. But this does not
mean that every act connected with the painting of the
picture is not deliberate: it is.

From 'Two Cultures'
Studio International
December 1970

I have myself always believed – through a decade of spray-guns and rollers and other methods of applying paint so that it was clinically impersonal, literally dead flat in quality – in the hand-stroked, hand-scribbled, hand-scrubbed application of paint: putting paint on a flat surface with a brush is just about the greatest possible pleasure I know. But no two artists can overlap in their nervous brush-writing. Further, hand-done paintwork – meaning the covering of areas, large and small, in paintings – is an infinitely powerful and subtle means for giving a colour-area its precise spatial function; you can manipulate space in dozens of different ways by the varied ways in which you paint-out an identical area-shape with an identical colour-mixture. The mere *brush-work* of an area endows it with differing kinds of space-creating power. You can weave it thick and tight, dense and opaque, in mutually self-obliterating heavy loops, for instance, which force the plastic plane which we sense in the skin of colour *back* on to the canvas – back right through it perhaps. Or the pigment can be semi-transparent, more lightly and rapidly applied, full of nervous flicking movements which seem to pick up the colour-area as if it were a blanket and hold it (illusionistically, of course) a fraction of an inch in front of the actual surface of the canvas. The actual scribble of the application can be infinitely varied; and can have (*must have*) a thousand differing effects, laterally, as a formal force influencing the *apparent* shape of all adjacent area-shapes in the painting. There is the incredible pull or push one can exert upon a flat area-shape by the way one's brush – yes, *brush* – churns a uniform colour-mixture in an adjacent area. Again, one may find one has induced a sort of life or vibration, in itself pretty unanalysable, in an apparently flatly painted, apparently uniformly smooth paint-area by a paint application which vanishes when dry, except that the brush-scribbles remain semi-visible in relief only. Last year my fifteen-foot canvases, involving sixty or more square feet of a single colour, were painted (in oil paint) from end to end with small Chinese water-colour brushes. But one doesn't hand-paint for the sake of the 'hand-done'; one merely knows that surfaces worked in this way can – in fact they must – register a different nuance of spatial evocation and movement in every single square millimetre. [. . .]

From 'Colour and Abstraction in the Drawings of Bonnard'
in *Bonnard Drawings 1893–1946*
The American Federation of Arts, New York, 1972

I [believe] that an extremely close relationship exists between the *composition* of a Bonnard seascape (which, formally, consists solely of differentiated horizontal bands or strips or strings of colour-texture) and the format of a contemporary horizontal stripe-painting; between a tall thin Bonnard interior, split from top to bottom by waveringly vertical strips of colour-texture, and a modern vertical stripe-painting. If I speak for a moment as a painter who found himself the innovator, in the early months of 1957, of what later became known as 'colour-stripe-painting', I may perhaps confess that it was not until years after the period of my colour-stripe-paintings had come to an end that *any* connection between my own stripe format and the compositions of Bonnard suddenly struck me for the first time. (I am referring, incidentally, to a similarity between concepts only: in actual texture or colour there is little or no connection between Bonnard and contemporary stripe-paintings of course.) Are profound influences, though, always so unconscious? Perhaps they are – or should be. Anyway, as late as 1966 when I wrote the [. . .] foreword [to the exhibition catalogue *Bonnard in 1966*, Victor Waddington 1966] I at least had never seen references anywhere to the fact that those lozenge-shaped areas and those wobbly, round-cornered squares which, in Bonnard, are synonymous with table-tops and tea-pots, or small clouds in a summer sky, were later seen floating, free of any but formal connotations, in the canvases of Rothko and Gottlieb, William Scott and myself.

There is another respect in which Bonnard proves, in looking back, to have exerted an extraordinarily innovatory influence. I [have drawn] attention to the unique importance which Bonnard bestows upon the edges of the picture, and the areas nearest the edges. It so happens that a number of English painters of my own generation, roughly speaking, have always instinctively utilised the edge-areas of their canvases in a way which, one now sees, derives ultimately from Bonnard: William Scott, Roger Hilton, Peter Lanyon and I myself were all explicitly criticised, over and over again, for this very characteristic by a leading American critic [Clement Greenberg] visiting Cornwall and London in the summer of 1959 – 'Why do you reach for the edges?' was his repeated reaction. I explained to him in Cornwall, and later again in writing, that the first four ineradicable formal statements in a rectangular painting were in fact the four physical edges of the canvas: further, that these four edges were the most powerful 'lines' in the whole composition and were the springboards from which every single movement across the picture surface derived its initial thrust. There is no shape, no area, no defining division between areas on the picture surface but has to *relate* first and foremost to those four edges and find anchorage in them. Finally, because the eye of the spectator, moving across the canvas, encounters and re-encounters the picture *edges* (which bounce it back into the composition again) with greater frequency than it encounters any other single shape or line inside the picture, these narrow areas lying parallel to the canvas's edges are possibly the most active pictorially. One feels it is the edges of the picture surface which are most visited by the eye. It is this edge-consciousness which Bonnard pioneered and which was transmitted to New York by way of that encounter, in Cornwall in [May] 1959, between a New York critic and myself. [. . .

. . .] The painting of Pierre Bonnard, so far from being a mere postscript to French Impressionism (a view still far too widespread), does in fact *remain utterly relevant* to living abstract painters, impinging with inescapable force upon our pictorial thought-processes at this very moment.

From 'Matisse and Aragon'
review of Aragon's *Henri Matisse – A Novel*
New Statesman
1 December 1972

Large Interior in Red (1948), one of Matisse's last major oil paintings, adorns the jacket of Aragon's second volume: early in 1951 I caused this picture to be placed on the cover of *The Listener*, in whose columns I was claiming: 'Matisse creates his objects more in terms of colour than form'. But it was in the *New Statesman* in July 1949 that I reported from Paris the first public showing of this and six other similar paintings of 1947–48, saying
'. . . in these canvases [Matisse] has moved forward: a very remarkable achievement for an old man . . . The new pictures are large and the flaring brilliance of their scarlets, oranges, crimsons, lemon-yellows, blacks . . . has a softness . . . that makes the works of the early 1940s look hard and brittle. The subjects are much the same – but the vision has developed still further. Scribbled expanses of brilliant thin paint evoke sunlight and shadow in ways hitherto unexplored.'

Twenty-three years on – and I would stand by every word of that. One's present preoccupations stem straight from Matisse.

From 'The Shape of Colour'
text of the 5th Power Lecture in Contemporary Art for 1973
published in *Studio International* February 1974 and in
Concerning Contemporary Art – the Power Lectures 1968–73, ed. Bernard Smith
Clarendon Press, Oxford 1974

One of the more curious dichotomies, when you come to think of it, is our mental tendency to divide *colour-shape*, or *colour-form*, into colour *and* form or shape *and* colour, as though one could have colour without shape or shape without colour. As far as the experience of our human eyes is concerned – and that, exclusively, is *the* experience which concerns a painter above all others – colour is shape and shape is colour. As far as pure visual sensation goes colour and shape are always one and the same thing. What we call shape is something that begins to be apparent because there is a place where one colour ends and another begins – and this meeting-place of colours becomes, in our consciousness, an edge, a line, an outline, a profile, a boundary or frontier between two differing colour-areas. I am gazing at an area of apricot-ochre: this apricot-ochre area is opaque but luminous and flattish; my eye rapidly traverses this flattish opaque apricot expanse and arrives at a frontier along which the apricot-ochre ceases and a field of violet-blue takes over: this meeting-point of apricot-ochre and violet-blue becomes in our consciousness a thing in its own right, a thing we call 'a line'; and this line – a thing created solely in our vision by the continuousness of the meeting-points of those two fields of ochre and blue – this particular line 'defines', as our verbal language would put it, the edge of a cloud in the sky.

[. . .] But by the time my mind was in possession of the concept 'a cloud in a blue sky', my full consciousness had ceased to focus itself upon the purely visual experience of an apricot-ochre opacity edging itself into mutual definition against an opposing area of violet-blue. There is thus always a rivalry between sensation as such and concepts as such. Apricot edging against violet: that was the sensation. A line between apricot and violet: that was half-way between a sensation and a concept. A cloud in the sky: now we've travelled all the way to a concept – and as that concept spreads itself inside the mind, at that very second sensation switches itself off, and momentarily – while you think your thought about that cloud – you are a blind man, seeing nothing, although your eyes stay open. This is why concepts, and also symbols, are the enemy of painting, which has as its unique domain the realm of pure visual sensation. [. . .

. . .] The painter is and always has been in search of one thing only: and that is, a new abstract configuration, a new but purely formal significance, a new pattern emerging out of the very mechanics of physical vision itself, a new shape in the organisation of colour. [. . .

. . .] To use the word 'ground' to describe what is in fact merely the largest colour-area in a painting of mine is convenient: but it is misleading – for the following reason. 'Ground' implies a pictorially passive area; a mere space, even a vacuum, in which – or against which – more positive shapes are set. Any painting in which the largest colour-area feels like a curtain or backdrop against which more formally definite or active forms are set; any painting where the largest area appears as an emptiness, a sky, a formally neutral environment or mere setting for a number of more individual shapes – this is a failure, from my point of view. I believe absolutely in what I call the formal equality of all parts of the painting. To me, no section of the picture-surface *should be less of a shape* than any other. To me, there, is *no* 'ground' in a good painting. The criterion of *shape* applies every bit as much to the largest colour-area in a painting – the so-called ground – as to the smaller ones. [. . .] If [. . .] large areas did not have the same formal completeness *as* area-shapes as the much smaller areas, then the painting would fail to meet that, to me, absolutely central criterion of the good painting – namely, the equality of parts, the equality or evenness of the pressure or movement which all its component parts must mutually exert upon each other. [. . .

. . .] It is my profound belief that this equal two-way definition of all dividing lines, all pronounced divisions between forms or colours, is characteristic of the best painting of any age. The so-called space between the arm and the hip in a nude by Michelangelo is itself a shape, on the picture-surface, every bit as definite and positive and complete as the shape of the arm or the torso to either side of it. In other words, the outline of that hip is a line which defines with equal intensity in two directions simultaneously. All paintings are thus like a jigsaw: every area-shape – like the pieces in a jigsaw – must be formally complete in itself and at the same time must be wholly accommodating to all the other contingent pieces surrounding it. All its edges mutually define both the piece itself and one side of an adjacent piece. [. . .

. . .] I find myself searching endlessly for new relational proportions as between colours or colour-areas. For instance, in 1969 I arrived at a series of very large paintings – fifteen feet long, or thirteen or eleven feet. [. . .] Looking back, the object here seems to have been to see how far a few of the familiar elements could be stretched out sideways into [a] long horizontal composition [. . .] without [the] *largest* area [. . .] disintegrating back into that vacuous background of neutral nothingness which I so much despise! I used to say, as far back as 1959, that what one was looking for, in stretching out a single colour-plane across four-fifths of a canvas, was a full emptiness or an empty fullness. In these very long, very large paintings of 1969 and after, I think one has added to that earlier requirement of 'full emptiness' this new one: to see how *big* a colour-area can become physically while still retaining a visible compactness in its image, a tightness in its design and organisation that remains totally readable, despite the expanded scale of that design, of those images. How far could one *expand* one's colour-areas without appearing to be *distending* any of them? [. . .] The plain physical impact of a large painting, the sheerly quantitative bombardment by the vibrations of really big areas of colour – these constitute a totally new factor. It was simply a fact that, in painting large, one was entering a field of physical sensation which just was not given off by smaller paintings.

From 'Art is Autonomous'
The Colour of Colour, E. William Doty Lectures
in Fine Arts, 1978
The University of Texas at Austin 1979

I have come, with hindsight (and by hindsight I literally mean thirty years) to recognise that this picture [*The Piano*, 1943; pl. no. 8] marks the greatest step forward in my whole life, in the sense that it is visibly related, in shape after shape, and colour after colour, to works typical of my production at point after point in time from the 1950s on. Indeed, I think I believe it would be true to say that the basic rhythms, the fundamental patterns which link all the colour-shapes we eventually recognise as being most typical of a painter are possibly established – even if they're somewhat disguised – at a very early stage in his career.

From 'Isles of Scilly – The Fabulous Archipelago'
The Observer Magazine
24 August 1980

Physical scale – this is always the greatest mystery. With your feet in a rock-pool, looking down, you suddenly read promontories, lake, islets, bays and fjords into the minutely ragged edges of the pool's surface as it eats into the granite, imagining yourself looking down from 30,000 feet up. And of course, there really is an *exact* relationship between the most minute geological manifestations and the coastlines on a map: the calligraphic linear patterns patent in the smallest surface of a granite pebble do precisely coincide with

western coastlines on the Ordnance Survey map. The design is the same whether the jagged or rippling contour is contained within a yard of the rock-pool's edge or extends along 100 miles of coast. Smaller suggests bigger. And vice versa. [. . .

. . .] One has only to spend a few hours on the Isles of Scilly to be virtually brainwashed by a very special kind of physical space and remoteness. One's whole mode of awareness changes dramatically. One's senses seem liberated. All visual perception appears to be more concentrated and, furthermore, quite effortless. One is aware of one's surroundings to an unusual degree, from the sea-washed twig among the wrack cast up at one's feet on the silver-white sand (tiny flecks of mica gleam everywhere in that sand, like minute silver mirrors) to the Day-glo pinks and yellows of the papery petals of the flowers on the mesembryanthemum which sprouts from the salty turf at the beach's edge. And, surely, the clarity of the whitest light in Europe plays its part in all this.

The central lagoon separating Samson, Bryher, Tresco, and St Martin's from St Mary's is so shallow that its sandy bed – only a few feet below the surface – causes it to turn a brilliant turquoise on a sunny day, a turquoise beyond which the deep ultramarines and indigo of the open sea outside the encircling islands dramatically signify the deeper ocean. Crossing and re-crossing this shallow sound, the open launches (the only transport between islands) deftly weave changing courses, according to the state of the tides; and no one heeds the bump and swish of the boat's bottom as it passes over banks of seaweed. And it is on these short trips between islands, from open boats, that one enjoys one more of the almost baffling spatial experiences of Scilly – namely, the sight of the rapidly changing silhouettes of rocks and islands which one thought one knew as one moves over the water between them.

From 'Heron's Nest'
Harpers & Queen
August 1981

When Delia and I moved to Eagles Nest in 1956, with our two small daughters, she was the tree-surgeon and gardener-in-chief; I was the hedge-clipper and the tracer of paths (since everything was overgrown). I had lived in the house for five winter months when a child, my parents having borrowed it from the Arnold-Forsters, and it was then that I first noticed that the gales shaped the trees and bushes at Eagles Nest into almost the identical streamlined silhouettes that the rocks possessed. Certainly, what has always fascinated me is the closeness of the relationship between the rhythmic shapes of the garden and those of the wild Zennor landscape surrounding it. The calligraphy of the Bronze Age walls of the tiny fields 250 feet below the house is reflected in the garden as are the silhouettes and profiles of the rocks, seen against the sky, which litter the surrounding moorland crests. All the garden's shapes seem to be a formal restatement, in microcosm, of the utterly informal patterns of this Celtic coastal landscape.

'A Note on My Gouaches'
written to accompany an exhibition of Heron's gouaches at
the Caledonian Club, Edinburgh
1985

My gouaches are not a substitute for the oil paintings. Nor are they preliminary sketches, or means for trying out new colour-shapes or configurations of dovetailed colour-shapes to feature in later paintings on canvas. They are works in their own right; and their quality, in fact, doesn't even overlap with the canvases' in many respects. Or so I feel.

A painting has a certain identifiable speed of execution, which it communicates. You can feel the exact speed of Van Gogh's painting hand, as your eye skips across the staccato-surfaces of jabbed, separate strokes of that square-tipped brush of his. You can also physically identify with the extremely swift and broad scribble-action in Matisse; the gliding brush whose speed changes every second as it makes the painting.

In my gouaches, the tempo is dictated, quite apart from the particular needs of the area-shapes I make, by the nature of the wet medium itself. I like the water in the paint mixture to lead me; to suggest the scribbled drawing which gives birth to the images.

My gouaches have always had this fast-moving fluidity of drawing, and a softness, coming from the watery medium itself, which the oil paintings cannot share. Throughout the 1970s, in fact, my gouaches and my oil paintings occupied very different departments in the field of pictorial experience. The canvases had to have a certain degree of rigidity, by comparison. It is only recently, in the development shown in my large (and small) canvases since 1981, [. . .] that an *apparently* more rough and ragged paint application brings the canvases more into line with that quality of fluent, fluid colour which has been a characteristic of the gouaches for a very long time.

From 'Painting is Silent'
a conversation between Patrick Heron and H. Cumming
Art and Design
vol. 3, no. 5/6 1987

[. . .] Throughout the 1970s I maintained this wobbly hard-edged development of very flatly painted, intense areas of full strength, not necessarily primary colours, but unmodulated, with no white added, no mixture – a very thin skin on a white ground of the strongest colours that the manufacturers could provide, all edging up against each other. Then suddenly I wanted to dip my brush into something and scribble it all over. And that's exactly what I did: I destroyed a number of paintings which survived from this rather immaculate development, that really ended with the 1977 paintings in my Texas retrospective exhibition. I began to sort of scribble and scratch, and produced a series of paintings, some of which I exhibited in 1983 at Waddington's. But by the time the Barbican made a semi-

retrospective show of my work, I concentrated for the main part on paintings made after 1982, and they drew me right back to the textures of Matisse and Bonnard, though the whole spatial meaning of the painting is totally different – they're not figurative to that extent. On the other hand, the sort of organisational patterns which I found myself embarking on again had the complexity of that sort of painting which put itself at the disposal of the received image from the natural scene. I'm thinking of the dots and dashes of a Bonnard, or even of a late Monet. These have obviously been very important for me recently.

In my most recent gouaches this puzzle between so-called figuration and so-called abstraction is stepped up yet again. I myself can hardly separate the categories. For instance, when I look round my room, the elements I see – daffodils, a glass decanter, purple spectacles, a jug, a piece of sky through the window – all make the kind of shapes which find their way into my gouaches. In one's attempt to discuss painting one hits on a way of saying something which seems meaningful. This is quite dangerous in a way, because what one should really be doing is leaving oneself open to the invisible suggestions of one's own reflexes when stimulated through the eyes. To make oneself available to previously uncharted rhythmic movements, suggestions and devices – this is the great ideal.

SELECTED WRITINGS ON PATRICK HERON

From Introduction by Basil Taylor to catalogue of
*Retrospective Exhibition of Paintings and Drawings by
Patrick Heron*
Wakefield City Art Gallery
April 1952

Many English painters have used the grammar of Cubism,
painters as various as Wyndham Lewis, Ben Nicholson,
Graham Sutherland; but Heron is one of the very few, I
believe, who has not only followed its logic but has also
accepted the purposes for which that grammar was
constructed. Cubism was evolved, we should not forget, for
the expression of common material objects, for bottles and
jugs, for the human body and the forms of landscape. Braque
has been as objective as the Le Nains, as Chardin or
Courbet. Cubism was not intended to communicate legends
or dreams, ideals or emotional experiences, although in
England, particularly during the past ten years, it has most
often been attached to modern paraphrases of the motives
of English romanticism. Heron has not been attracted by the
metaphysical or the allusive or by the indulgences of
Expressionism, nor has his Cubist language been a
fashionable dress for conceptions which suggested
themselves originally in quite a different appearance. His
writings in the *New English Weekly* and the *New Statesman
and Nation* include some of the best criticism in English of
the painting of the school of Paris, and show how profoundly
he has understood the painting of his own century.

'The painter', said Braque, 'thinks in forms and colours; the
object is his poetic aim'. I know of few painters working here
who use form and colour with such a natural freedom and
assurance (and it is worth recording here Heron's
admiration for Matthew Smith and Ivon Hitchens). His
problem has been, I suspect, not to discover his talent, but
to use it most expressively. And this essential talent and
intelligence is clear from the time he first began to work with
the processes of an adult [. . .]

Heron has the essential gift of a good painter, without which
no true understanding of a grammar of style is possible. He
can set into perpetual motion and tension a relationship of
forms and colours, and, for me, this admirable vitality is
enriched by another quality whose worth may perhaps be
more debatable. His pictures make themselves, in Braque's
phrase, under the brush, discover themselves, so to speak,
in the process of painting as words come together in the
most eloquent rhetoric. This habit cannot be induced, but
must be the expression of a kind of talent which is not
sufficiently valued at the present when fluency is too often
distrusted.

From Introduction by Robert Hughes to exhibition catalogue
Retrospective: Patrick Heron
Richard Demarco Gallery, Edinburgh
June–July 1967

[. . .] More recently – witness the work of Americans as
diverse as Stella, Judd, Morris – a kind of critical speculation
about the limits of art has become the subject-matter for
some artists. [. . .] Your attention is shifted away from the
plastic object as a complex of forms, towards its *implications*
about other images in an assumed cultural context.
Linguistics has become the subject-matter of art; painting
itself, a form of criticism.

But there exists a tradition – one is still tempted to say, *the*
tradition – of uniquely visual language. Its art is neither
conceptual nor critical, but sensuous. You start from
coloured shapes which 'do things' to your sensations – to
your sensuous awareness of size, shape, texture, distance,
colour, pattern and space. Bonnard, Matisse and Braque are
its supreme exponents in this century. If Patrick Heron's
work is to be rightly seen, it is essential to note that his
concerns as a painter are continuous with theirs. They begin
from the recognition that there are things which colour,
disposed on a flat surface, is uniquely fitted to do – and that
although it can be made to do other things, such as conjure
up illusions of perspective, these are not its primary
functions. The central point of Heron's work, which one can
see developing with total consistency over the last twenty
years of his output, is the idea of 'colour as space'. [. . .

. . .] But, as Heron wrote in 1958, 'Space must never be too
deep, or the colour too flat . . . Painting has to synchronise,
in every gesture or statement, two distinct forms of
organisation – one in illusionistic depth, the other across the
surface of the canvas'. Otherwise, one may add, the
abstractness of the image will be lost. It is possible to
imagine that space in colour could become as tricky and
mannerised, because as predictable, a technique as space
in perspective did. That is why Heron finds it necessary to
contradict one's expectations, and not to exploit fully, as a
programme, the use of colour as a way of simply rendering
forms in deep space. The painting remains a painting – that
is to say, an object containing certain relationships, but not
a window. Every interaction of shape, every bite of colour
against colour in Heron's work exists within a guarded context.
For this reason, his colour has never been diffuse; and since
the Cubist pictures, it has never been prone to figurative
interpretations. One may contrast Mark Rothko's colour to
Heron's: in the former, an undefined, fluttering expansion of

horizontal colour patches, interrupted, almost by chance, by the edges of the canvas; in the latter, a structural formation of colour, meticulously thought out in terms of the edges of the picture, from which all naturalistic readings are excluded. (Long Island sunsets have come to look like Rothkos, but nothing in the Cornish landscape can be read as a Heron.) Whether or not you share Heron's conviction that the *only* direction left for painting to explore is that of colour, it is, I think, evident that the diffuse, omnidirectional colour of Rothko and the 'field' painters has very little left to offer. The problem now is to re-complicate the picture surface, to get away from the grand-scale simplicity, whether tremulously expansive or pompously minimal, which has stamped so many approaches to colour in the last decade. On this fresh integration, the existence of painting in its traditional sense depends; and should the synthesis take place, Patrick Heron's work will have had an exemplary role in bringing it about.

From 'Patrick Heron: the Development of a Painter' by Ronald Alley
Studio International
July–August 1967

Although he was one of the first English art critics to write appreciatively of the Parisian post-war abstract painters (especially Soulages and de Staël) and although his works of 1950–52 are sometimes quite difficult to decipher at first sight, he had reservations for some years about the absolute merits of non-figurative art. [. . .]

Late in 1955 he began to experiment with tachisme in two or three pictures such as *Winter Harbour: 1955* (exhibited in the Contemporary Art Society *Seasons* exhibition and now in the Vancouver Art Gallery) in which the original composition was almost completely obliterated by an overlay of horizontal and vertical bars of colour [. . .

. . .] as London correspondent to the American periodical *Arts* from 1955–1958, his whole-hearted support for their work was of great help to the American painters [the Abstract Expressionists] themselves at a period when they were still struggling to obtain recognition in their own country. [. . .]

These Tachist pictures were followed in 1957–58 by a more regular series composed of parallel stripes or bands of different colours and widths executed in thin washes like watercolour. In these works Heron attained for the first time his full liberation as a colourist, a lyrical romanticism and inventiveness which is illustrated by such titles as *Incandescent Skies – Yellow and Rose*, *Strata of Green and Scarlet Vermilion* and *Atmospheric Painting* (*olive and green*). Their seductive colours, laid on in loose overlapping washes, produce a shallow spatial undulation. Several of the earliest ones are reminiscent to some extent of Rothko's pictures, although they tend to be narrower and to have a greater number of colour bands, but the series as a whole is quite different. A picture like *Vertical Light: March 1957*

even anticipates the stripe-paintings of Morris Louis which were not executed until several years later, though it is looser and more 'soft-edged' in construction. Nevertheless, the colour stripes are placed side by side like bands of coloured light. He eventually stopped painting stripe pictures in the summer of 1958 when he realised that they bore a slight resemblance to sunset over the sea – the kind of effect which could often be observed from his house at Zennor and which may have influenced him subconsciously. [. . .]

His growing reaction against what he felt to be the over-simplification of American painting eventually led him from about 1963 to re-complicate his compositions once more. He broke away from the idea of a ground lapping round the forms and began to make the ground an active area, divided up like everything else. Or rather he tried not to have a ground at all but to give all the areas equal weight and interest. [. . .]

The stand which Heron has taken recently against the dominance of American painting (particularly in *Studio International*, December 1966) becomes very easy to understand in the light of his development: indeed it seems almost inevitable. He believes that the American painters have pushed simplification to its ultimate extreme and that it must be followed by some sort of re-complication of the picture surface, in which British artists and not the Americans are now taking the lead. 'But of course it is also obvious', he wrote in 1962, 'that colour is now the *only* direction in which painting can travel'.

From 'On Patrick Heron's Striped Paintings' by Alan Bowness, from catalogue to *Patrick Heron: a Retrospective Exhibition of Paintings 1957–66*
Museum of Modern Art, Oxford
May–June 1968.

I can think of few more disconcerting pictures seen in England in the last twenty years than Patrick Heron's striped paintings of 1957. One must consider the circumstances in which they were first shown. It was at a curiously titled exhibition at the Redfern Gallery – *Metavisual Tachiste Abstract* – in April 1957. [. . .

. . .] Certainly his conversion to abstraction attracted much comment at the time, most of it unfavourable. He had been too forthright an art critic for many people, and because he wrote art criticism his paintings were often dismissed as unserious and simply decorative. Heron had painted some abstract pictures in 1952, but the real change of style came in 1956. And when he did change he was accused somewhat paradoxically of both seeking originality for its own sake, and of slavishly copying the newly discovered American painters.

Matters were not improved when a large group of the striped paintings appeared at Heron's one-man exhibition in February 1958 – his last at the Redfern Gallery. Virtually

nothing was sold – which is why it has been relatively easy to bring most of the pictures together again for this exhibition at Oxford. Looking at them again ten years later one can understand why they were so upsetting. At that time qualities of paint texture and touch and expressive brush-work seemed to matter very much – indeed they were the things one looked for first in abstract painting. What was one to make of these parallel stripes of colour? Admittedly the structure reflects the movement of the painter's hand, and one could relate the brush-strokes to other pictures (including Heron's own garden paintings of 1956) which have a certain calligraphic quality. Yet this was all done with such lack of deliberate concern for texture and matière: the paint was so thin, and applied immediately to the canvas in a single stroke. All the artist seemed to be interested in was the relationship of these bands of colour, echoing chords across or up and down the picture plane.

One should remember that these striped paintings were the first ever seen anywhere. We are now familiar with the idea from many sources, and in particular from the late pictures of Morris Louis, all done well after Heron's vertical bands, and just possibly (though not necessarily) dependent on them, as certain New York critics, magazines and dealers, had had photographs of Heron's work; and one influential American critic had actually seen such vertical stripe-paintings as *Vertical Light: March 1957* at Zennor in Cornwall before they were shown in London. Louis certainly painted some beautiful striped painting, but, like too many American painters, he pursued a single idea in too ruthless and ultimately destructive a fashion.

Maybe it would have been better for Heron's international reputation had he gone on painting striped pictures from that day to this. He need scarcely have changed, and we would have read them in slightly different ways as the years passed, noticing at one point the quality of their edges, at another the form to ground relationship and so on. But Heron has never stood still – in fact his temperament compels him to look always for the contrary of what he is doing as a means of furthering his progress, or if you like to work from thesis to antithesis to synthesis in an everlasting sequence.

From Introduction by Alan Bowness to exhibition catalogue *Patrick Heron: Recent Paintings and Selected Earlier Canvases*
Whitechapel Art Gallery, London
June–July 1972

At the time one was told that Heron was simply following Rothko. Now if this means that he was exceptionally quick to appreciate Rothko's quality and his importance, it is true, and there are indeed a few pictures which show the absorption of this influence. But the striped paintings of 1957 and the open paintings that immediately succeeded them are not really like Rothko at all, and the American paintings they do now recall are later in date. Speaking as someone who has known them from the time that they were painted, they seem to me to have got better year by year, assuming

an authority that comes with age. I am inclined to claim now that Heron's paintings of 1957–58 are a major statement by a major British artist, and they occupy in the context of their time a situation analogous to William Scott's black and white pictures of 1954, or, to go further back into the past, Ben Nicholson's white reliefs of 1936.

From 'Recent Paintings', by Alan Gouk in catalogue to *Patrick Heron* exhibition
Barbican Art Gallery 1985

But beginning around 1980, the somewhat uncharacteristic meticulousness which had driven the paintings of the 1970s began to be overtaken once more by the rebellious promptings of arm and hand.

It is the mark of a truly adventurous spirit that he throws his reputation into the balance with each new group of paintings; not yet another performance of self-assured mastery, using one's accomplishment to charm and flourish, but a true beginning again. 'He has again and again put his whole art in question unbiased by his past achievement', is how Roger Fry put it, speaking of Matisse. [. . .

. . .] As the series has developed, it is above all in the relaxation of their drawing that the newest pictures are remarkable, and this relaxation has allowed perhaps greater diversity of incident, variety of type of silhouette, and textural variety, than at any time in Heron's previous work.

The loosening enables great subtlety of transition between the various sub-worlds which are accommodated within the one image, and also a sudden sharpness at any desired point. Shapes are delimited just as clearly as ever, but the precise character of the wayward, wandering drawing does not tie them together, but rather, untied, the coloured areas, filled out velvety soft at one point, loosely scored and scraped with pungent accent in another, are freed to participate in a gently persuasive fusion of their own, like new morning mushrooms breaking through the grass-roots at dawn, or crocus buds opening to the pale light of spring. And all this has gradually brought an altogether more sophisticated and artistic measure of control. Intensity is no longer something which drives the artist in its hot pursuit. Heron has once more found his touch.

The first impression is likely to be, on seeing the largest of the new paintings, that they are somehow not finished [. . .

. . .] It has, I am sure, been tempting to wish to see the oil paintings take on more of the qualities of the gouaches (and incidentally of the carpets) which have maintained a consistently high standard throughout the years, and have often been superior works of art to the oils.

But this is precisely the by now familiar kind of unity Heron's completely unforced intrigue is not going to give us. Little by little one begins to rise to the unique features of the unsteadying sensuosity on offer, and to see how pacific a

unison that deliciously unfinished finishedness provides.

Apart from the inherent quality of his best paintings, Patrick Heron remains of vital importance to the onward of British painting for two reasons. He is our one contact with that moment at which British painting had the most unambiguous links with the continent, without that sense of an unbridgeable inferiority which causes most of our efforts to strain and distort the fundamental eloquence of the means with ponderous intent – that moment at which the objective world, unsullied by romantic fantasy, first met an English interpreter in this century to do justice to it. I am speaking of the confident Matthew Smith of the 1920s and 1930s. And secondly, because of the link with Matisse – feeling through colour. 'I feel through colour: it is thus through colour that my picture will always be organised' (Matisse): not that his paintings are like Matisse's, or his feeling akin (as I have suggested, St Ives light has not the velvety lambency of Cap d'Antibes: Heron's light is more akin to the 'diffuse and violent' light of Braque, with his tonal northern harshness too); but this is his primary identification nonetheless, whence comes his extreme reliance on the first coup of colour, and a confidence in the capacity of decorative art to be sustainer of the highest ambition for painting. [. . .]

If Heron is a deal more fallible and less subtle than Matisse in modulating this colour with tonal range and finesse, that subtlety is beginning to come in again. To do justice to the finer and more imponderable qualities of colour which are beginning to emerge in these new paintings, one needs to begin to think not so much of spectral colour, yellow, orange, red, violet, blue, green; more of unique qualities of substance, degrees of material quality and of the light that is reflected from them – gold, amber, olive, saffron, lime, mimosa, mustard, moonstone, milk-white, ivory, cream, silver, butter, pearl, donkey, suede, beige, tan, coffee, dove-grey, sepia, wine, aubergine, ruby, amethyst, sapphire; with these more sentient, earthy yet aerial qualities of colour which paint by some miracle can be led to evoke, he is coming more onto Matisse's ground than he has in a good number of years.

From 'The Innocent Eye' by Peter Fuller
Artscribe no. 54
September/October 1985

In the 1970s these works [the 1957–58 stripe-paintings] were to become bones of contention in Heron's argument with the Americans over precedent. The crux of Heron's position was that so far from having always been at the receiving end of influence emanating from New York, several painters of his generation, including himself, had consistently exerted 'crucial influence' upon New York painting from the late 1950s onward. Heron established his case beyond any reasonable doubt – and it has never been answered. There have been those who have said that it just does not matter who did what first; but the truth always matters, in art, no less than in life. I would go further. I believe not only that

Heron's stripe-paintings preceded those of Morris Louis, but also that they are better, much better, in aesthetic terms.

Just look at the freshness and clarity of Heron's painting of 1956–58. There is a dowdy and depressing feel about even the best Morris Louis canvases in comparison. In fact, with few exceptions, Morris Louis's paintings, today, have the look of last season's used and abused fashions. Heron was always a painter of superior sensibility, colour sense, and painterly intelligence. His work manifests a love of tradition, and a mastery of skills and techniques, which Louis's lacked. Originality always shines out in the end over and above second-hand novelty. The greater sense of life in Heron's colour has to do with a certain replenishment from landscape and natural form, however much he may consciously have tried to resist this. (Someone as visually sensitive as Heron could hardly *not* have been profoundly affected by his move to Cornwall, especially when that countryside was already redolent with childhood memories for him.) Louis, on the other hand, really only produced Washington studio colour, plastic colour. Heron always had an intuitive grasp of the importance of creating and crafting a surface. [. . .]

After his stripe-paintings, Heron pursued his programme of 're-complicating the picture surface'. [. . .] But Heron also characteristically refused the central, symmetrical 'bunching' of his shapes which, like Louis's vulgar colours, appealed to banal and unsophisticated tastes. The compositional 'drawing' in a Heron is, I believe, more independent of colour than he likes to suggest; this drawing, surely must be over in the first minutes, perhaps seconds, of creating a canvas – long before the full weight of the colour values can be assessed. Such drawing in Heron seems to be derived from an intuitive sense of balance, which, unlike repetitious, mechanical symmetry, can also be related to natural form. Even in black and white photographs, it is easy to perceive just such a 'balance' in the disposition of the rocks and boulders in the Cornish landscape.

CHRONOLOGY

1920	30 January, born Headingly, Leeds
1925–29	Family lived near Newlyn and in Lelant and St Ives; moved to Welwyn Garden City, September 1929
1937–39	Part-time student at Slade School of Fine Art
1940–44	Agricultural labourer, Cambridge and Welwyn
1944–45	Assistant at Bernard Leach Pottery, St Ives; moved to London after marriage to Delia Reiss in 1945, and resumed painting
1945	Painted in summer at Carbis Bay
1945–47	Art critic for *New English Weekly*
1946	Painted in summer at Mousehole; annual visits to St Ives 1947–54
1947	*Vlaminck Paintings* (Lindsay Drummond/Les Editions du Chêne, Paris) Series of talks on contemporary art commissioned by BBC Third Programme Became art critic for *New Statesman and Nation* (until 1950; further contributions to 1955)
1950–54	Occasional reviews in *Art News and Review*
1953–56	Taught at Central School of Arts and Crafts
1955	*The Changing Forms of Art* (Routledge and Kegan Paul, London. US edition, Noonday Press, New York 1958) *Ivon Hitchens* (Penguin Modern Painters) Became London correspondent to *Arts Digest* (later *Arts*, New York)
1956	April, moved to Eagles Nest, Zennor, near St Ives
1958	Resigned from *Arts* (New York) and took 'vow of silence' Took over Ben Nicholson's Porthmeor studio *Braque* (Faber Gallery Series, London)
1959	Awarded Grand Prize (International Jury) in 2nd John Moores Liverpool Exhibition
1965	Awarded Silver Medal at VIII Bienal de São Paulo; lectured in São Paulo, Brasilia and Rio de Janeiro
1967	Visited Australia, lecturing in Perth and Sydney
1973	'The Shape of Colour', Power Lecture in Contemporary Art, delivered in Sydney, Brisbane, Canberra, Melbourne, Adelaide and Perth
1977	Created CBE
1978	'The Colour of Colour', E. William Doty lectures in Fine Arts, delivered at the University of Texas at Austin
1980–87	Trustee of the Tate Gallery
1982	Hon. D.Litt. (University of Exeter)
1986	Hon. D.Litt. (University of Kent)
1987	Hon. Dr (RCA)

1947 Downing's Bookshop, St Ives
 Redfern Gallery, London (and also 1948, 1950, 1951, 1954, 1956, 1958)
1952 Wakefield City Art Gallery (retrospective) touring to Leeds, Halifax, Scarborough and
 Nottingham
1953 II Bienal de São Paulo (12 paintings)
1959 Waddington Galleries, London (and also 1960, 1963, 1964, 1965, 1967, 1968, 1970, 1973,
 1975, 1977, 1979, 1983, 1987)
1960 Bertha Schaefer Gallery, New York
1962 Bertha Schaefer Gallery, New York
 Grinnell College, Grinnell, Iowa
1963 Galerie Charles Lienhard, Zurich
1965 Bertha Schaefer Gallery, New York
 VIII Bienal de São Paulo, touring South America 1965–67
1967 Richard Demarco Gallery, Edinburgh (retrospective)
 Kunstnernes Hus, Oslo (retrospective)
 Dawson Gallery, Dublin
1968 Museum of Modern Art, Oxford (retrospective)
 Park Square Art Gallery, Leeds
1970 Waddington Galleries, London (prints)
 Waddington Fine Arts, Montreal
 Rudy Komon Gallery, Sydney
 Mazelow Gallery, Toronto
 Harrogate Festival (Gallery Caballa)
1972 Whitechapel Art Gallery, London
1973 Hester Van Royen Gallery, London
 Bonython Gallery, Sydney
1974 Skinner Gallery, Perth, W. Australia
 Prints on Prince Street, New York
1975 Rutland Gallery, London
1977 Galerie Le Balcon des Arts, Paris
1978 University of Texas at Austin Art Museum (retrospective)
 Bennington College, Vermont
1979 Oriel, Cardiff
1981 Riverside Studios, Hammersmith, London
1984 Abbot Hall Art Gallery, Kendal, Cumbria
1985 Castlefield Art Gallery, Manchester, and Arcade Gallery, Harrogate
 Barbican Art Gallery, City of London (retrospective)
 Newlyn Art Gallery, Newlyn, Cornwall
 Caledonian Club Theatre, Edinburgh
1986 Northern Centre for Contemporary Art, Sunderland

SELECTED MIXED EXHIBITIONS

1949	*Salon de Mai*, Paris
1950	*Aspects of British Art*, Institute of Contemporary Arts, London
1951	*Sixty Paintings for '51*, Arts Council, London (Festival of Britain)
1951–52	Three British Council Exhibitions: Western USA; Canada; and Sweden
1953	*Space in Colour*, Hanover Gallery, London, exhibition devised by Patrick Heron.
	British Watercolours and Drawings of the XXth Century, British Council exhibition at the Brooklyn Museum, New York
1954	*British Painting and Sculpture, 1954*, Whitechapel Art Gallery, London
1954–55	*British Art 1900–1950*, British Council exhibition in Copenhagen and Oslo
1955	*International Exhibition of Painting*, Valencia, Venezuela
1955–56	*Six British Painters from Cornwall*, touring exhibition to Montreal, Vancouver, Hamilton, Toronto, Winnipeg, etc.
1956	Sir Herbert Read's *Critic's Choice*, Arthur Tooth and Son, London
	Recent Abstract Painting, Whitworth Art Gallery, Manchester
1957	*Statements – a review of British abstract art in 1956*, Institute of Contemporary Arts, London
	Peinture Anglaise Contemporaine, touring exhibition to Musée des Beaux-Arts, Liège; Galerie Perron, Geneva; and Brussels
	La Peinture Britannique Contemporaine, exhibition at Salle Balzao, Paris
	Dimensions – British Abstract Art 1948–57, organised by Lawrence Alloway at the O'Hana Gallery, London
	Premio Lissone, Milan
	Metavisual, Tachist, Abstract, Redfern Gallery, London
	John Moores' Liverpool Exhibition I
1958	*Abstract Impressionism*, Arts Council Exhibition organised by Lawrence Alloway shown at Nottingham and London
	British Guggenheim Award Paintings, Whitechapel Art Gallery, London
	The Religious Theme, organised by the Contemporary Art Society at the Tate Gallery, London
	British Abstract Painting, Auckland City Art Gallery, New Zealand
1959	*John Moores' Liverpool Exhibition II* (Main Prize)
	Eleven British Painters, group show of painters from Cornwall at Jefferson Place Gallery, Washington DC
	Four English Middle Generation Painters, Waddington Gallery, London
1960	*Seventh Exposition*, Tunisia
	British Guggenheim Award Paintings, Royal Watercolour Society Gallery, London
1961	*13 Brittiska Konstnarer*, Stockholm
	Carnegie International, Pittsburgh
	University of Nebraska Annual
	Watercolour International, Brooklyn Museum, New York
1962	*Arte Britanica na Seculo XX*, British Council exhibition in Lisbon, Oporto, Coimbra
	Six Painters, Waddington Galleries, London
	Contemporary British Gouaches, British Council exhibition touring Europe
1962–63	*British Art Today*, San Francisco Museum of Art, Dallas Museum for Contemporary Arts, Santa Barbara Museum of Art
1963	*British Painting in the Sixties*, organised by the Contemporary Art Society at the Tate Gallery, London
1963–64	*Contemporary British Painting*, British Council exhibition touring Canada, also shown at the Louisiana Gallery, Copenhagen
1964	*Painting and Sculpture of a Decade: 54–64*, Calouste Gulbenkian Foundation, Tate Gallery

1965	Hume Tower, Edinburgh (with Bryan Wynter)
1967	*Recent British Painting*, Peter Stuyvesant Foundation, Tate Gallery (touring S. Africa and Australia)
1970	*British Painting and Sculpture 1960–1970*, at the National Gallery of Art, Washington DC, exhibition organised by the Tate Gallery and the British Council
	Kelpra Prints, Hayward Gallery, London
1973	*First Sydney Biennale*, Sydney
	Europalia 73, Great Britain: Henry Moore to Gilbert and George, Palais des Beaux-Arts, Brussels
1974	*Some Significant British Artists: 1950–1970*, Rutland Gallery, London
	British Painting '74, Hayward Gallery, London
1975	*The British Are Coming*, Cordova Museum, Lincoln, Mass.
1977	*British Painting 1952–1977*, The Royal Academy of Arts, London
	Cornwall 1945–1955, New Art Centre, London
1977–78	*Cor na Pintura Britànica – Color en la Pintura Británica*, British Council exhibition touring South America
1983	*Pintura Britanica Contemporanea*, Museo Municipale, Madrid
1984	*British Artists' Books 1970–83*, Atlantis Gallery, London
	English Contrasts, Artcurial, Paris
1985	*Kunstwerk*, Peter Stuyvesant Foundation, Amsterdam (Silver Jubilee exhibition)
	Royal College of Art Printmaking Appeal Fund Exhibition, Barbican Centre for the Arts, London
	Recalling the Fifties, Serpentine Gallery, London
	St Ives 1939–64, Tate Gallery, London
1986	New Grafton Gallery, London (with Ivon Hitchens)
	Royal Academy Summer Exhibition
	Annual Open Exhibition, Royal West of England Academy, Bristol
	Forty Years of Modern Art 1945–1985, Tate Gallery, London
	Side by Side: Contemporary British and Malaysian Art 1986, British Council exhibition, Kuala Lumpur
1987	*British Art in the Twentieth Century: The Modern Movement*, Royal Academy of Arts, London (touring to Staatsgalerie, Stuttgart)

PUBLIC COLLECTIONS

London:	Tate Gallery, British Council, Arts Council of Great Britain, Victoria & Albert Museum, Peter Stuyvesant Foundation, Calouste Gulbenkian Foundation, British Museum, National Portrait Gallery, Contemporary Arts Society, British Broadcasting Corporation, Shell-Mex Limited
Aberdeen:	Aberdeen Art Gallery
Bedford:	Cecil Higgins Art Gallery
Bristol:	Bristol City Art Gallery
Cambridge:	Fitzwilliam Museum
Canterbury:	Eliot College, University of Kent
Chichester:	Bishop Otter College
Cardiff:	National Museum of Wales
Eastbourne:	Towner Art Gallery
Edinburgh:	Scottish National Portrait Gallery
	Scottish National Gallery of Modern Art
Exeter:	Exeter Art Gallery
	Cornwall House, Exeter University
Galway:	University of Galway
Kendal:	Abbot Hall Art Gallery
Leeds:	Leeds City Art Gallery
Leicester:	Leicestershire Education Committee
Manchester:	Granada Television
	Manchester City Art Gallery (Rutherston Collection)
Newcastle:	Hatton Art Gallery, Newcastle University
Northern Ireland:	CEMA
Norwich:	Norwich Art Gallery
Oxford:	Merton College, Pembroke College, New College, St John's College, Lady Margaret Hall, Nuffield College
Oldham:	Oldham Art Gallery
Plymouth:	Plymouth City Art Gallery
Southampton:	Southampton Art Gallery
Stirling:	University of Stirling
Wakefield:	Wakefield City Art Gallery
Warwick:	University of Warwick
Australia:	The Art Gallery of Western Australia, Perth; Power Gallery of Contemporary Art, University of Sydney; Queensland Art Gallery, Brisbane; Art Gallery of South Australia, Adelaide; Art Gallery of New South Wales, Sydney
Canada:	Art Gallery of Ontario, Toronto; London (Ont.) Art Gallery; Montreal Museum of Fine Arts; Musée d'art contemporain de Montréal; Vancouver Art Gallery
USA:	Albright-Knox Art Gallery, Buffalo, New York; Brooklyn Museum, New York; Carnegie Museum, Pittsburgh; University of Michigan Museum of Art, Ann Arbor; Smith College Museum of Art, Northampton, Mass.; University of Texas at Austin Art Museum; Toledo Museum of Art, Ohio; Frederick R. Weisman Foundation, Los Angeles
Europe:	Gulbenkian Foundation, Lisbon; Boymans-van Beuningen Museum, Rotterdam; Peter Stuyvesant Foundation, Amsterdam

SELECTED BIBLIOGRAPHY

Note

The following abbreviations are used throughout the bibliography:
New English Weekly: NEW
New Statesman and Nation: NSN
Arts (New York): *Arts*

Writings by Patrick Heron

'Ben Nicholson', *NEW*, 18 October 1945

'To Paris Via Stockholm', *NEW*, 15 November 1945

'Picasso', *NEW*,10 January 1946

'The Pasmore Penguin', *NEW*,7 February 1946

'Paul Klee/Cézanne's Watercolours', *NEW*, 21 February 1946

'Bernard Leach', *NEW*, 27 June 1946

'Braque', *NEW*, 4 July 1946

'Henry Moore and Barbara Hepworth', *NEW*, 31 October 1946

'Paul Nash I', *NEW*, 13 February 1947

'Paul Nash II', *NEW*, 6 March 1947

'A Cubist's Creed', BBC Third Programme broadcast, 10 April 1947

'Nicholson and Soutine', BBC Third Programme broadcast, May 1947

'Sickert and Keene', BBC Third Programme broadcast, 12 June 1947

'Bonnard, Vuillard, Sickert', *World Review*, June 1947

'The Ethics of Mr Herbert Read', *NEW*, 31 July 1947

Vlaminck Paintings 1900–1945, Lindsay Drummond/Les Editions du Chêne, Paris, August 1947

'Turner and Constable', BBC Third Programme broadcast, 26 September 1947

'Smith, Craxton and Freud', BBC Third Programme broadcast, 4 November 1947

'Smith, Craxton and Freud', *NSN*, 8 November 1947

'The School of Paris', *NSN*, 22 November 1947

'Modern British Painters', in British Council exhibition catalogue, November 1947

'Victor Pasmore at the Redfern Gallery', *NSN*, 6 December 1947

'Van Gogh at the Tate', *NSN*, 27 December 1947

'Cubism, Constructivism and Architecture', *Architects' Yearbook III*, January 1948

'Artists in Cornwall', *NSN*, 17 January 1948

'Rouault's "Guerre" and "Miserere"', *NSN*, 24 January 1948

'Marc Chagall', *NEW*, 26 February 1948

'Juan Gris', *NSN*, 20 March 1948

'Paul Nash Memorial Exhibition', *NSN*, 27 March 1948

'Adrian Ryan', *NSN*, 17 April 1948

'Barbara Hepworth/Lawrence Gowing', *NSN*, 24 April 1948

'Drawings from the Albertina/Augustus John', *NSN*, 15 May 1948

'Courtauld Exhibition at the Tate', *NSN*, 22 May 1948

'Sculpture in the Park', *NSN*, 29 May 1948

'Graham Sutherland and Bryan Wynter', *NSN*, 12 June 1948

'Round the Galleries: Adler, Vuillard, Le Brocquy/A Picasso Portrait', *NSN*, 25 June 1948

'August Exhibitions: Turner, Sutherland, Gear', *NSN*, 14 August 1948

'Jack Yeats', *NSN*, 21 August 1948

'MacBryde and Colquhoun', *NSN*, 4 September 1948

'The Criticism of Contemporaries', *NSN*, 2 October 1948

'Julian Trevelyan/Picasso Lithographs', *NSN*, 9 October 1948

'Henry Moore: Drawings', *NSN*, 23 October 1948

'Ivon Hitchens/Ben Nicholson', *NSN*, 20 November 1948

'Letter from London', *Magazine of Art* (New York), November 1948

'John Minton', *NSN*, 12 February 1949

'Hitchens, Dufy and others', *NSN*, 19 March 1949

'Frances Hodgkins', *NSN*, 26 March 1949

'Contemporary American Art: A Note', *Magazine of Art* (New York), March 1949

'The School of London', *NSN*, 9 April 1949

'Reality for the Painter', *NSN*, 16 April 1949

'Sutherland and Wood, *NSN*, 30 April 1949

'Wyndham Lewis', *NSN*, 7 May 1949

'Wyndham Lewis the Artist', *NSN*, 14 May 1949

'Chirico, Marchand, Colquhoun, MacBryde and W. Nicholson', *NSN*, 21 May 1949

'Munich and Vienna I', *NSN*, 28 May 1949

'Munich and Vienna II/Degas at Roland Browse & Delbanco', *NSN*, 4 June 1949

'Picasso Lithographs/Massimo Campigli', *NSN*, 11 June 1949

'Paris, Summer 1949', *NSN*, 16 July 1949

'Salon de Mai Ve', *NSN*, 30 July 1949

'A Paradox of Criticism/Summer Exhibitions', *NSN*, 13 August 1949

'Monsieur K's Choice', *NSN*, 3 September 1949

'William Townsend', *NSN*, September 1949

'James Pryde', *NSN*, 1 October 1949

'Peter Lanyon/Adrian Ryan', *NSN*, 15 October 1949

'The Necessity of Distortion in Painting' lecture at Leeds University, 24 October 1949
 (published in *The Changing Forms of Art*, 1955)

'Lurçat, Le Brocquy, Lelia Caetani, McWilliam', *NSN*, 29 October 1949

'Miss Clough and Miss McCannell', *NSN*, 5 November 1949

'Francis Bacon and William Gear', *NSN*, 3 December 1949

'English and French in 1950', *NSN*, 7 January 1950

'John Minton', *NSN*, 14 January 1950

'A Perpetual Collector', *NSN*, 21 January 1950

'The Impressionists and Post-Impressionists at Burlington House', *Art News and
 Review*, January 1950

'Space in French Landscape', *NSN*, 4 February 1950

'Fernand Léger', *NSN*, 25 February 1950

'The Return of the Image', *NSN*, 18 February 1950

'New Sculpture by Epstein/Julian Trevelyan/Aeply Replicas', *NSN*, 18 March 1950

'London–Paris/Roy de Maistre', *NSN*, 25 March 1950

'The Private Collector', *NSN*, 1 April 1950

'The Poetry of Measure', *NSN*, 8 April 1950

'Mintchine', *NSN*, 22 April 1950

'Trends in Contemporary British Painting', BBC Third Programme broadcast,
 28 April 1950

'The French Contemporaries/Lucian Freud', *NSN*, 29 April 1950

'Matthew Smith and Barbara Hepworth', BBC Italian Service broadcast, July 1950

'Hitchens, Venard, Rowntree', *Art News and Review*, 18 November 1950

'Victor Pasmore/Picasso in Provence', *Art News and Review*, 30 December 1950

'Painting and Photography', *Penrose Annual*, 1950

'The Changing Jug', BBC Third Programme broadcast, January 1951, published in
 The Listener, 25 January 1951

'Paintings by Adrian Stokes', *Art News and Review*, 24 March 1951

'Younger British Sculptors', *House and Garden*, March 1951

'Barbara Hepworth', catalogue introduction to retrospective exhibition at Wakefield
 City Art Gallery, April 1951

'Hills and Faces', *Penwith Society Broadsheet*, 2 June 1951

'Paintings by Peter Lanyon', *St Ives Times*, 22 June 1951

'Mobiles', *House and Garden*, June 1951

'Picasso', *NSN*, 20 October 1951

'Keith Vaughan', lecture at the Institute of Contemporary Arts, 24 October 1951

'Bonnard and Visual Reality', *NSN*, 24 November 1951

'Abstract Painting in Britain', catalogue note to British Council exhibition, January 1952

'A Master Potter's Aesthetic', *NSN*, February 1952

'Art's Scientific Credentials', *NSN*, 29 March 1952

'Ben Nicholson', *NSN*, 17 May 1952

'Ivon Hitchens', *NSN*, 14 June 1952

'Roger Hilton', *NSN*, 24 June 1952

'The Power of Paris', *NSN*, 19 July 1952

'Pottery and Painting', lecture at Dartington Hall, International Conference of Craftsmen in Pottery and Textiles, July 1952

'Barbara Hepworth', *NSN*, 18 October 1952

'Types of Abstraction: Terry Frost and Alan Davie', October 1952, published in *The Changing Forms of Art*, 1955

'Space in Contemporary Painting and Architecture', *Architects' Year Book V*, January 1953

'Fruit or Thorn?', *NSN*, 24 January 1953

'Paul Feiler', *NSN*, 14 February 1953

'James Cant', catalogue introduction, February 1953

'Turner Resurgent/Opposing Forces', *NSN*, 21 February 1953

'Alan Reynolds and Others', *NSN*, 7 March 1953

'Mexico', *NSN*, 14 March 1953

'Picasso in Rome', *NSN*, 16 May 1953

'Graham Sutherland', *NSN*, 6 June 1953

'William Scott', *NSN*, 20 June 1953

'Braque', *NSN*, 27 June 1953

'Georges Braque', catalogue introduction to exhibition of graphic works, Gimpel Fils, June 1953

'Space in Colour', catalogue introduction to exhibition at Hanover Gallery, July 1953

'An Australian in London', *Art News and Review*, 20 February 1954

'Peter Lanyon', *Art News and Review*, 6 March 1954

'Inspiration for the Painter' *NSN*, 1 January 1955

The Changing Forms of Art, Routledge and Kegan Paul, London 1955 (paperback, Noonday Press, New York 1958)

Ivon Hitchens, Penguin Modern Painters, London 1955

'Space in Colour – Notes on 9 British Painters', *Arts Digest*, 15 March 1955

'Barbara Hepworth – Carver', *Arts Digest*, 1 May 1955

'Art is Autonomous', *The Twentieth Century*, September 1955

'John Berger and Social Realism', *Arts*, November 1955

'Moore, Richier, Stanley Spencer', *Arts*, January 1956

'Peter Lanyon', *Arts*, February 1956

'Henry Moore – Pro and Con' by Patrick Heron and Basil Taylor, *Encounter*, 29 February 1956

'The Americans at the Tate Gallery', *Arts*, March 1956

'Alan Davie, Terry Frost', *Arts*, April 1956

'Gear, Hilton, de Staël, McWilliam', *Arts*, May 1956

'Riopelle, Ceri Richards', *Arts*, June 1956

'Renoir', *Arts*, August 1956

'Is Cézanne Still Alive?', *Arts*, October 1956

'John Wells and Bryan Wynter', *Arts*, November 1956

'Artistes Abstraits et Critiques Réalistes', *Preuves*, 69 (Paris), November 1956

'Braque at the Zenith', *Arts*, February 1957

'Profile – Ben Nicholson', *The Observer*, 21 April 1957

'Introducing Roger Hilton', *Arts*, May 1957

'Tachism', *Arts*, June 1957

'Kandinsky, Bacon, Butler', *Arts*, September 1957

'Tachism, Butler, Frost, Wynter', *Arts*, October 1957

'Monet', *Arts*, November 1957

'Armitage, Scott', *Arts*, December 1957

'Derain Reconsidered', *Arts*, January 1958

'Five Americans at the ICA; Hilton', *Arts*, May 1958

'Degas', *Arts*, June 1958

'Niarchos Collection', *Arts*, September 1958

'Dubuffet, Poliakof, Frost, Bell', *Arts*, October 1958

Braque, The Faber Gallery series, London 1958

'A Note on my Painting: 1962', catalogue of Galerie Charles Lienhard exhibition, Zurich, January 1963, reprinted in *Art International*, 25 February 1963

'B. S. Turner', catalogue introduction to exhibition at Leeds City Art Gallery 1964

'Bonnard in 1966', catalogue introduction to exhibition at Victor Waddington Gallery 1966

'The Ascendancy of London in the Sixties', *Studio International*, December 1966

'A Kind of Cultural Imperialism?', *Studio International*, February 1968

'Colour in my Painting: 1969', *Studio International*, December 1969, and Edward Meneely and Christopher de Marigny, *EM46 Patrick Heron Retrospective*, ESM Documentations, New York 1970

'Two Cultures', *Studio International*, December 1970

'Murder of the Art Schools', *The Guardian*, 12 October 1971

'Colour and Abstraction in the Drawings of Bonnard', catalogue essay in *Bonnard Drawings 1893–1946*, The American Federation of Arts, New York 1972

'Notes on my Painting: 1953–1972', in Whitechapel Art Gallery exhibition catalogue 1972

'The Shape of Colour', text of the 5th Power Lecture in Contemporary Art for 1973, published in *Studio International*, February 1974, and in *Concerning Contemporary Art – the Power Lectures 1968–73*, ed. Bernard Smith, Clarendon Press, Oxford 1974

'Tony O'Malley', broadsheet, 1973, and introduction to *Tony O'Malley* exhibition, Wills Lane Gallery, St Ives 1974

'Art in Danger', *The Observer*, 19 May 1974

'The British Influence on New York', *The Guardian*, 10, 11, 12 October 1974

'Barbara Hepworth' (Obituary), *The Observer*, 25 May 1975

'Tony O'Malley', introduction to catalogue of touring exhibition, South West Arts/ Irish Arts Council 1975

'Bryan Wynter', introduction to exhibition catalogue *Bryan Wynter 1915–1975*, Hayward Gallery, August 1976

The Shapes of Colour: 1943–78, limited edition volume of 20 signed and numbered screenprints, Kelpra Editions and Waddington & Tooth Graphics, London 1978

'The Colour of Colour', E. William Doty Lectures in Fine Arts, 1978, The University of Texas at Austin 1979

'Two Impressionists – father and daughter: Norman and Alethea Garstin', catalogue introduction to exhibition organised by Penwith Society of Arts, Penwith Gallery, St Ives and touring 1978

'Penzance', *The Observer Magazine*, 1 July 1979

'A Brush with Purity', An obituary (Ivon Hitchens), *The Guardian*, 31 August 1979

'The Isles of Scilly – The Fabulous Archipelago', *The Observer Magazine*, 24 August 1980

'My Favourite Garden – Abbey Gardens, Tresco', *The Observer Magazine*, 21 June 1981

'Heron's Nest', *Harpers & Queen*, August 1981

'Page Two: Ben Nicholson OM: 1894–1982', *Art Monthly*, no. 54, March 1982

'How the Tories develop Philistinism to a Fine Art', *The Guardian*, 23 December 1985, and *Art Monthly*, December 1985

'Address given by Patrick Heron after the Conferment of the Honorary Degree of Doctor of Letters at the Degree Congregation of the University of Kent, in Canterbury Cathedral July 18 1986', *Art Monthly*, September 1986, and *Private View*, School of Art and Design, CCAT, Cambridge, no. 6, spring 1987

'Blue Cranes in the Sky' (Richard Rogers' Lloyds Building), *Architectural Review*, October 1986

'Francis Davison: A Personal Note', in catalogue to exhibition at Redfern Gallery 1986

'Margaret Mellis: A Personal Note', in catalogue to exhibition at Redfern Gallery 1987

'Painting is Silent', conversation between Patrick Heron and H. Cumming, *Art and Design*, vol. 3, no. 5/6 1987

'Patrick Heron in Conversation with Michael McNay – Abstraction and Intimations of Landscape', *Artists Talking*, Lecon Arts Tape/Slide Talks 1987

Writings on Heron by Others

Hugh Gordon Porteus. 'Patrick Heron', *NEW*, 23 October 1947

Robert Vrinat, 'Début de saison artistique à Londres', *L'Âge Nouveau* (Paris), January 1949

David Sylvester. 'Patrick Heron', *Art News and Review*, 6 May 1950

Basil Taylor. 'Patrick Heron', *NSN*, 6 May 1950

Basil Taylor. Introduction to catalogue of *Retrospective Exhibition of Paintings and Drawings by Patrick Heron*, Wakefield City Art Gallery, April 1952 and tour

Basil Taylor. 'Space in Colour', *The Times*, 26 July 1953

Alan Bowness. 'Form and Content', *The Observer*, 11 September 1955

Basil Taylor. 'The Painter as Critic', BBC Third Programme, 14 September 1955

Raymond Mortimer. 'Art Critics in a Fix: and a Painter on Some Modern Masters', *Sunday Times*, 18 September 1955

Unsigned. 'Space in Colour: Mr Patrick Heron's New Pictures', *The Times*, 19 June 1956

Unsigned. 'Painter as Critic', *Times Literary Supplement*, 6 July 1956

Unsigned. 'The Spectrum on Canvas: Mr Patrick Heron's New Paintings', *The Times*, 28 February 1958

John Russell. 'Heron Aloft', *Sunday Times*, 13 December 1959

Unsigned. 'Preoccupation with Colour: Mr Patrick Heron's New Paintings', *The Times*, 29 November 1960

Stuart Preston. 'An English Modern', *New York Times*, 17 April 1960

Carlyle Burrows. 'Heron has Debut', *New York Herald Tribune*, 17 April 1960

George Dennison. 'Month in Review', *Arts* (New York), April 1960

J.-P. Hodin. 'Patrick Heron', *Quadrum II*, Brussels 1961

Helen Lambert. 'UK's Patrick Heron, US's Paul Jenkins', *New York Herald Tribune*, 6 March 1963

David Storey. 'Towards Colour', *NSN*, 8 March 1963

Norbert Lynton. 'London Letter', *Art International*, 25 April 1963

Alan Bowness. Introduction to catalogue of VIII Bienal de São Paulo, British Council, London 1965

B. Robertson, J. Russell, Snowdon. *Private View*, Nelson, London 1965

John Russell. 'Underlining the Difference', *Sunday Times*, 7 May 1967

Robert Hughes. 'Colour Standing Up Alone', *The Observer*, 14 May 1967

Norbert Lynton. 'Heron Exhibition', *The Guardian*, 19 May 1967

Ronald Alley. 'Patrick Heron: the Development of a Painter', *Studio International*, July/August 1967

Robert Hughes. Introduction to exhibition catalogue *Retrospective: Patrick Heron*, Richard Demarco Gallery, Edinburgh, June–July 1967

Alan Bowness. 'On Patrick Heron's Striped Paintings', *Patrick Heron: a Retrospective Exhibition of Paintings 1957–66*, Museum of Modern Art, Oxford, May–June 1968

Edward Meneely, Christopher de Marigny. *EM46, Patrick Heron Retrospective*, ESM Documentations, New York 1970

Hilton Kramer. 'The American Juggernaut', *New York Times*, 3 January 1971

Geoffrey Nicholson, 'Z: Zennor: Patrick Heron, Painter', *Sunday Times Magazine*, 12 December 1971

Michael McNay. 'Heron's Nest', *The Guardian*, 21 June 1972

Alan Bowness. Introduction to exhibition catalogue *Patrick Heron: Recent Paintings and Selected Earlier Canvases*, Whitechapel Art Gallery, London, June–July 1972

Hilary Spurling. 'East End Flame Thrower', *The Observer*, 25 June 1972

Hilton Kramer. 'Patrick Heron's Art on View in London', *New York Times*, 11 July 1972

Lenore Nicklin. 'The Interlocking Artist', *Sydney Morning Herald*, 15 June 1973

Laurie Thomas. 'Stirred by a Wobbly Hard-Edger', *The Australian*, 16 June 1973

Daniel Thomas. 'Artist's Passion for Colour', *Sydney Morning Herald*, 21 June 1973

Sandra McGrath. 'Colour is the Medium and the Message', *The Australian*, 23 June 1973

Bruce Adams. 'In Control of Colours', *Sunday Telegraph* (Sydney), 24 June 1973

Nancy Borlase. 'Brilliant Use of Colour, Form', *The Bulletin* (Sydney), 30 June 1973

Laurie Thomas. 'Through the Critic's Eyes Darkly', *The Australian*, 30 June 1973

Donald Brook. 'Victims of a US Hardsell?', *Nation Review* (Sydney), 6–12 July 1973

'Patrick Heron Interviewed by James Faure Walker & Brandon Taylor', *Artscribe*, no. 2, spring 1976

R. C. Kenedy: 'Patrick Heron: Abstract Impressionist', *Paintings by Patrick Heron 1965–77*, University of Texas at Austin Art Museum 1978

Brandon Taylor. 'Abstract Colour Painting in England: The Case of Patrick Heron', *Art History*, vol. 3, no. 1, March 1980

John Russell Taylor. 'High Flying Heron', *The Times Preview*, 4–10 September 1981

Peter Fuller, 'Patrick Heron', *Art Monthly*, no. 50, October 1981

James Faure Walker, 'Patrick Heron', *Artscribe*, no. 31, October 1981

Adrian Lewis. 'British Avant Garde Painting 1945–56', *Artscribe*, no. 34, 31 March 1982; no. 35, June 1982

Alan Gouk. 'Patrick Heron', *Artscribe*, no. 34, 31 March 1982; no. 35, June 1982

Colin Nears (director). *Patrick Heron*, BBC *Omnibus* film, screened 13 March 1983

C. Collier. 'Heron Exhibition at Waddingtons', *Studio International*, no. 196, 1983

Tom Cross. *Painting the Warmth of the Sun: St Ives 1939–75*, Lutterworth Press, Guildford 1984

Kevin Crooks (director), Jonathan Harvey (associate producer). *Painting the Warmth of the Sun*, TSW Production for Channel Four, screened 7, 8, 9 April 1985

Vivien Knight. 'The Pursuit of Colour' – James Faure Walker. 'Patrick Heron: the 1970s' – Alan Gouk. 'Recent Paintings', in exhibition catalogue of *Patrick Heron*, Barbican Art Gallery 1985

Sarah Jane Checkland. 'A Painter's Craft', *The Times*, 6 July 1985

William Packer. 'Bright Bursts of Abstract Colour', *Financial Times*, 16 July 1985

Richard Seddon. 'Heron in Flight', *Yorkshire Post*, 22 July 1985

John Russell Taylor. 'Healthy Rebuff for Thoughts of School', *The Times*, 23 July 1985

Michael McNay. 'Star with the Stripes', The Guardian, 23 July 1985

Cissie Lodge. 'Urgent Need to Champion the Painter's Rights', *The News Line*, 24 July 1985

Linda Talbot. 'Letting the Paint Squirm Loose', *Hampstead & Highgate Express*, 26 July 1985

Lucy Ellmann. 'Controlling the Paint', *Times Literary Supplement*, 9 August 1985

Mary Rose Beaumont. 'Patrick Heron', *Arts Review*, 12 August 1985

Richard Cork. 'Serene', *The Listener*, 29 August 1985

Ray Rushton. 'Patrick Heron', *Journal of the Royal Society of Arts*, August 1985

Peter Fuller. 'The Innocent Eye', *Artscribe*, no. 54, September/October 1985

Margaret Garlake. Review of various exhibitions, *Art Monthly*, September 1985

Clare Henry. 'Patrick Heron', *Glasgow Herald*, 20 November 1985

John Read (producer/director). *South Bank Show: Patrick Heron*, LWT Production, screened 9 February 1986

Giles Auty. 'Unfamiliar Ground', *The Spectator*, 14 March 1987

Plates

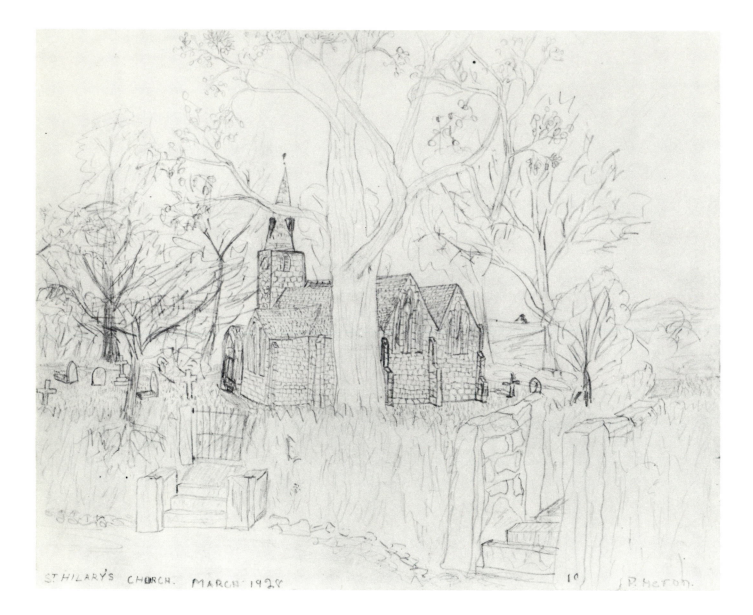

1 St Hilary's Church: March 1927 pencil on paper 10 × 12in/25·4 × 30·5cm

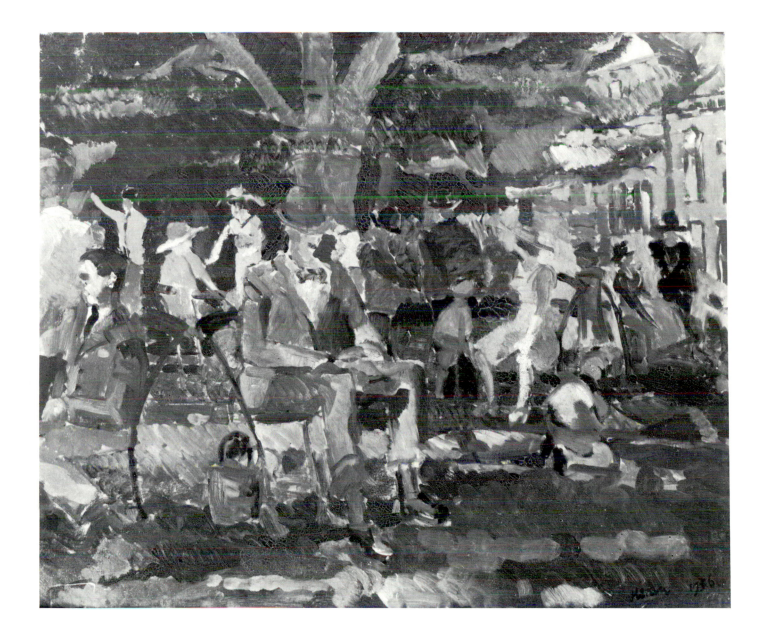

2 Fete at Hatfield House 1936 oil on board 22½ × 27in/57·2 × 68·5cm

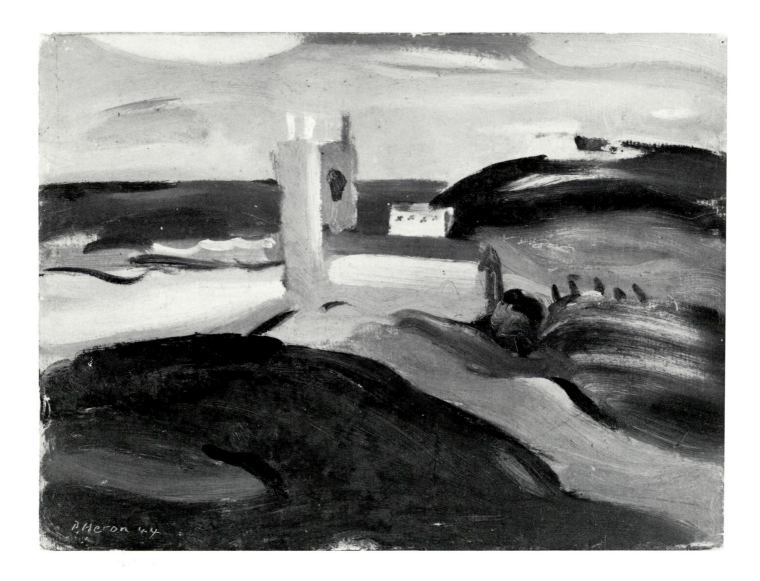

3 Church on the Sandhills 1944 oil on cardboard $8\frac{5}{8} \times 11\frac{1}{4}$ in/21·8 × 28·6cm

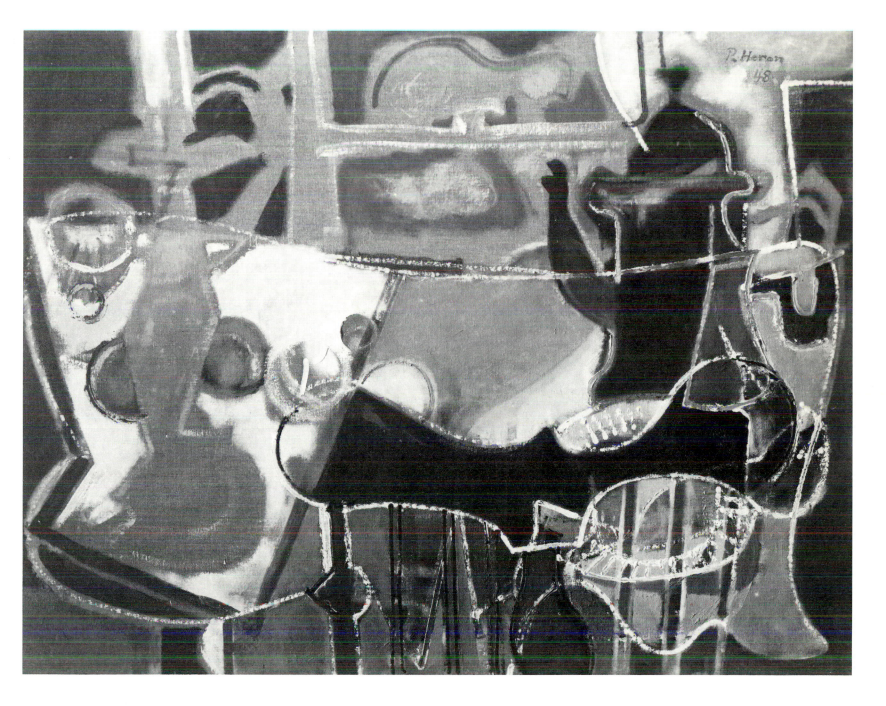

4 Night Still Life 1948 oil on canvas 28 × 36in/71 × 91·4cm

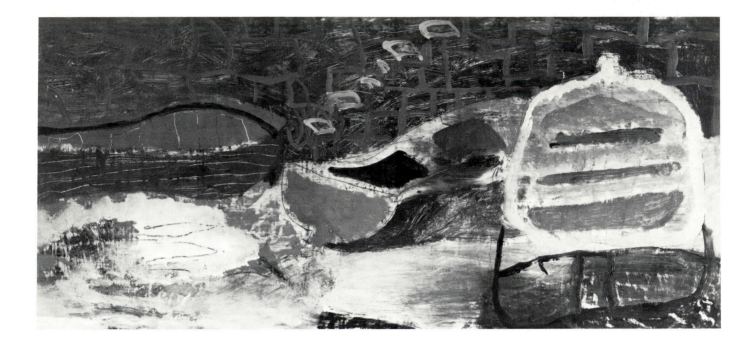

5 Harbour Bottom 1948 oil on canvas $10\frac{5}{8} \times 23\frac{1}{8}$in/26·9 × 58·7cm

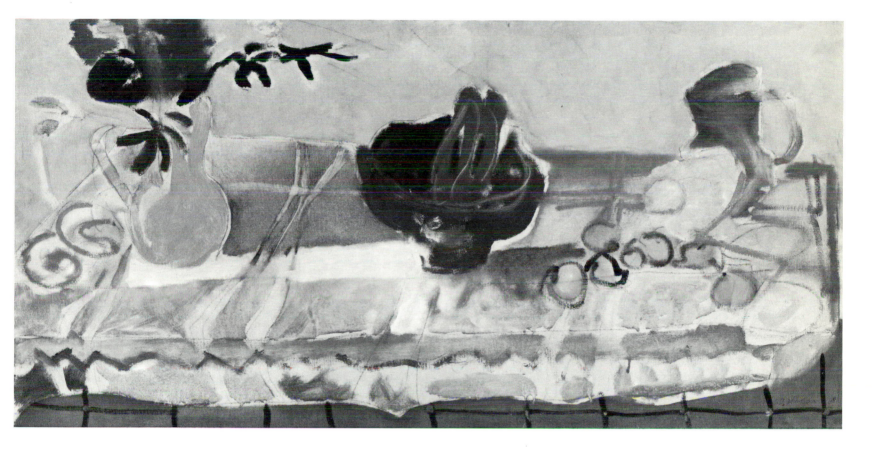

6 Still Life with Black Bananas 1948 oil on canvas $17\frac{3}{4} \times 35\frac{3}{4}/55 \cdot 5 \times 91$cm

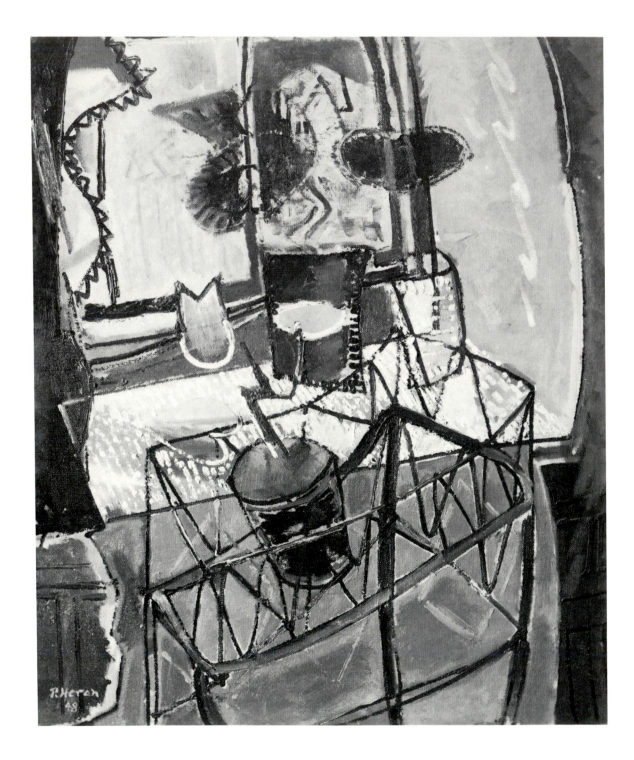

7 The Jardinière 1948 oil on canvas 30 × 25in/76·2 × 63·5cm

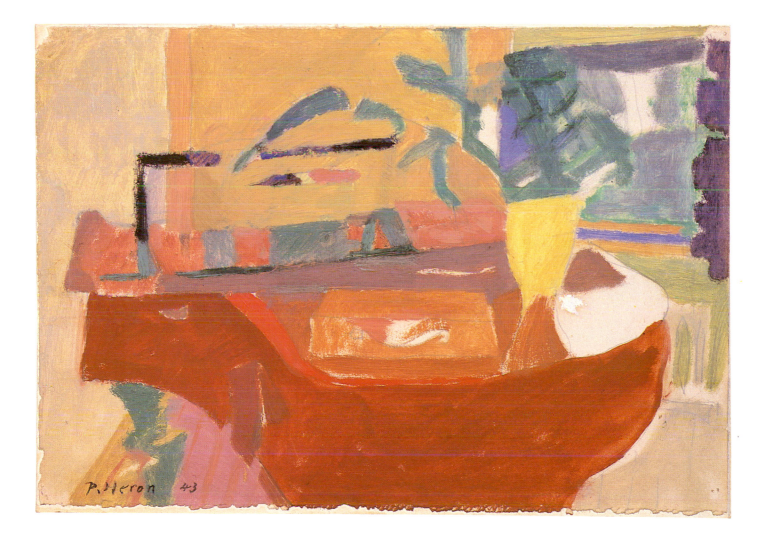

8 The Piano 1943 oil on paper 7½ × 10¾in/19 × 27·3cm

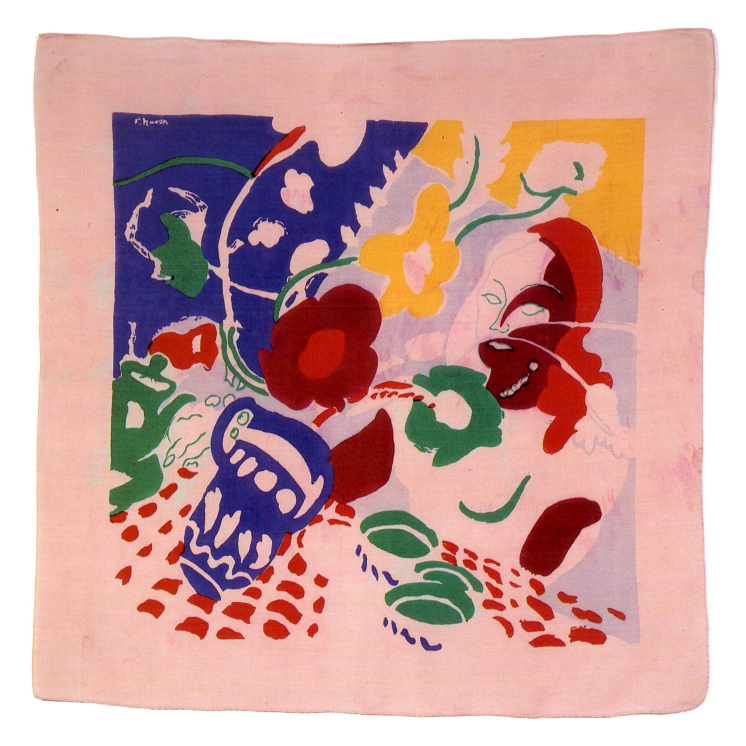

9 On the Terrace 1944 printed fabric for Cresta Silks 26 × 26in/66 × 66cm

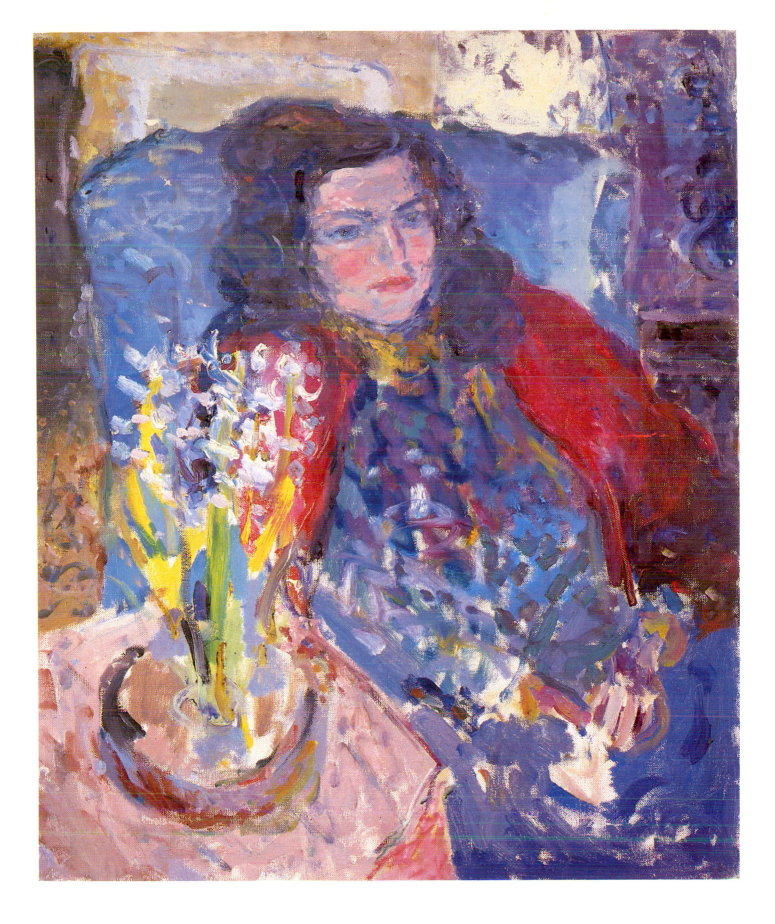

10 Delia 1947 oil on canvas 30 × 25in/76·2 × 23·5cm

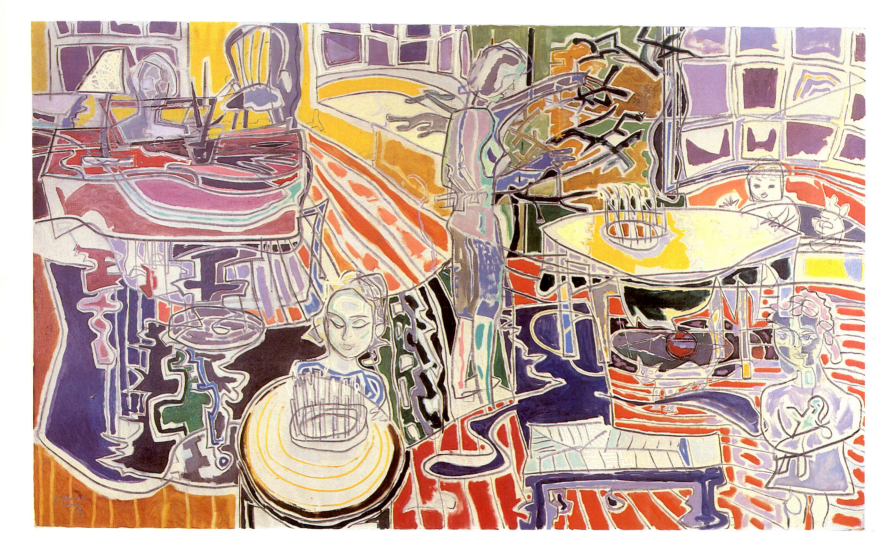

11 Christmas Eve 1951 oil on canvas 72 × 120in/182·9 × 304·8cm

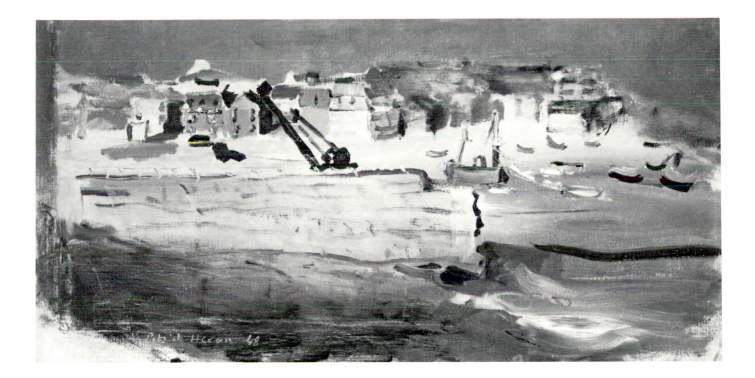

12 St Ives Harbour 1948 oil on canvas 12½ × 25in/31·8 × 63·5cm

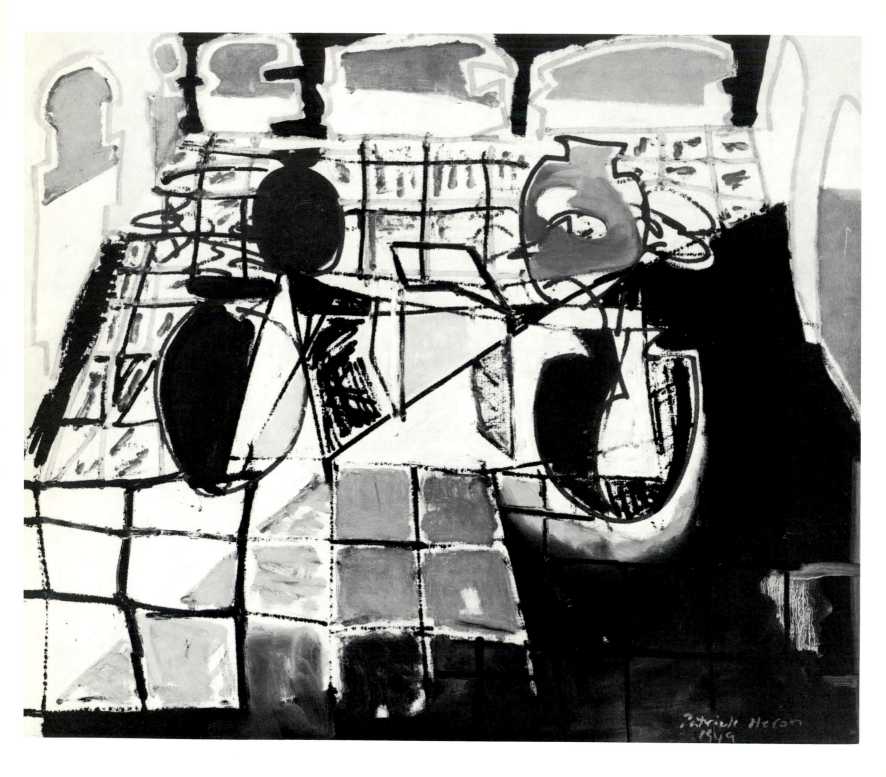

13 Courtyard, Cap d'Antibes 1949 oil on canvas 25 × 30in/63·5 × 76·2cm

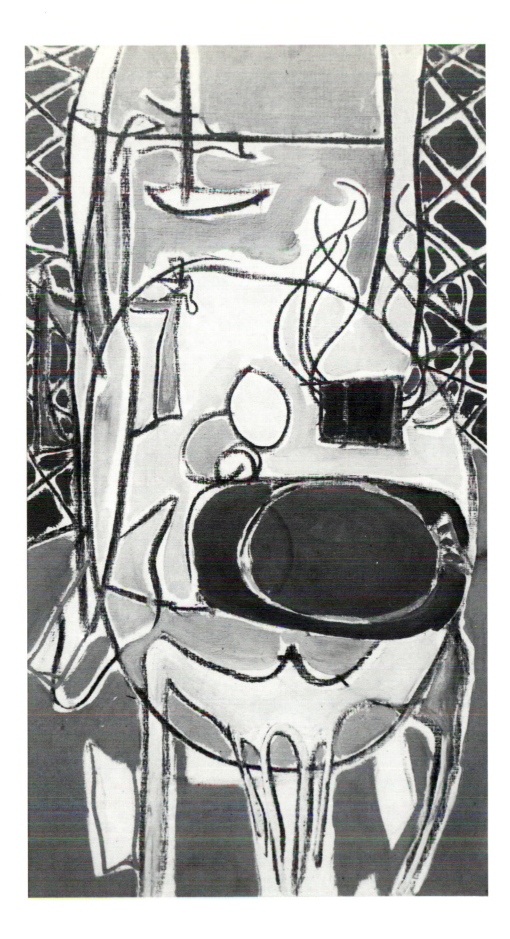

14 Round Table against the Sea 1949 oil on canvas 36 × 20in/91·4 × 50·8cm

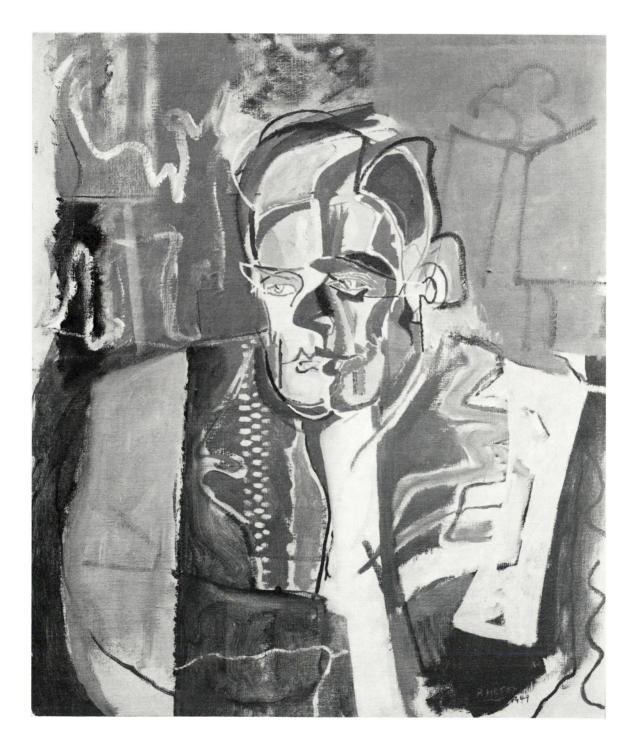

15 Portrait of T.S. Eliot 1949 oil on canvas 30 × 25in/76·2 × 63·5cm

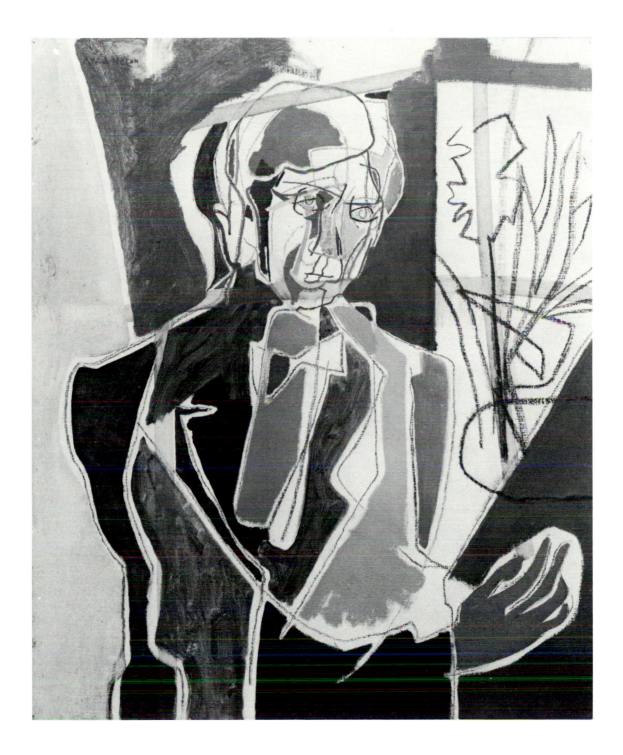

16 Portrait of Sir Herbert Read 1950 oil on canvas 30 × 25in/76·2 × 63·5cm

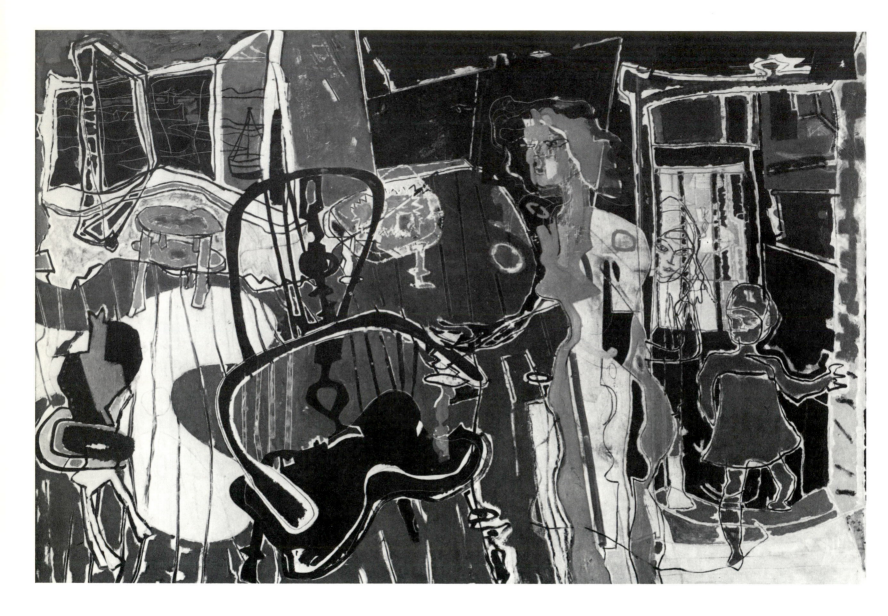

17 The Room at St Ives 1952–53 oil on canvas 48 × 72in/121·9 × 182·9cm

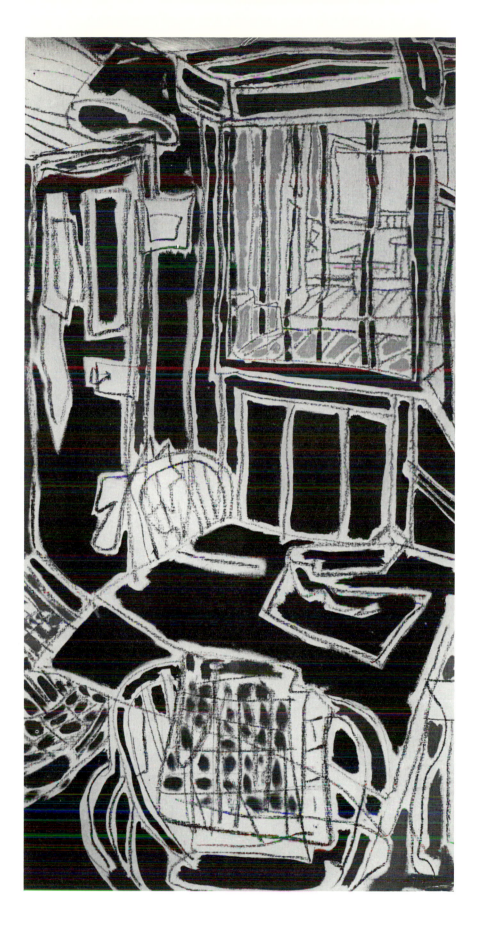

18 The Studio Stair, St Ives 1952–53 oil on canvas 36 × 18in/91·4 × 45·7cm

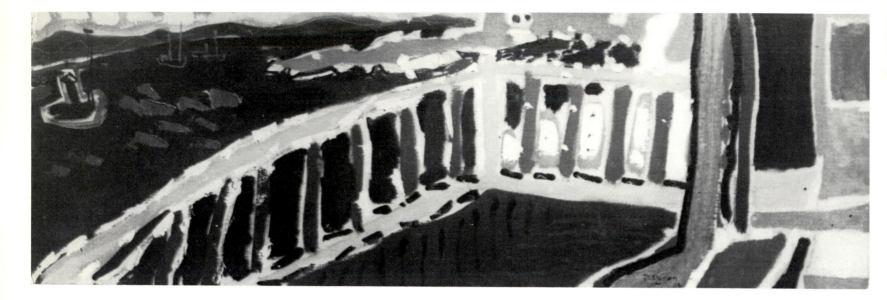

19 Balcony with Rough Sea, St Ives 1953–54 oil on canvas 12 × 48in/30·5 × 121·9cm

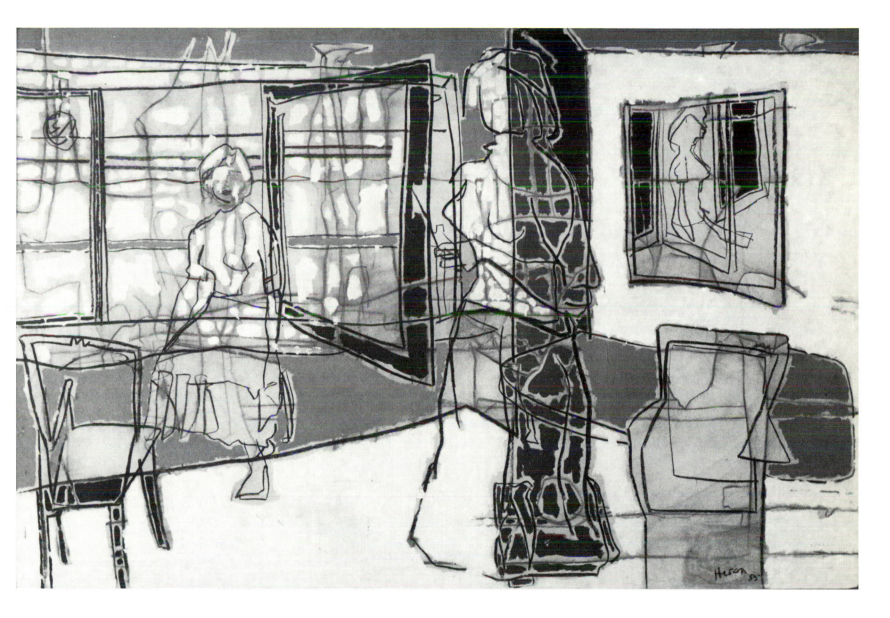

20 Girl in Harbour Room 1955 oil on hardboard 48 × 72in/121·9 × 182·9cm

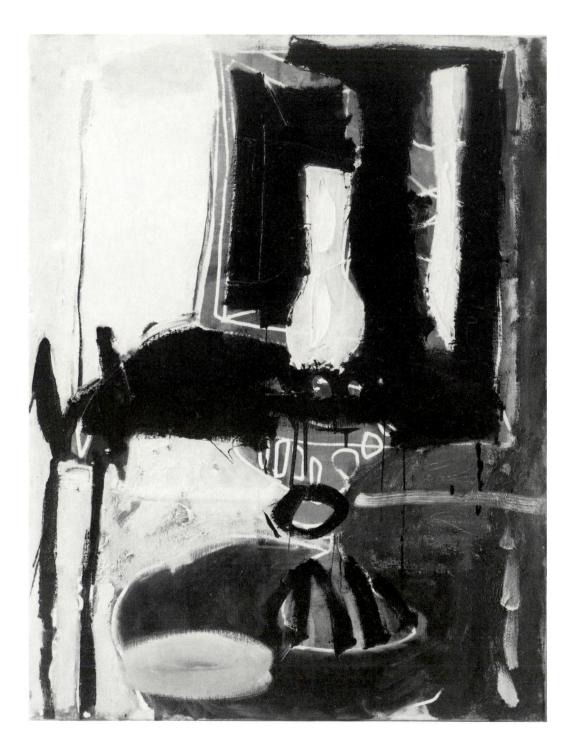

21 The Lamp 1955 oil on canvas 40 × 30in/101·6 × 76·2cm

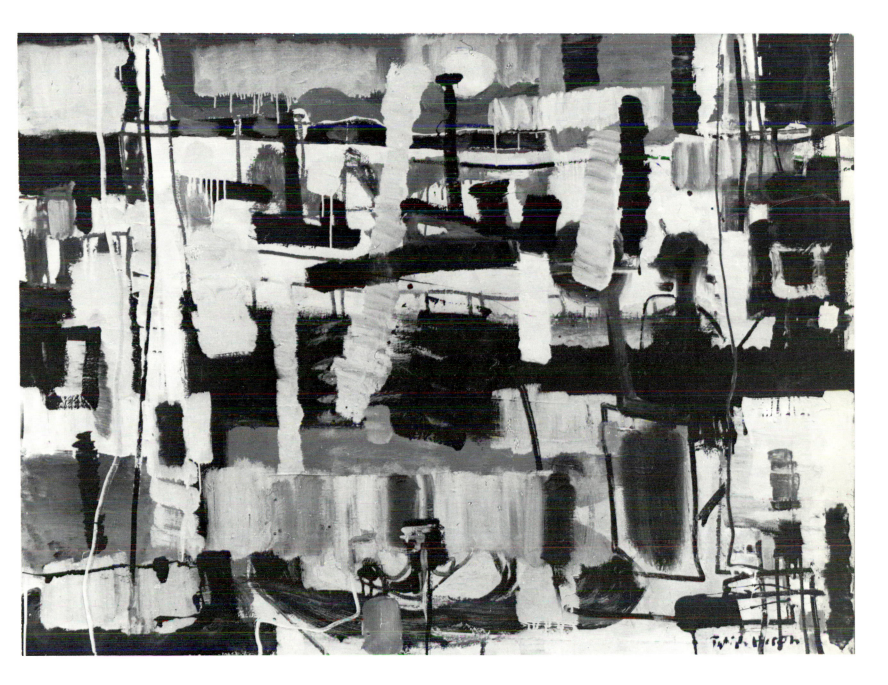

22 Winter Harbour 1955 oil on canvas 40 × 50in/101·6 × 127cm

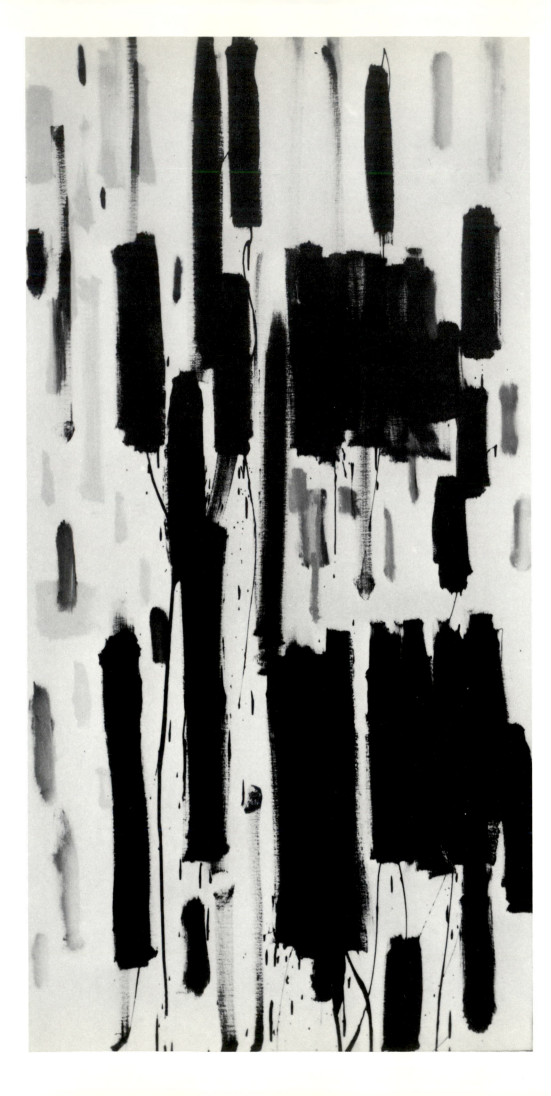

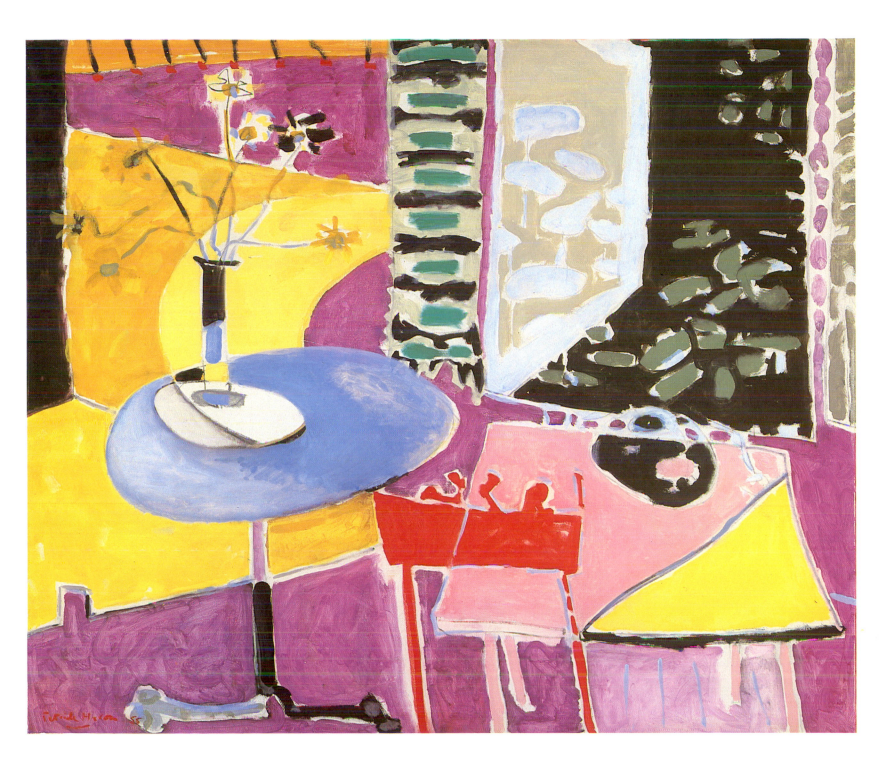

opposite : 23 Black and White Vertical I: April 1956 oil on canvas 72 × 36in/182·9 × 91·4cm
above : 24 Interior with Garden Window 1955 oil on canvas 48 × 60in/121·9 × 152·4cm

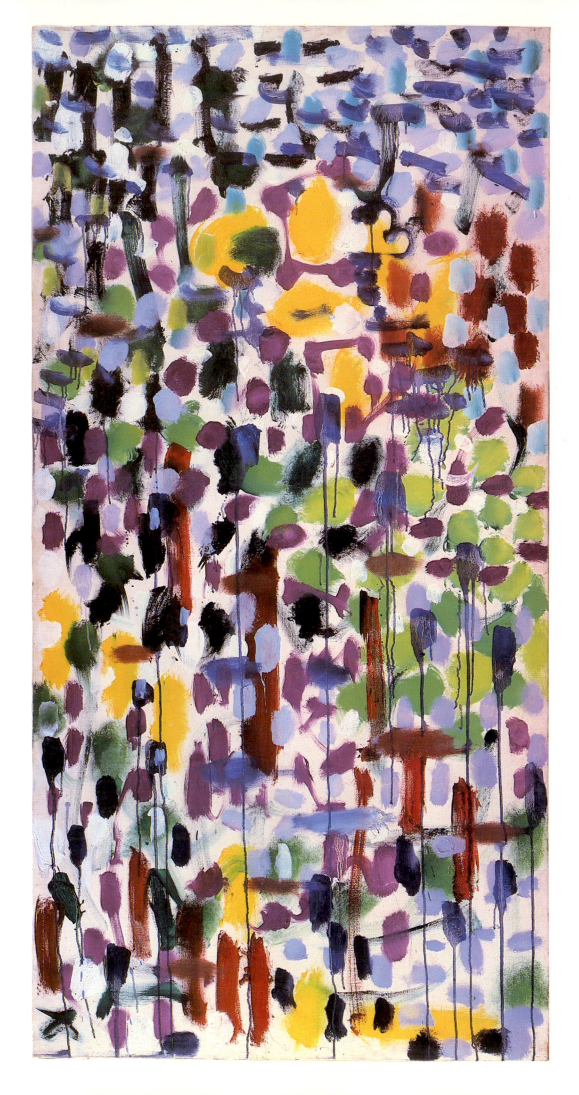

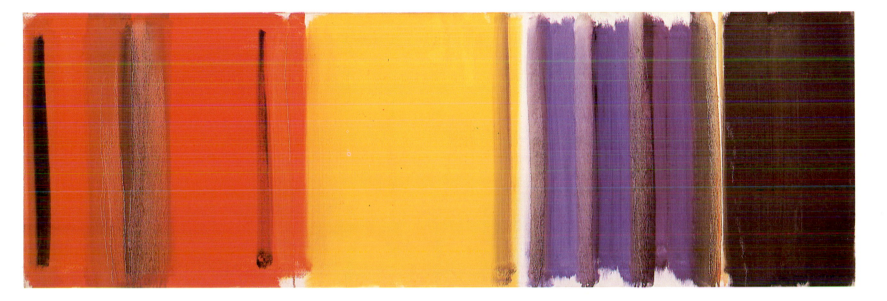

opposite: 25 Autumn Garden 1956 oil on canvas 72 × 36in/182·9 × 91·5cm
above: 26 Scarlet, Lemon and Ultramarine: March 1957 oil on canvas 24 × 72in/61 × 182·9cm

overleaf: 27 Red Horizon: March 1957 oil on canvas 72 × 36in/182·9 × 91·5cm

28 Camellia Garden: April 1956 oil on canvas 72 × 36in/182·9 × 91·5cm

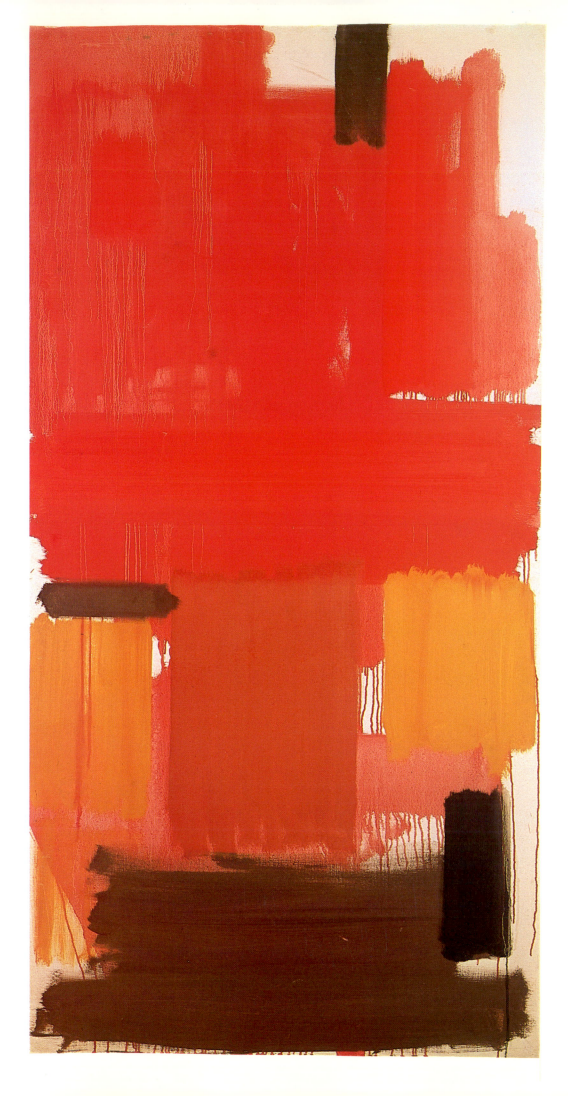

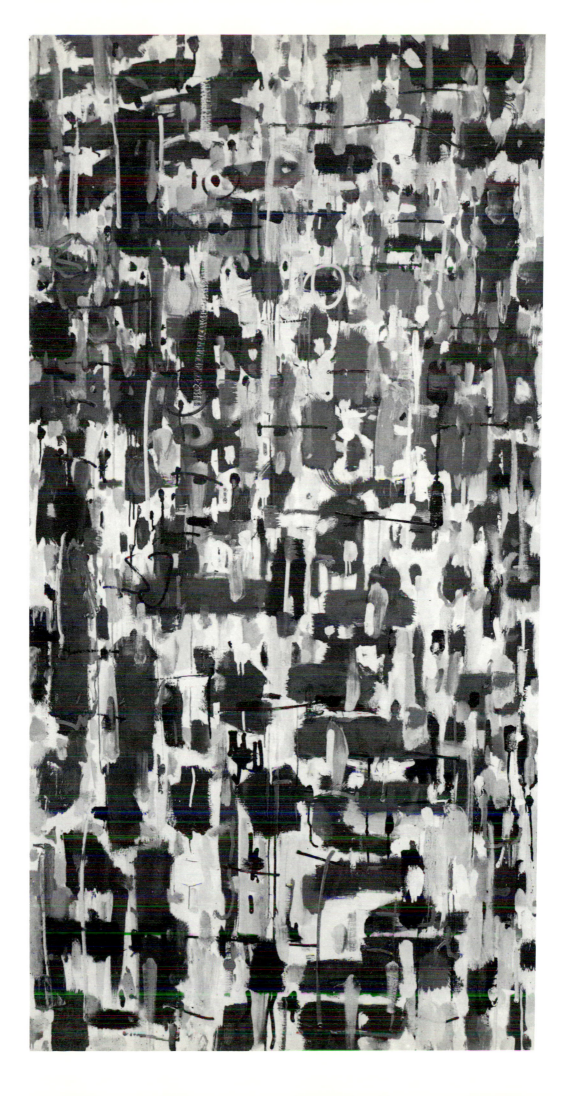

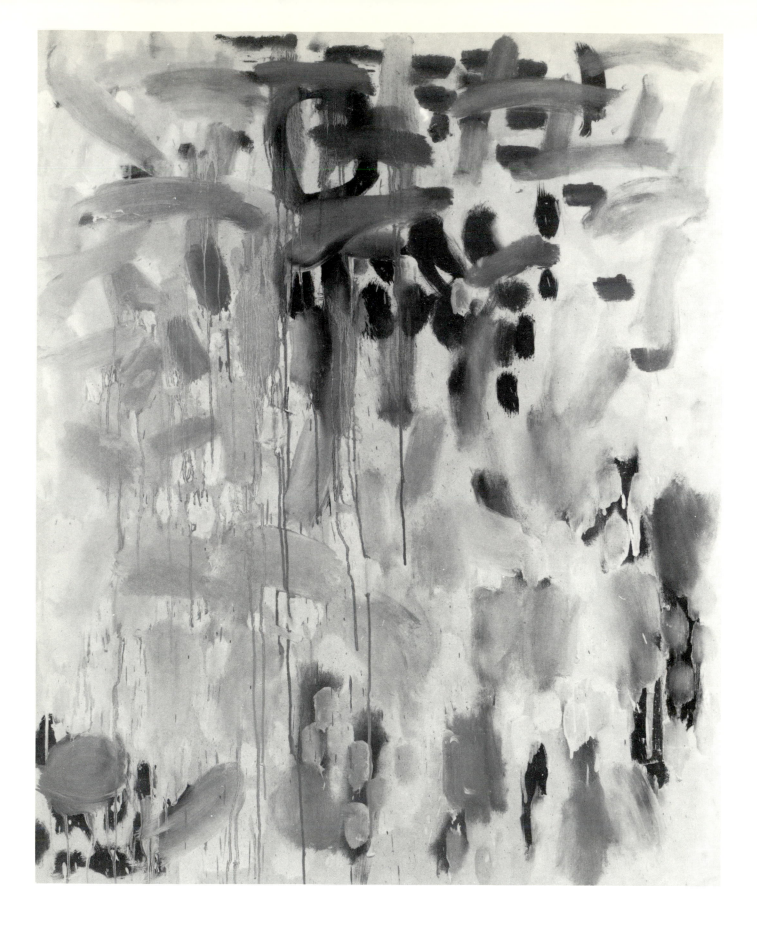

29 Garden Painting: August 1956 oil on canvas 48 × 36in/121·9 × 91·5cm

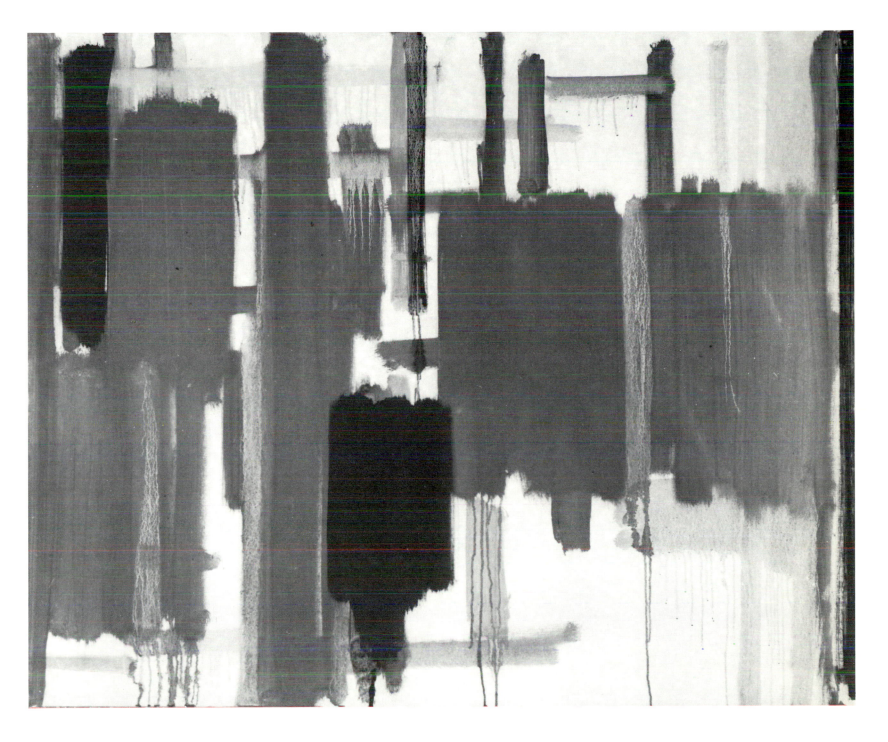

30 Scarlet Verticals: March 1957 oil on canvas 40 × 50in/102 × 120cm

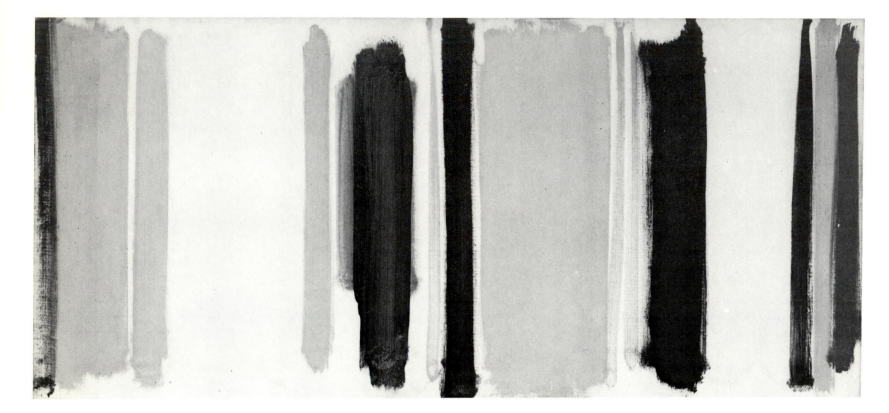

31 Vertical Light: March 1957 oil on canvas 22 × 48in/55·9 × 121·9cm

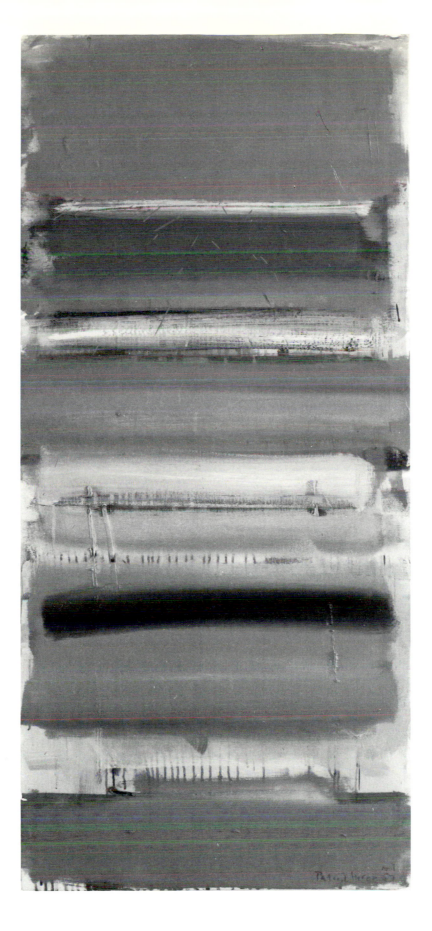

32 Ochre Skies: April 1957 oil on canvas 48 × 22in/121·9 × 55·9cm

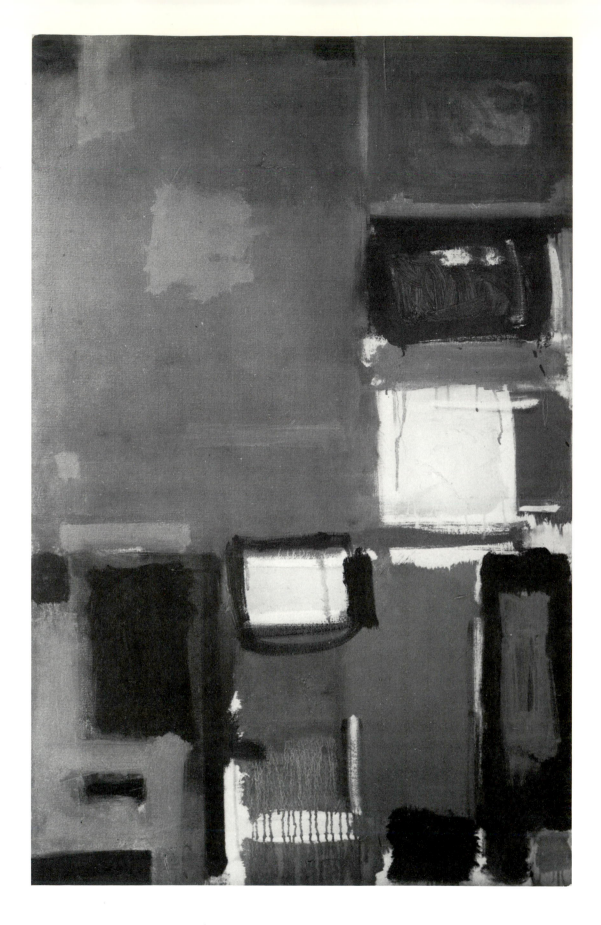

above: 33 Yellow and Violet Squares in Red: February 1958 oil on canvas 48 × 30in/121·9 × 76·2cm
opposite: 34 Images in Red: August–September 1958 oil on canvas 72 × 36in/182·9 × 91·5cm